Using Museums as an Educational Resource Second Edition

Using Museums as an Educational Resource

An Introductory Handbook for Students and Teachers
Second Edition

GRAEME K. TALBOYS

3050762

© Graeme K. Talboys 2010

All rights reserved. No part of this publication may be reproduced, stored in a retrieval system or transmitted in any form or by any means, electronic, mechanical, photocopying, recording or otherwise, without the prior permission of the publisher.

Graeme K. Talboys has asserted his right under the Copyright, Designs and Patents Act, 1988, to be identified as the author of this work.

Published by

Ashgate Publishing Limited

Wey Court East Union Road

Farnham

Surrey, GU9 7PT

England

Ashgate Publishing Company

Suite 420

101 Cherry Street

Burlington

VT 05401-4405

USA

www.ashgatepublishing.com

British Library Cataloguing in Publication Data

Talboys, Graeme K.

Using museums as an educational resource: an introductory

handbook for students and teachers. -- 2nd ed.

1. Museums and schools. 2. Museums--Educational aspects.

I. Title

069.1'5-dc22

Library of Congress Cataloging-in-Publication Data

Talboys, Graeme K.

Using museums as an educational resource: an introductory handbook for students and teachers / by Graeme K. Talboys.

p. cm.

Includes bibliographical references and index.

ISBN 978-1-4094-0145-2 (hardback) -- ISBN 978-1-4094-0146-9 (ebook)

1. Museums and schools--Handbooks, manuals, etc. 2. Museums--Educational aspects--Handbooks, manuals, etc. I. Title.

LB1047.T35 2010 069'.15--dc22

2010021909

ISBN 978 1 4094 0145 2 (hbk) ISBN 978 1 4094 0146 9 (ebk)

Printed and bound in Great Britain by MPG Books Group, UK

CONTENTS

List of Figures Acknowledgements		vii ix
Introduction		1
PART I	FIRST PRINCIPLES	
1	What is a museum?	7
2	Why take pupils to museums?	23
3	Why special skills are necessary to use museums for teaching	37
PART II	PREPARATORY STRATEGIES	
4	Aspects of a visit	47
5	Planning a visit – general	55
6	Planning a visit – risk assessment and management	67
7	Preparing for a visit – the teacher	73
8	Preparing for a visit – the pupils	79
9	The visit	83
PART III	USING THE RESOURCE	
10	Working on or with a site	91

11	Working with a building	101
12	Working with objects	109
13	Working with pictorial material	119
14	Working with documentary material	127
15	Using a loan service	135
16	Using simulation	139
17	Using the written word	151
18	Using online and digital sources	155
PART IV	FOLLOWING-THROUGH	
19	Follow-up	161
20	Longer term strategies	165
Bibliography Index		173 179

LIST OF FIGURES

2.1	Relation of memory and understanding to involvement	25
5.1	Sample letter and consent form	61
5.2	Sample next of kin contact form	62
6.1	Sample risk assessment form	71

ACKNOWLEDGEMENTS

In one sense, this book is the fruit of many years work. However, I was able to take time out from a busy work schedule, compile my research, and write most of the text because of a grant from the St Hild and St Bede Trust. I would like to thank them for the faith they had in me-I hope this work goes some way to repaying that.

In addition, many individuals, each in their own particular and peculiar ways, have contributed to the writing of this book. Some were willing, others not. Some did so directly, some by convoluted ways. Some did so consciously; others subconsciously; none, I trust, unconsciously (my teaching isn't quite that bad). Most made positive contributions, some negative. To them all I would like to extend my thanks.

Many of these people must remain anonymous for they are the thousands of pupils and the many hundreds of teachers and student teachers that I have worked with. Their names would be too numerous to mention, even if I knew them all. There are, however, some folk whose names I do know that I can and must mention for their own particular and useful contributions.

My thanks, then, to Howard Mullen, my mentor in those early and sometimes difficult years of my teaching career; to Fiona Marsden and Catherine Tonge who gave me my first ever job in a museum, and to all the others with whom I worked in Sussex; to the group of student teachers at what was Brighton Polytechnic who set me off on this particular track; to Susan Mills, the Revd Ian Hunter Smart, the Revd Paul Baker, Ann Alexander, John Archibald, Tom Robson, Jenny Robinson, Bob Clint, and Elizabeth Bell and to all the other staff and volunteers at St Paul's Church and what was then The Bede Monastery Museum (now Bede's World), Jarrow; to David Day and Linda Burton (lecturers), and to Lisa Duggleby and Val Bryson (students) at the School of Education, Durham University; to Frank Bennett for his research, kindly lent and very useful; to Jo Cunningham, Caroline Lloyd, Helen Sinclair, and all the other members of the Museums North Education Panel; to Catkin, much deprived of her favourite chair; and last, but not least, to my wife, Barbara, whose husband is no longer the sound of a computer keyboard, punctuated by heavy sighs, coming from another room.

For all that I have been assisted by these many good folk in their own various ways, the idiosyncrasies and errors of this work are all my very own.

Auchenflower May 1994 In addition to the foregoing I would like to thank Dymphna Evans at Ashgate for providing me with the opportunity to bring this work up to date, Pam Bertram (also at Ashgate) for turning my typescript into the book you have in your hands and John Pickin at Stranraer Museum where the research trail was picked up. Catkin, sadly, is no longer with us. Barbara continues to be a wonderfully supportive companion. Without her it really would not have been possible to write the original text or return to it all these years later.

Clas Myrddin May 2010

INTRODUCTION

When I first wrote this book it was clear that whilst many teachers were enthusiastic about the use of museums as an educational resource, most had not been equipped with the necessary skills to do so by their formal training. They were self taught. Although highly competent, it seemed to me short-sighted on the part of the powers that be that trainee teachers were not taught the requisite skills for working outside the classroom as an integral part of their studies.

A lot has changed in the sixteen years since this book was written. Sadly, a great deal more has not. For whilst it is clear there is now a greater recognition of and emphasis on the use of museums in teaching; it is also clear that little has been done to put this into action on a systematic basis. The best time for this, for a number of reasons, would be during initial training. Once teachers become immersed in the day-to-day concerns of their work, they have, even with the best will in the world, little opportunity to take the time that is necessary to acquire the new skills and the new ways of thinking that are required for museum work.

Despite this, most teachers do recognise the importance of taking their pupils out of the classroom and into other learning environments. Unfortunately, not all of them have the expertise or resultant confidence to take such a step. Others find the task so onerous, in addition to everything else they have to cope with, they see the effort involved apparently outweighing the benefits that accrue. And, of course, there are still (and always will be) those teachers who do not see the value of visits but who, even so, sometimes get dragged along to help.

There are two other types of teacher: those who take to working in museums like the proverbial fish takes to water; and student teachers — with assignments and teaching practice and occasionally with tutors who believe in the efficacy of museum visits. These have all been part of my constituency as a museum education officer and over the years I have tried to help as many of them as I could.

Until this book was written, that help had always been on an *ad hoc* basis, responding to requests from a variety of quarters to provide a day or a half-day training session in some aspect of education work in museums. That, of course, was far from a satisfactory way of approaching the problem. It seemed to me that what was needed was a book that would guide teachers through the intricacies of planning, preparing, executing and following up a museum visit. What is more, it needed to be a book aimed specifically at those who were learning to become teachers so that they could integrate what they learn from it with the mainstream of their studies.

Of course, I was not the only one to have thought all this. Many of my colleagues in the museum world felt the same and still do. It was a concern that was felt elsewhere. Her Majesty's Inspectorate of Schools in England and Wales had written a number of reports referring to museums and various aspects of education. In particular, their report A Survey of the Use of Museum Resources in Initial Teacher Training 1991–1992 (HMI 1992), accurately identified several problems in respect of the use of museums. The main findings of the survey were as follows:

- Although each institution introduced some primary and secondary phase students to learning from museums through a subject component, a phase course or an optional course, not all students received this training.
- The time allocated to museum education ranged from half a day to 18 days. Some museum visits were followed up by seminars in the institutions and some but not all courses required students to reflect on learning from museum resources in written assignments.
- Some good sessions were seen in museums when students were shown fine examples of teaching techniques by museum education officers. Students were introduced to ideas and resources of relevance to the National Curriculum about which they previously knew little.
- Students responded well to the tasks set in museums whether they had to analyse individual objects, review whole displays or prepare lessons for pupils.
- Not all institutions had sufficient books and journals which outlined both theories of learning from museum resources and practical examples of schools' use of museums. Some but not all students were given bibliographies and helpful duplicated material.
- The extent of students' training in the use of museum resources depends on the interests of individual tutors. All institutions need to ensure that students are aware of the educational use of museums. Where such training occurs it is of considerable value to the students.

In addition, the HMI team felt that 'all students would benefit from being given a basic collection of material which included a bibliography, ideas for planning learning from objects and museum displays, note of museum educational facilities in a sample of local and national museums, and a guide to planning visits'. Furthermore, they stated that 'institutions should consider giving all students the opportunity to learn about the educational use of museum resources'.

Although a more recent study (Hooper-Greenhill et al. 2006) has shown: 'Museum staff report that ... teachers are more confident and expect more from museums, as their knowledge and understanding of how museums can be used increases. Schools are broadening and deepening the way they use museums, getting involved in longer term relationships and projects.'; Ofsted later concluded (Ofsted 2008) that: 'The management of learning outside the classroom was not consistently good and

the schools and colleges surveyed did not always exploit its potential or evaluate its impact sufficiently.' Whilst many museums have moved in to fill the gap by providing more sophisticated and inventive forms of training for practising teachers, along with partnerships with Initial Teacher Training/Initial Teacher Education (ITT/ITE) providers, there is clearly a lot more that needs to be done.

In the absence still of any systematic attempt to train teachers in the use of museums this book is primarily for those who are following courses of initial teacher training. That is the ideal time to make this sort of study and assimilate these new skills. It is then that study is a strong habit. It is then that the material herein can more easily be integrated with studies on child development, the psychology and sociology of learning, theories of education, and subject matter.

The text is based on tried and tested lectures and practical sessions and forms the core of a course of work which can be followed either in timetabled, tutor-led sessions or by individuals in their own time as a personal project. It also acts as a handbook of first resort for those planning visits.

Of course, this does not preclude its use in other ways and by other people. I am well aware that this book may be used by individual practising teachers as well as for in-service training with groups. Indeed, I hope that it is. Nor need it stop there, for there are many people involved in taking children to museums (in groups, families, as home teachers, or as individuals) who may benefit from this book – not to mention the children themselves. There are also those who have no connection with children at all but whose love of museums may be enhanced by having the skills at hand to appreciate them more deeply.

Be that as it may, I had to choose a specific audience to address in order to focus my thoughts. And, having chosen a specific audience, I have further limited the scope of the work in line with that. It would not, after all, be possible to cover everything in one volume and still make it a portable and easily accessible work of reference.

To begin with, it is limited to introducing the basic skills necessary for working with the material aspects of our cultural heritage in a museum environment (although this necessarily includes elements of preparatory and follow-up work). It is also limited to those things that I know about from my own experience. I have not attempted to review or assess theoretical material or make assumptions about areas of which I know nothing. Thirdly, it is limited to working with pupils in the 5 to 18 age range.

It does not look at the detail of specific subjects (statutory or otherwise). The content of the curricula directed by statute and taught by schools represents a very unstable volcano and I have no intention of working its slopes. Like all volcanoes it provides very fertile ground but it is a landscape that is susceptible to catastrophic change. There are plenty of other fertile areas to be worked – such as the methodologies of various subjects and their relation to working with material culture in the museum environment – but they deserve a study of their own at the appropriate time.

A lot of what is touched on in this work also has relevance to Environmental Studies and should be considered in that context, particularly in view of the discussion in Chapter 1. Some of the skills mentioned herein have come from that quarter and, in reality, there is a great deal of overlap between what is discussed here and work that can be done in that field. However, like the other areas mentioned above, Environmental Studies *per se* does not come within the scope of this work.

All of these things excluded from the scope of this work will be touched upon here and there within the text. It would be impossible not to do so. What is more, much of what *is* discussed herein will be relevant to aspects of those things I have excluded and will, therefore, be of use to teachers working with pupils in those areas. But those doing so must remember that, in their case, this work does not constitute the whole story. For them there may well be other skills that are needed for successful work.

This book, then, working within the limitations mentioned, has very simple aims. The first is to introduce the reader to the discussion about what museums are. This is essential if one wishes to work with them and goes part way to answering why it is that museums should be used in the education of children – which is the second aim. Thirdly, it aims to provide a comprehensive outline of how to plan a visit. Finally, it aims to provide an introduction to the basic skills that are necessary if teacher and pupil are to make successful educational use of museums.

You can, if you wish, sit down and simply read this book from cover to cover. The full benefit will come, however, when you start to put its ideas into practice. After all, as the old eastern proverb has it:

Hear, and you forget. See, and you remember. Do, and you understand.

But do not be slavish. Take your time when reading and think about what is presented. You don't have to agree with everything but if there are aspects you feel uncomfortable with, do try to come up with a workable alternative. This is, after all, an introduction. How your relationship with the subject develops beyond this is in your hands and your heart.

Museum visits are always likely to occur as a result of the enthusiasm, confidence and expertise of individual teachers. The ultimate responsibility for the successful use of museums by students also rests with them. Museum education staff (if they are there and if they can be spared) can provide good work sessions, but organisation, preparation and follow-up are all in the hands of the teacher. I hope that, after having worked through this book, you will have that enthusiasm, confidence and the beginnings of an expertise that you will wish to develop – not only for the benefit and enjoyment of the pupils in your charge, but also for yourself.

FIRST PRINCIPLES

WHAT IS A MUSEUM?

Before we look at the intricacies involved in planning, preparing, carrying out and following up a visit, we need to come to some understanding about what a museum is. Definitions are many and have proliferated over the years. They are, unsurprisingly, similar; differing in ways that reflect the perspective of those making them. In essence, however, a definition will be composed of two interrelated parts. The first will be a description of what a museum is in terms of physical presence; the second is concerned with the purpose.

To add to the complexity of the issue, terminology has also changed. Words go in and out of fashion, depending on cultural and political trends and pressures. This is not necessarily a bad thing as it requires each generation to re-examine that which they seek to redefine.

In the UK, for example, a large source of funding for museums is the Heritage Lottery Fund. They have a definition of what they mean by 'heritage' and applications for money invariably point up those aspects of a project and make liberal use of the word 'heritage'. Although by no means new, it is a term that is fast becoming ubiquitous. Heritage sites, heritage centres, heritage landscapes, heritage trails, heritage education...all abound. Heritage is a useful blanket term, although there are those who feel that overuse has devalued its worth as a descriptor.

It is important, therefore, that we pin down what we mean, looking for what exists beneath the terminology of the day. But this is not just an exercise in pedantry. There are three very good reasons for having a definition. To begin with, as hinted above, it is important that you are aware of what is meant every time the word 'museum' is used in this text. Without that clarity, further discussion could well become confusing. After all, your idea of what a museum consists of may not be congruent with that used herein or, at the very least, you may not have formed a clear idea of your own and be in the dark about what is meant. Secondly, the discussion of definition necessarily stimulates wider discussion about museums. It is all too easy to use museums for teaching without ever considering their wider role in society. And, although it is beyond the remit of this book to consider this question in depth, it is nonetheless important when thinking about one aspect of what museums are (that is, places of learning for school pupils), to know of, or at least to have considered, some of the other aspects. Thirdly, to rehearse these arguments now is to give your petitions an extra dimension when convincing your colleagues, your head of department,

your school head or your governing body that visits to museums are well worth all the costs involved.

To start us on the road to a definition, I would like you to try a simple exercise. Divide a sheet of paper into two with a vertical line. Head one of the resulting columns A and the other B. All I want you to do now is make two lists. To begin with, write down in column A the names of all the museums you can think of – that is, ones you have visited, ones that friends have told you about, ones you have learned of through the media and so on. While you are writing this list, you can be compiling your second list in column B. This should contain only those museums that you have actually visited no matter when or for whatever reason that might have been.

You will have noticed, in compiling your lists, that column B is, of necessity, shorter than column A. You may also have noticed that this was not quite the simple exercise I claimed it to be.

There may well have been institutions that you wanted to include but did not because, on reflection, you felt they were not actually museums. Did you, perhaps, feel the need for a separate column in which to place art galleries? Is an art gallery within a museum something in its own right or is it simply part of the museum? And were there some institutions about which you could not make a decision? For example, have you ever been to a site of archaeological interest in a remote field with minimal interpretation available only in the nearest town several miles away? And what about reconstructions where so little of the original remains that all that can be offered is a hi-tech ride through a replica peopled by the latest in animatronics? Or, at the other end of the scale, low-tech replicas using only those materials, tools and skills available at the time erected on original sites and populated by actors who play out the lives of those who would have lived there? And what about the vast sacred landscapes created in times so distant there is little or no psychological continuity between those who laboured to form them and ourselves? Or the foundations of an historically important building? What about a working farm or industry using pre-war methods, running as a commercial concern, that is also open to the public?

Which of these is a museum and how do we decide?

It is because of these uncertainties that we need to establish, if we are to get any further, a working definition to which we can refer and which will provide a framework upon which to build. But such a working definition will not be arrived at easily.

Let us start on safe ground. Let us start with something we definitely know to be a museum – the British Museum. The British Museum is a large building within which there are many galleries, rooms and corridors in which are displayed many collections of artefacts – artefacts large, artefacts small, artefacts foreign, artefacts domestic, artefacts prehistoric and artefacts which fall within living memory. There are also shops, places to get refreshment, guide books, attendants in uniforms – in fact, all the things you would expect of a museum.

But that is not all. There are many parts of the British Museum that the public never or rarely see. Within the building there are storerooms, workshops, offices,

staffrooms and many people whose task it is to ensure the place runs smoothly – from Director to cleaner. And it does not stop there because the British Museum extends beyond the building in Great Russell Street. It has outposts where some reserve collections are held, it has outposts where other collections are displayed, it has staff working up and down the country, it is consulted by people outside the organisation, it is a tourist attraction that contributes a great deal to the local and national economy, and it is an educational establishment.

Furthermore, the British Museum has not always been as it is now. It was conceived, designed, built and has continued to grow and develop. It has its own history, one that is so interesting it could well provide sufficient material for a small museum all of its own.

But which of these things makes it a museum? Could we dispense with any of them and still call it a museum? Are there other essential functions that need to be considered but which are not to be found at the British Museum? Already the task of producing a definition is becoming complicated. After all, many of the functions mentioned above are not unique to museums. Conversely, some institutions that are recognised as being museums do not fulfil all of these functions.

Despite the many questions posed so far to which we have yet to provide an answer, we do at least have the first element of a definition. The clue to this is in the fact that, in common with the British Museum, all museums exist in four dimensions. That is, they all have a history. And just as a museum must have physical coherence to exist in space it must have conceptual and organisational coherence to exist in time. Nothing, however, can continue its existence without changing. So, if the existence is to remain coherent then the change must be coherent. Therefore, the one element that applies to any and all museums, even though we have yet to reach any conclusions about a definition, is that they are organic – organised structures that, through time, grow, develop and, due to 'environmental pressures', evolve. This is not unique to museums but it is something they all are and it must, therefore, be included in any definition.

It will be apparent from the limited discussion so far that museums, by their very nature, require a definition that is prescriptive. That is, it will need to be a definition that recognises long standing custom, one that suggests a museum should be a certain type of institute with a distinctive combination of characteristic qualities because that is what they have always been, but which also recognises that evolution has played its part and should be part of the definition. Any definition that is proscriptive, that is, a definition that inhibits inclusion or evolution by laying down strict laws derived without preferential reference to custom, will simply be inadequate.

We must, however, be careful with prescriptive definitions, especially if we are not conversant with the complexities of that which we are trying to define. In our thinking about things with which we are not overly familiar we often fall into the error of accepting stereotypes at face value. It is easy enough to do. And this is just as true of museums as it is of anything else.

Stereotypes derive from lack of knowledge and understanding. This can be illustrated by the fact that when I first started working in museums people used to

ask me, 'What do you find to do all day?' Such a question derives from a lack of understanding about what museums are and what they are there for, other than a vague notion that they are repositories of old things the public can go and look at.

Similarly, most people's image of a museum, even now, is of a late-nineteenth century building with large dark rooms, squeaky polished floors, a hushed atmosphere and glass-fronted cases containing objects. Despite the fact that museums increasingly no longer fit that description, it is still a popular image – particularly carried by adults from their childhood experience of museums. It is an image that must be dispensed with because it acts as a barrier. Even with my own experience of working in museums it is an image that is tucked away in my mind – probably because of the long childhood hours I spent in museums of that type.

It is important, however, to get beyond that stereotypical notion because the physical structure is not, of itself, the museum any more than the physical structure is, of itself, the church or the school. Admittedly the physical structure has a bearing on the thing (whatever it might be), but the essence of the thing is the reason behind the structure being there or being used in the way it now is. This applies even when the subject of the museum is the building that houses it.

Much better then, to consider what a museum is from the point of view of the purpose of the place; and if we do that it quickly becomes clear that the physical structure and the image of it we might carry can be quite superfluous. What we need is an idea about what it is that makes a museum recognisably distinct from other forms of institution. After all, much has changed in the museum world in recent times. Open air sites have become popular as have industrial archaeology, maritime museums, mining museums and so on. It often seems that any old closed down factory, warehouse or industrial site can become a museum.

All of these new institutions have come under the aegis of the museum world, reflecting the desire of our society to preserve some memory of those aspects of our daily life (no matter how grim) that are passing away. Such new entries to the fold have provoked arguments about just what museums are and how they should face up to the challenges presented by an aggressively competitive world that is so economically, socially and politically different from the early days of the founding of the great national museums and their provincial counterparts.

As with many other institutions (like schools and churches), museums do not have a single function. Rather, they consist in a set of closely related functions that derive from a core purpose. That core purpose, of course, relates to the definition we are seeking. If, however, we can identify and clarify the individual functions within the set we will have taken a step closer to that definition.

So, what purposes are served by museums? Or, to put it another way, what jobs take place within them? Some of the answers may seem obvious, but there are others that may not. Each of them is worth considering in their own right.

Collecting: Finance permitting, museums actively collect artefacts that fall
within the remit of their collecting policies. There are many sources for
objects from the open market to donations and bequests. Some museums

- have wider collecting policies than others. A national museum will collect across a broad range. A museum in a house that was the residence of a famous person will only be interested in artefacts to do with that person (and then, perhaps, only from the period in which they lived there).
- Care of the collection: Once an artefact is in a museum it must be cared for.
 Whether it goes into a reserve collection or is on display, its environment must be carefully controlled to mitigate the effects of the atmosphere, temperature, humidity, light and so on.
- Conservation: Some artefacts need more than simple care. They are, perhaps, so badly damaged or decayed they need active conservation to prevent further deterioration and to make them secure for storage or presentable for display.
- Preservation and storage: Museums are repositories of artefacts, many of
 which are never displayed. There are many reasons for this, not least of
 which is the fact that many artefacts are not very interesting to look at.
 Nonetheless they are still important enough to be preserved for study. Most
 museums have much more in their reserve collections than is on display in
 public galleries.
- Research: Finding out about artefacts is also of importance. They are, after all, collected partly with the intention of improving understanding about them and their history. But research also takes place into better forms of management, presentation, preservation, conservation, interpretation and education.
- Display of artefacts: Museums are for the public, so artefacts have to be displayed in ways that allow best access to the artefact consistent with its safety, care and conservation. Curatorial and educational decisions have to be made about what should be displayed along with conservation and artistic decisions about how the artefact should be displayed.
- Interpretation: When artefacts are displayed there has to be some degree of interpretation so that visitors can make sense of what they see. Even if there is no obvious interpretation, the artefacts exist in a context that affects the way they are viewed. No form of interpretation is neutral and decisions have to be made about what a display is intended to convey
- Public access: There is much more to this than just opening the doors. Revenue has to be balanced against costs such as heating, lighting, environmental control, wear and tear and so on. Other factors such as security and visitor flow need to be considered along with providing facilities such as toilets, refreshments and interpretation.
- Education: Museums are educational resources of great importance for pupils and students at all levels of study, and not just for the most obvious reasons. Learning and education are inherent in their very existence.
- Social function: Museums are part of the community in which they exist even if they are not museums relating specifically or solely to that locale. They may well have regular visitors, friends' organisations and so on as

well as offering a secular opportunity for solace and contemplation.

- *Economic function*: Not only are museums employers, they attract visitors to the area in which they are situated, generating income for themselves and their locale.
- Custodianship of heritage: There is an active role that museums can play beyond their own four walls in that, having the expertise, they can help in making decisions about what is worth preserving and how to go about it. They also have a role as protectors, lobbying when others fail to do so.
- Administration: All of the above has to be administered. Catalogues have to
 be made and kept up to date, information has to be processed, research has
 to be published, materials have to be produced for visitors, staff have to be
 paid and trained and so on.

That is part of what museums find to do all day. Of course, the above list is the product of contemporary thinking. Our concerns are not those of our forebears. We are much concerned (some would say obsessed) with preserving the past and recording our own times in the minutest detail for posterity. Actually working to produce a viable future in which our passion for preservation can be appreciated seems, at times, to have a much lower priority.

It has only been since the late eighteenth century that the word *museum* has come to mean a place that fulfils some of the functions listed above. And herein lies one of the problems that beset anyone trying to produce a definition. We have already identified that over time museums have evolved – some of them in seemingly unrecognisable ways. Yet they are essentially the same. The greatest change would seem to have taken place in our attitude towards them.

The original meaning of the word *museum* was 'a place of contemplation, a philosophical institution, or a temple of the Muses'. As we have come to know them, museums are a way of satisfying our curiosity about other times and other places. They are a method of communication, transmitting from one generation to the next that which is considered of importance to the culture in which the museum exists. This is not necessarily a narrow, xenophobic aim, for many museums contain items from cultures other than the one in which they exist. While this can, in a number of cases, be contentious (especially with regard to objects of religious and spiritual significance to the culture from which they were removed), it does express a desire to understand cultures other than one's own.

There are, of course, many ways of communicating from one generation to the next. Many cultures had, and some still retain, strong oral traditions and through this medium have, for many centuries, passed on those parts of their culture thought important enough to need to survive mere human existence. Hence a museum was originally a place of contemplation or philosophical discussion because not even concepts worthy of preservation remain unchanged. They have to adapt if they are to survive.

Oral traditions were and are to be found in cultures that do not set much store by material possessions or which do not possess the means to manufacture on a large

scale. Where concepts have been made material, the nature of those societies has made it possible for all to visit and come to know these things. What is culturally important to them is invested, on the whole, not in things but in people and ideas. But in societies where cultural importance has become invested in objects (and in this I include books), there has grown a need to preserve these objects. This has much to do with the development of civilisation – that is, city dwelling. Nomadic and village dwelling people had little or no time or space to devote to objects that were not essential to their survival. City dwellers have such space and, increasingly, they have had time. One sad result of this is that material objects, especially those invested with some significance, have come to be deemed worthy of more protection and investment than living beings.

It is the earliest cities that led to the earliest known museums. What appears to be a museum, for example, has been discovered in the precincts of the temple at Ur. During the sixth century BC there was a school attached to the temple in which two rooms contained a number of objects that pre-dated the school by as many as sixteen hundred years. If nothing else, there seems to be a long link between schools and museums.

In classical Greece, many collections of works of art were formed from votive offerings to particular deities. These were catalogued and conserved, and could be viewed by visitors (devout and tourist alike) on payment of a small charge. The Acropolis in Athens had areas devoted to the display of examples of paintings by different artists.

Many wealthy and influential Romans were avid collectors and there was considerable public display of art and other curios. Agrippa, for example, believed that the best works of art should belong to the people and he opened his collections to the public. But there was no state policy on such things and access, conservation, disposal and the like were all left very much to individual collectors.

The Far East also saw collections being made through the centuries but these, again, were made by the rich and were for the benefit of the rich. Collectors did act as patrons, however, and much fine work was produced as a result. As in Greece and Rome, objects and collections found their way into temples as offerings. One such was made by the widow of the Japanese Emperor Shomu (eighth century AD) to the Buddha Vairochana. The Todaiji temple at Nara had a special building constructed for this collection known as the Shoso-in which stands to this day, its collection still intact.

Medieval Europe, from the fifth century through to the Renaissance, saw very little collecting activity to begin with. The collapse of Roman influence saw the remergence of many long suppressed cultural and national groups, each vying with others to re-establish themselves. Political ambitions and survival left little time for conservation of the past and patronage of the arts. As Christianity spread, however, an interest in Christian relics and art grew. Churches, cathedrals and monasteries began to amass relics of many types as well as paintings, altar decorations and vestments. Although of cultural significance, the economic importance of such artefacts was not overlooked either – they attracted pilgrims and they attracted the pilgrims' money.

In the sixth century AD, Islam was responsible for a surge in North Africa and the Middle East in the collecting of objects, mostly associated with the tombs of Muslim martyrs. Islam was also responsible for the formulation of *al-waqf* which involved giving, in perpetuity, property for the public good and religious benefit.

It was not until the Renaissance, however, that current patterns of collection and preservation began. The economic power of certain individuals and families meant that by the fifteenth century there were a number of fine collections in existence. Lorenzo the Magnificent, for example, inherited a collection developed by his Medici forebears that included books, intaglios, precious stones, tapestries, paintings, sculptures and a variety of curios including the 'horn of a unicorn', for which an incredible 6,000 florins were paid.

These collections were often housed in specially built rooms and buildings, many of which were open to those members of the public able to afford the entrance charge. Indeed, some were popular enough to be mentioned in tourist guides of the day.

Such collections were not confined to Italy any more than they were confined to works of art. Scientific collections were also made as the interest in science spread to the wealthier strata of society. Natural history collections were also extremely popular, particularly those that could show creatures from other parts of the world, becoming available to collectors because of the great voyages of exploration being undertaken by Europeans.

By the seventeenth century, the application of scientific method to an understanding of nature and humanity was already becoming well established. Many of the collections were being organised along scientific lines and by the early eighteenth century, advice was being published on classification, collection care and sources of material. This was also the age that saw the birth of the learned society. These too formed collections as well as investigating the artefacts in their care.

The latter years of the eighteenth century and the early years of the nineteenth century saw a number of collections being opened to the public in Europe and elsewhere. Experiments were made with displays, offering, for example, paintings by school, artefacts in chronological order and so on – things we now take for granted. The presentation and care of these objects were also now of prime consideration.

Despite all this, it was not until the beginning of the nineteenth century that museums were overtly cast in the role of contributor to national and cultural consciousness. They had in fact been evolving towards this all along, but once they gained a degree of autonomy and became self aware of their evolution, much more importance was placed upon their role in the education of the people of the region or culture in which they existed.

By the early years of the twentieth century, much had changed in the museum world. Urbanisation saw many new museums emerging, some state run, others under the patronage of local government, independent organisations and individuals. Some were very specific in intent; others had a less clear vision.

There was also a move towards areas of interest other than high art as recognition grew of the importance of folk culture. And as the scope of museums broadened, so too did their approach to display. It was no longer sufficient simply to place objects in glass fronted cases with a label to identify them. Whole environments have now been re-created as the originals have disappeared. It is now possible, for example, to visit museums of mining housed in what were once working pits. Some museums have even helped to preserve traditional crafts and industries by employing redundant craftspeople to display their skills and to train others.

Short of catastrophe, we will not return to non-civilised society (even if cities evolve beyond recognition) and we are not likely to become non-literate again. But, in certain respects at least, some museums have come full circle. Some now preserve non-material things and others are becoming places of philosophical discussion.

Museums today come in all shapes, sizes and functions, but they all seem to be bound by a common desire to transmit across the generations that which they consider to be an important facet of our cultural being, and to transmit it effectively, professionally and for all people (in theory at least – since they are open to the public). In that sense they act as a national and cultural memory. The better our memory (in terms of access and understanding) the better our ability to understand the world.

Given that there *are* now many kinds of museum, it would be pertinent at this point to consider just who is paying for them. This proves to be no less complex than any of the other aspects of museums we have looked at. The following list is a much simplified picture of the real situation. In reality, museums rely on many sources of finance, but in general these are the distinct types of museum in terms of funding:

- 1. National museums (which house collections of national and international importance) funded by national government.
- 2. Provincial museums (which house collections of regional or local importance) funded by local government.
- 3. University museums (which house teaching collections) supported by their parent university.
- 4. Independent museums (of many sizes and degrees of importance) financed through charitable trusts.
- 5. Private museums (of many sizes and degrees of importance but mostly small) kept running with money from the pocket of the individual who owns them.

In effect, the first three rely heavily on money derived from taxation. All of them supplement their incomes by charging for various things including entrance to the museum and professional services, running commercial ventures such as shops and refreshment centres, business sponsorship, applying for grants from various bodies and accepting donations.

All these types of museum come in many shapes and sizes and are concerned with many different aspects of our own and others' culture. Their funding or status has little bearing on what type of museum they are and little more on how good they are as museums. Many other factors are also involved. One of the more important is style or the way a given museum approaches being a museum. Some have consciously adopted a style they believe will attract visitors, others a style that they believe enhances their collection. Others have been content to allow their style to develop from what they see as best practice in all sorts of fields.

There are, of course, many styles or approaches and most museums do not stick rigidly to one or purposely exclude others. More often than not there are external factors that dictate to a lesser or greater degree what style they have. Although there are many styles and combinations of style they can be summed up (in no particular order) as follows:

- Open air in which all or part of the museum consists of artefacts that are displayed in the open air.
- Hi-tech in which a great deal of technology is used to present the artefacts.
- Low-tech in which little or no technology is used.
- Interactive in which visitors are encouraged to touch, handle or otherwise work with what the museum displays.
- Community a museum run for and by its local community.
- High-brow a museum that aspires to 'high culture' and intellectual pursuits.
- Low-brow a museum that concentrates on 'folk culture' and domestic pursuits.
- Formal in which there is an atmosphere of formality and a degree of distance between the institute and its public.
- Informal in which there is an informal atmosphere and engagement is encouraged.
- Traditional a museum which best fits the stereotype.
- Modern a museum which works hard to avoid falling within the stereotype.
- Purpose built a museum designed and built to be a museum.
- Make-shift a structure no longer fulfilling its original purpose and adapted to house displays of artefacts.
- Environmental a museum centred on and celebrating some particular aspect of a living community (urban or rural).

There are doubtless many other styles that can be described, but – and this is a key question – in relation to what? What is all this energy, all this diversity of style, funding, type and purpose directed towards? We know already that museums collect and preserve examples of material culture. But what does that encompass?

The answer, quite simply, is everything. You may, for example, find collections and museums devoted to any of the following: advertising, aerial photography, aeronautics, agriculture, anatomy, anthropology, archaeology, architecture, arms and armour, astronomical instruments, autographs, bells, botany, carpets, ceramics and glass, cinematography and photography, clocks and watches, coins and medals, computers, contemporary crafts, costumes and accessories, cutlery, design, dolls and dolls' houses, ecclesiology, embroidery and needlework, engineering, entomology, ethnography, famous people, fine arts, fire engines, folk materials, food, fossils, furniture, gardening, gems, geology, history, hygiene, industry, interior decoration, jewellery, lace, leather, local history, locks and keys, machinery, magic, manuscripts, medicine, metalwork, militaria, milling, mining, music and musical instruments, natural history, packaging, panelling, paper making, philately, plastics, primitive art, printing, religion, science, shipping, social history, sport, tapestry and textiles, theatre, town planning, toys, transport, underwear, vehicles, witchcraft, xylophones, yeomanry and zoology.

And it doesn't stop there for within each of those subject headings (and the many more I could have listed) there are subheadings and specialisms, the minutiae of material culture preserved for the specialist and obsessive alike. This bewildering array of subject matter, however, boils down to a much simpler formula. All museums are concerned with artefacts of aesthetic, archaeological, cultural, historical, scientific, social and spiritual interest.

There have been trends in the museum world recently that reflect a breaking away from the traditional content of a museum as well as from the traditional forms of display of that content. For the world is changing as well. Things familiar only ten or twenty years ago are now disappearing fast. Some countries are now moving into a post-industrial phase of their development and if that aspect of their culture is not preserved in museums it will disappear for good. No matter how dire an industry, for example, there will always be those who, for personal or academic reasons, want to see it preserved in memory if not in actuality. The same is also true of war. We all hope we never see or experience a war in our lives but, having worked for a while in a public library, I am only too well aware of the number of men and women who have been through such an experience who spend hours reading about them. Perhaps it is an attempt to make sense of what it was that so changed their lives – a thing they could not understand and see the whole of at the time. The same function is fulfilled, I believe, by museums. They can tell the whole story (in outline at least), be it of war or coal mining or anything else, in a way that is readily assimilated, safe and which can be returned to again and again.

We have a collective desire to remember, to muse upon and to make sense of our personal and cultural past and pass that understanding on to future generations. There are many ways in which this can be catered for, some better than others. The good (and bad) old fashioned museum with its hushed atmosphere still exists in great number – and long may the good ones continue for they fulfil a great need, that of the chance to observe and reflect on their contents in peace and quiet. There

are precious few places left in which to do that. But much has changed since museums were built as edifices of self-improvement and showcases that reflected the cultural and aesthetic mores of the late nineteenth century. National museums, provincial museums and the collections of learned societies have been joined by collections and sites from a much wider background of intent and content.

The broadening of purpose shows that there has been a change in what is considered important enough to preserve. It also heralds a change in those who make the decisions. There are now many people involved with museums from many backgrounds with many reasons for wishing to preserve many different things. While this largely uncoordinated approach means there is duplication of effort in some areas and no effort at all in others, it is a healthier approach than, for example, the state dictating at all levels what is and what is not worthy of preservation. However, it should be remembered that what we see in museums is there as a result of decisions made by people who are, in a number of cases, a long way from being directly accountable to the people who visit those museums.

This 'hidden agenda' is not necessarily sinister. There are many reasons why some things are displayed in preference to others. Most, if not all, have to do with the state of the artefacts and the identity and effectiveness of the museum. These sorts of decisions need to be made by experts and we should trust them to make the best decisions they can. It is, however, worth remembering that when you visit a museum, such decisions have been made.

If, as all this implies, museums act as the collective memory of a people (a person is shaped by their memories; a culture is shaped by its past), then it is essential that a people has access to its museums just as it is essential they have access to their own memories. Without access, memory is worthless.

A museum cannot, therefore, ever be just a collection of physical objects. There are no museums without people – people and their ability to interact with aspects of their own and other people's material culture, people and their ability to come to some sort of understanding of both their material culture and themselves. A museum should, therefore, in some way be a place that offers the opportunity to see, touch, hear and have sensual, emotional and intellectual interaction with what is in that place. It should be an experience similar to listening to music, visiting a library, reading a book, going to the theatre or cinema – a confrontation with artefacts that can lead to contemplation and revelation.

There are, though, some people who have collections, buildings and sites in their guardianship who feel that the only way to care for them properly is to exclude all access to them. You can see their point to a degree – after all, schools would be wonderful places to work if it weren't for the pupils but that, of course, would defeat the object. And the same is so of museums. They have a responsibility to their community – even if that community is scattered thinly throughout the population as a whole. And they can only operate successfully while they are prepared to recognise that responsibility and, thus, sustain the trust and confidence of their community.

If time and space permitted, I would continue this discussion. I hope it has, at least, inspired you to think a little more deeply about museums. They can so easily be taken for granted. Sadly, things that are taken for granted are all too often neglected. We neglect our museums at our peril.

So let us consider what we have discussed so far.

- To begin with, and most important of all, a museum must be a genuine artefact or a collection of genuine artefacts of aesthetic, archaeological, cultural, historical, social or spiritual importance and interest within a dedicated space. The actual subject matter or content is irrelevant except that it be original. The artefacts should also be good examples of their kind (not necessarily the best) and examples which show how things both develop and degenerate over time.
- A museum must be concerned with the preservation and conservation of artefacts.
- Museums are organic. That is, they have an organised structure composed
 of distinctly functioning parts dedicated to the overall survival of the
 structure. They grow, develop and they evolve.
- Museums should be concerned with space as much as with time. That is, they should be concerned with satisfying our curiosity about other cultures (past and present) as well as our own culture (past and present). In order to achieve this, artefacts should be displayed in some defined context.
- Museums should be sensitive to the spiritual and cultural worth of artefacts to the culture from which they derive.
- In preserving, conserving and keeping artefacts in dedicated places, museums
 act as a means of storing national, cultural and collective memories, which
 can then be passed from generation to generation.
- In order to be effective transmitters of memory, museums must be open to all people. Anyone who wishes to enter them should feel comfortable about doing so.
- Museums should inform. Artefacts need interpretation if people are to make sense of what they see. Information needs to be sensitive to popular and academic need.
- As well as informing people, museums should allow them the freedom to explore for themselves, not just physically but also intellectually, emotionally and spiritually.
- A museum must, therefore, in some way, be a place that offers the opportunity for both passive and active experience of and sensual, emotional, intellectual and spiritual interaction with what is in that place.
- A museum should be a place of learning, serving its own needs and the needs of others.
- Museums should be places of enjoyment. Visiting a museum should be pleasurable.

From the above can be produced the following definition for use in the rest of this book.

A museum is an organic institution or dedicated space open to all wherein an event occurred or a genuine artefact or a collection of genuine artefacts of aesthetic, archaeological, cultural, historical, social or spiritual importance and interest is preserved, conserved and displayed in a manner in keeping with its intrinsic and endued worth. As such, it is an informative means of storing national, cultural and collective memories, where people can explore, interact, contemplate, be inspired by, learn about and enjoy their own and others' cultural heritage.

It is fairly obvious from this definition that a museum is much more than a building containing a collection of old objects in glass cases. Indeed, such a definition greatly widens the scope of places to visit in order to further one's teaching.

There is, of course, the most readily accepted form of museum – a building in which artefacts are displayed in a variety of ways. But there is much more. There are art galleries. There are libraries housing archives, documents, letters, original texts, photographs, audio recordings and so on. There are public records offices. There are also buildings (complete or in ruins) which are of interest for their role in history or as examples of 'typical' forms of their period: houses of many type, halls, castles, public houses, public baths, civic buildings and so on. Some of them may be open to the public, some may even house museums, and getting into others may present more of a challenge. Places of worship, of whatever faith, culture or time, living or redundant, may be considered the ultimate in museums, a place of the muses. With their years of devotional use they are places of mystery, places where all can learn, where all can stand in wonder.

As much awe, wonder, learning and musing is generated amongst visitors to the great Neolithic henges – also places of celebration in their time. So, archaeological sites, too, are museums, whether they are under excavation, interpreted, with displays of excavated material attached, the sites of experimental approaches to understanding the past or even just out in the wilds with a sign indicating you are in the right place with nothing else but a few sheep to keep you company.

Then there are living sites such as farms and landscapes managed in ways unchanged for centuries; historic gardens; graveyards; collections of rare breeds of animal; Sites of Special Scientific Interest that may be examples of managed ecologies; craftspeople who practise 'traditional' crafts using old methods, tools and materials; and so on. And there are even some working factories, shops, railway stations, theatres and other such places that can offer insights into our material culture and its past.

There are doubtless many more examples that could be cited. It is 'museum' in this broad sense that is used throughout this book. Anywhere that you can find the source material that will bring you closer to an understanding of the effect of the human presence on the planet is in some sense a museum. And where such things are, people are as well, doing just that – trying to better understand themselves and

the world, and just as importantly, taking pleasure in this. The works of humankind, despite our own constant participation in such works, never cease to amaze us. But we must never forget, no matter how much we may stand in awe of these things, there are many lessons to be learnt – not just about them, but from them as well.

WHY TAKE PUPILS TO MUSEUMS?

CONCRETE REASONS

Now that we have a definition of the word museum, it is time to consider why it is important that they be used in the education of children. We live in straitened times when schools have to watch over, account for and justify every last penny they spend. It is a sad fact of life that teachers will be called on, more and more, to justify the expense of taking pupils out of the classroom. In addition, recent years have been witness to much upheaval in education. A great deal of time and energy has been spent on the introduction into teaching of so many new approaches and practices in such a short space of time that teachers have often been deterred from doing anything that does not relate to keeping their heads above water. Although the situation is improving on some fronts, teachers now find that they have to produce new schemes of work, learn new skills, plough through ever increasing bureaucracy and cope with quixotic and political changes to the curriculum. As a result, visits to museums, with all the work involved if they are to be conducted properly, may not seem to possess the high priority they once did.

It is quite possible to teach children for the whole of their school career without ever leaving the classroom. And it would undoubtedly make life easier if the security of those four classroom walls were never abandoned. Much that is good can, of course, be done within the classroom, but never to leave its confines would severely limit the effectiveness and relevance of what those pupils are taught – and it seems to me that this is precisely what recent and forthcoming trends in education are in danger of doing. The pressures they exert are severely restricting the opportunities for the wider and less tangible elements of education to be given their proper and rightful place, despite exhortations to expand opportunities for learning outside the classroom.

It is for this reason that I believe now, more than ever, children should be taken out of school to make greater use of the vast educational resource that is museums. And having produced a definition of a museum, I think we have also begun to answer why they are so necessary to the education of our young.

Teachers of history rarely need to be persuaded of such value. The study of history is probably the major reason for school groups visiting museums. Primary teachers also feature largely amongst the converted. However, there are a vast number of teachers in Primary and Secondary education, as well as in specific

subjects other than history who never consider using a visit or series of visits to a museum to enhance their teaching. There are many reasons for this state of affairs but the following three reasons are the most common.

The first is that a large proportion of teachers do not know what their local or nearest museums contain. Or, in the case of a small proportion, they do not realise there is a local museum. Perhaps teachers should undergo an in-service training session that pinpoints all such sites (museums, libraries, places of worship, shopping centres, parks, amusement arcades) within the school's locale?

The second reason is that many teachers lack the confidence to take a party of pupils beyond the secure confines of their classroom. In most cases this is because they lack the necessary experience to have gained confidence – a classic Catch 22 situation. It is not, however, an insoluble problem, just one that takes time to solve.

Finally, a lot of teachers are unaware of how museum work could complement their classroom studies. Such a concept was not included in their courses of study when they first trained. Most in-service training is prompted by changes in regulation and law that must be absorbed rather than genuine broadening and deepening of the arts of teaching.

These three reasons do not stand apart from each other. They are closely interrelated. If you set out to solve one, you will inevitably be touching upon areas of knowledge and practice that are relevant to the other two. In fact, the best way to solve them is to tackle them as a whole.

There is sometimes a fourth reason put forward, that the nearest museums do not have material relevant to what is being studied. This is, however, much more in the nature of an excuse than a true reason. It may be so in some rare cases, especially if the nearest museum is a specialist museum, but most schools are situated within distance of what they need and most museums can be found to have something that fits the bill. This is especially so when you consider the length of a pupil's school career and the great number of subjects studied during that time.

The value to be had from visiting museums does not simply relate to the overt knowledge gathering exercise that most people consider to be the only reason for a visit. The old eastern proverb quoted in the Introduction is well backed up by research into the way we learn, the results of which are reflected in Figure 2.1.

Most museum work tends to be at the active end of the scale and is, therefore, likely to make more of an impact than text based classroom work. As well as being able to identify subject links with particular collections and demonstrate that active learning leads to better retention of information and a deeper understanding of a subject, cross-curricular links also prevail throughout any visit – again more readily than they can in school.

There are three distinct elements to cross-curricular links, all of which are pulled to the fore of any work done in museums (rather than existing as the substratum of the normal curriculum subjects). The first of these concerns those aspects of education that are relevant to all pupils no matter what their ability or interest. A good example is that all pupils should be prepared for life in a multicultural society. The second element concerns those skills that are relevant

We tend to remember and understand:	When:	Involvement:
10% of what we read	Reading	P a
20% of what we hear	Listening	S
30% of what we see	Looking at pictures	S i V
	Viewing an exhibition	е
	Watching a film	
	Watching a demonstration	
70% of what we say	Taking part in a discussion	A c
	Giving a talk	t i
90% of what we do	Giving a dramatic presentation	v e
	Simulating a real experience	
	Doing the real thing	

Figure 2.1 Relation of memory and understanding to involvement

to all subjects such as oracy, numeracy and literacy; the ability to study with purpose; problem solving; along with social and personal accomplishments. Finally there are themes that relate to more specific aspects of life beyond school such as careers guidance, health (physical, spiritual and emotional), citizenship, and economic and environmental understanding. The relevance of all these to museum work is not difficult to see.

All museums are educational resources in the broadest sense of the word. Pupils should be taught how to use them and they should be encouraged to explore them – and not just in school time. But it is not just a matter of offering a physical resource that schools do not and could not hope to possess. Nor is it just a matter of using the resource to pass on a conveniently packaged bundle of facts. Museums have spiritual, aesthetic and emotional content as well. After all, everything you see in a museum has a human connection (even the stuffed animals – they had to be killed and stuffed). No museum can be truly objective and no museum, in my

opinion, should pretend that it is. The human connection should always be made. That is, after all, how you first interest the pupils. Connect things with them and they want to know more. The older they become, the more easily they will be able to appreciate objective elements of what they study.

Bearing all the above in mind, it is time to delineate specific reasons why pupils should be taken on visits to museums. There is no concern here with specific subject matter. You may have the joy of that task when you begin to relate the skills in this book to specific visits that you make. What we are concerned with at present are good educational arguments that you would be able to use to persuade a very sceptical head teacher. One day that is precisely what you will have to do.

The Demands of the Curriculum (Including Examinations)

To begin with, there is great scope for introducing pupils to artefacts that will enable them to increase their fund of knowledge. This relates to all areas of the curriculum. All subjects (some more than others) present the opportunity to make a study of material culture in a museum setting.

Secondly, curriculum studies increasingly stress the importance of making use of what can be found beyond the classroom. Teachers are encouraged to make use of primary source material of varying kinds and the prime repositories of such material are museums.

Thirdly, museum work presents the opportunity to escape the straitjacket of whatever curriculum is laid down for you to work from. There is a world beyond those confines and it is important that pupils are given the opportunity to develop their own interests and skills.

Finally, the work of examination groups is greatly enhanced by visits to museums. By the time pupils reach the age when public examinations are to be taken, they have many of the skills and much of the maturity required to make excellent educational use of museums. There is much scope at this age for pupils to be actively involved in museum based projects as part of their studies. Sadly, it is a fact that the majority of 16–19-year-olds are not taken to museums let alone encouraged to make use of them.

To Promote Active Learning

Taking pupils out of the classroom *can* change them into active learners, if only for that trip, offering an alternative to the mainly passive learning they do in school. The skills required to make full use of a museum certainly encourage active learning. Often, as a result, it is those who do less well in a classroom situation who cope best during a visit. When they can do, they understand. This is particularly true of those who struggle with reading, a point expanded on below.

Concrete work is the foundation for abstract work. The more concrete work children do at an early age, the better they are able to move to abstract reasoning

as they grow. Nor can you start too soon. Reception classes are ideal as there are games to be played with objects as well as stories to be told and illustrated. Young pupils cope well with the challenge of visiting unfamiliar surroundings. They have voracious appetites for new experience.

Active learners tend to do better in their school careers, and not just in academic terms. They tend to have better motivation and better skills, especially in new and difficult situations. They actually learn how to learn; which is the best thing they can ever hope to achieve.

What is more, pupils learn a great deal more comprehensively when they are actively involved with what they are learning about. They come to know things by first hand experience which is the best route to understanding. Museums offer the perfect opportunity to set up such learning situations.

To Work with Objects Rather than Text

Language, it is said, defines experience for its speakers. That may well be so, but experience has to be had in the first place for it to be defined. We do things long before we can talk about them. It is, therefore, very important that pupils are given the opportunity to have first hand experience of the world.

Museums contain, or are, the real thing and although the written word may feature during any visit it is the artefact that dominates. For many, seeing and touching leads to believing and understanding what they had previously merely accepted because they had been told it by their teacher. Access to genuine artefacts and practitioners, therefore, is exceedingly important.

However, this is not an either/or debate – text versus object as a teaching medium. The need is for a more balanced approach to providing materials from which pupils can learn. Much too much emphasis is placed on the written word as a medium for information. It cannot be denied that it is important, but material culture in the form of artefacts has as much to offer once the skills to interpret it are available.

Language Development

Contradictory as this may seem, following the previous point, visiting museums is very important for language development. Museums constantly expose pupils to new experiences and to define those experiences they have to use language. They will need to speak, listen, read, write and learn new vocabulary to cope with the visit and make sense of it afterwards. Such purposeful use of language engages pupils both passively and actively in a balanced way.

This makes visits especially useful for pupils with learning and/or language difficulties. Undertaking work in a situation that is so rich in experience can often be the stimulus that overcomes or sidesteps problems and opens new channels of communication.

Development of Cross-curricular Skills

There are many skills having cross-curricular implications that can and need to be developed for successful museum work. Most of these arise from the fact that pupils are no longer working with and to written texts. Working with artefacts and extracting information from them is no easy thing and this often requires skills not fully developed elsewhere or in combinations not normally required.

In particular, pupils will need to be able to observe, record, analyse recorded material and synthesise the results of analysis. They will also need skills in discussion, speculation based on evidence, explanation of ideas and arguments, constructing theories, testing them and modifying them in the light of subsequent discovery.

It is obvious that such skills have a much wider area of use than museum work, but it is museums that can offer the best environment for their practice and development.

Development of Concepts

The 'development of concepts' sounds suspiciously vague, so it is important to be precise about such things if you are to maintain credibility in your arguments. This is especially so if you are working with younger children, as conceptual development is not often considered such a priority as the development of concrete skills. If properly introduced, however, ideas can begin to take root at a surprisingly early age. They might not bear fruit for many years, but that is no reason for not planting early.

Remember, too, that only certain concepts are open to development in the museum environment. They can, of course, be developed elsewhere but they are especially relevant to the kind of work that museums can offer best and are particularly susceptible to that kind of stimulus.

To begin with, one can start to get to grips with such encompassing concepts as chronology, change, continuity and progress. More specific and object based study can lead to the development of ideas such as design (that is, that the products of humanity were made in accordance with a pre-existing plan or to fit a pre-existing need) and how that is affected by use, availability of materials and so on. Objects have also been imbued with bias; that is, they can be written off in a person's mind because of associations he or she may already have with objects of a similar type. For example, girls may write off material from the Second World War as being 'boys' stuff', just as boys may write off domestic implements as being 'girls' stuff'.

Collections of objects open up the possibility of exploring such ideas as typology, typicality (that is, how typical of its type is a given object) and survival (the reasons why some things survive and others do not).

Museum work can also lead to the investigation and development of ideas about what is original material, what is fake, what is a copy, what is the difference between a fake and a copy and so on. This then leads into other conceptual areas

such as the why and what of collection, preservation and conservation, as well as the whole question of what is meant by heritage and museum.

There are many other concepts that will be touched upon when you work in museums, some of which are discussed in the second part of this chapter. Although these things are abstracts, and although you are never likely to be concerned directly with them (unless you are working with 15–18 year olds), they are, nevertheless, worth keeping in mind when you plan a visit. Pupils do tend to ask the most pertinent questions.

An Opportunity to Contemplate and Be Inspired by Material Culture

Even if pupils are unable to handle objects or explore a ruin, they can actually share a space with these things. In sharing a space they can be given time to contemplate them. Meditation, despite its association with eastern religious practice, has a long and worthy tradition in the west. Nor is it confined to religion. Exercising the mind in some way that pupils can usefully cope with (such as thinking about the skills involved in constructing, by hand, an accurate clock) provides a very important extra dimension to the study of material culture.

Museums should not just be places of study. One of their functions, after all, is as a home for the muses. Therefore, museums should also be places of inspiration and insight. Analysis should give way to synthesis. Knowledge should give way to understanding. Study should give way to feeling. Without this, pupils are not being fully educated.

The Opportunity to Become Acquainted with Our Own and Others' Cultural Heritage

Although we live in and live for the present, it is important to understand that the present has been shaped by the past and that it will be instrumental in shaping the future. The better we understand the past, therefore, the better chance we have to understand and guide the present, contributing at the same time to the foundation of a stable and viable future.

Knowing the facts of history, however, is not enough. Inherent in understanding is the need to develop awareness, respect and value for our cultural heritage as well as an awareness of, and respect for, different cultural traditions and values. This is particularly so in shaping a multicultural society. We all need to have an understanding of the cultural heritage of those with whom we share a space if we are to live in anything approaching harmony.

Understanding is different from adopting or merging. There is no implication that one culture should give way to another or deny what it is in case those of other cultures are offended. One cannot dictate to another. If there are differences, these too should be explored, understood and accepted.

Community Awareness and Socialization

Taking pupils out of school and introducing them to other aspects of their cultural environment (especially ones they might not otherwise get the opportunity to visit) and teaching them 'how to behave' in such places is itself a learning experience that should not be denied. Young pupils are often taken on visits to their local library to be introduced to its personnel, learn how to find books and have stories read to them. Why should they not visit museums in the same way? Acclimatisation is extremely important. If pupils feel comfortable in a museum they will be inclined to use it and learn how to use it sensibly.

And there is, of course, what we might call the hidden curriculum of museum visits – the whole gamut of social behaviour that can be learned on such occasions. This learning derives partly from seeing how others behave, partly from the way the trip is organised and so on. This aspect of visits is considered in more detail later on in the book.

The Opportunity to do Things that Cannot be Done in School

Teaching and learning are highly complex activities that are strongly influenced by the environment in which they take place. Work that is done in museums, if properly planned, can rarely be duplicated in the classroom — unless the museum you are working with has a particularly good outreach service. Even then, there is nothing like a fresh environment for stimulating new ways of thinking. Offering that to your pupils can only be good for them.

What is more, there is a question of motivation. Over a long period of time it can become extremely difficult to maintain high levels of motivation in pupils – even highly motivated ones. They become stale and bored with the same old routine. A day out with well planned preparation and follow-up can be extremely stimulating.

Visits also provide the opportunity to widen and deepen teacher-pupil relationships. A different setting with different working conditions can help to forge links that would not normally be formed. This is especially so if the opportunity is used to provide a success for those pupils who are more used to failing.

It is Good for the Image of the School

Taking pupils out to museums is good for the image of the school – provided, of course, that your pupils behave themselves. Good planning, preparation and plenty of experience are the keys to success. And not only does this create a good impression with the place you visit, but also with other people who might be there at the time.

It is also good publicity for the school when it needs to broadcast (for whatever reason) what it does for its pupils. It impresses inspectors, parents, tax payers, politicians, policy makers and community leaders to know that pupils are being

actively involved in the world around them. Taking children out should be part of school policy. On the whole, provided costs are reasonable, parents are supportive of that kind of activity. It is also an effective way of involving parents as they may be able to help on the day of the visit.

If the school where you work does not have this as part of its policy then you should try to persuade the powers that be that it should be so. Quite apart from anything else it makes the organisation of trips easier and less time consuming.

To Keep Museums Open and Learnt About

This final reason might sound suspiciously like special pleading, because that is exactly what it is. If schools decrease their use of museums, or stop visiting altogether, museums will lose a fair proportion of their visitor numbers. It also means that the capacity of museums to cope with schools may wither – funding being switched to other areas or simply cut altogether. If, on the other hand, schools build up a strong relationship with museums, such that they become important features in the education of pupils, museums have a stronger case when arguing for the maintenance or increase of their budgets.

School visits can also be an active agent in the evolution of museums, an agent for the good. The more schools that visit a museum, the more that museum has to look to what it has on display to assess how suitable it is for schools. When planning temporary exhibitions or new permanent exhibitions, educational use also has to be taken into account. Having to look at things from a new perspective can often open up new avenues or help to solve old, seemingly intractable problems.

Lastly, but by no means least, there are the museums themselves. The work that goes on within them from the curator to administrative staff, from conservator to cleaner, are all possible careers and are all of interest in their own right. The same is true of those activities that are contiguous with museums such as archaeology, architecture, the history of art and so on. And there are also the wider questions about the history and development of museums, their place in society and their role in the future. There is much about them that is worthy of study.

There, then, are a dozen reasons, sketched out very briefly. Each of them could be expanded upon, especially with reference to the specific situation you find yourself in as a teacher. And there are probably a dozen more reasons as well. It will be well worth your while becoming familiar with them and rehearsing their use.

ABSTRACT REASONS

The scope of this book limits it to a discussion of material culture. But do not think that just because we are concerned with material culture, the only way to appreciate it is through facts or material means. There are other ways of coming to know about things; and there are other good reasons why children should come into contact with our cultural heritage.

There are still too many teachers, often following the dictates of a predetermined curriculum, who want their pupils to gather facts. Facts are important and the desire to derive as much as possible from a visit is understandable. But it should be remembered that we live in a society almost pathologically obsessed with the acquisition of facts. They can be obtained anywhere in our information rich society – and are often better sought for in more conducive conditions than can be afforded by some museums.

This is not to deny that facts can and should be sought out at such venues. Some can only be found there and getting pupils to design their own investigations to discover these facts is of inestimable value. However, finding facts should never be the sole or main reason for visiting a museum.

The problem is, as Bertrand Russell wrote, 'We know too much and feel too little'. Stimulation of the imagination and of our emotions is of equal importance to gathering and analysing data. Pupils should be inspired by what they see and do and should come to a better understanding of things as a result of this. That does not happen merely by visiting, any more than facts are learnt merely by visiting. All these things have to be worked for.

Schools and museums have much in common in this respect. In particular, both aim to engender interest in the human condition as manifested in the social and physical environment. Both, too, should be trying to foster the capacity to think critically and speculate about these same manifestations.

People today are heirs to a remarkable inheritance – physical, social and cultural – and one of the central aims of education must be to induct people into that inheritance, to enable them to understand it, to enjoy it, to question it, to make good use of it, to protect it, to enrich it and to exercise prudent stewardship over it.

Most pupils today are urban dwellers and most pupils – despite our being a multicultural society – are manifestly steeped in a narrow, pervasive, monoculture that owes little to their 'cultural heritage' and even less to their personal experience.

Lack of cultural diversity, a cultural identity based on alien or fictional values, is damaging to the viability of a society. It is as damaging as lack of genetic diversity is to a species or to life as a whole. It is of great importance, therefore, that pupils are introduced to as much of the cultural heritage of their forebears as possible, as well as the cultural heritage of the land in which they live (if that be different).

Cultural heritage is one of those much used and much misused terms that really needs to be defined if it is to make any sense. For the purposes of this book, anything that we have inherited from our forebears and has contributed to the shaping of our culture is our cultural heritage — be that contribution large or be it small. This, of course, leaves everything open to discussion — which fact itself is part of that heritage and which is what makes it the dynamic, evolving, organic entity that it is.

This is not simply to do with material culture. We are as obsessed with material culture as we are with facts. Indeed, the two obsessions are linked. But our cultural heritage goes way beyond this. It includes for discussion everything: 'low' and 'high', material, spiritual, aesthetic, economic, environmental, philosophical, popular, 'lifestyles' and so on. And we cannot consider or respond to that heritage

if we do not make contact with it and are not offered the opportunity to understand it and be inspired by it – inspired to explore it, criticise it, and enhance it.

First and foremost in terms of cultural heritage, it is important to consider that which had an enormous effect on the earliest post-glacial inhabitants of these lands: the landscape and the natural environment. Nowadays most of the 'natural' environment and a fair proportion of the landscape are human made and human managed (or mismanaged). That brings it within the scope of this book for it is part of our material culture.

Much that our early ancestors knew has gone, replaced by a working landscape that itself has undergone radical changes in the last 50 years. Despite all that, it is important for pupils to get out into that landscape and get to know the natural environment, learn some of the truths about it – rather than the biased stories of various vested interests. Much as we have shaped the natural environment, it has also shaped us – and done so at a fundamental level. This concern is not the narrow one of environmental studies, vitally important though they are. It is more to do with the nature of our being and how that has evolved.

The built environment is important too and deserves close study and understanding, but the context for that is the natural environment. It was the natural environment that shaped us as a species, not cities. That is why, for all the advantages that cities bestow, they cause us such trouble. Civilisation is relatively new to human beings and it is a mixed blessing.

There are those who feel the importance of nature is much inflated, especially in respect of child development. I was once informed in a discussion on the countryside, in all seriousness, that nature was 'not the real world'. However one interprets that statement, it is arrant nonsense. As a species we are part, a very small part (for all our impact), of the natural world. We evolved in the natural environment and were shaped by its pressures. We are still evolving, but the 5,000 years that a few of us have lived in cities and the 200 years that the majority of us have lived in cities, represents only a tiny fraction of a percentage of our life as a species. We still belong to the natural environment. It is a genetic attachment. Any attachment we may have, as individuals or as a society, to city life, is a personal or possibly cultural habit and nothing more. Indeed, city life may well act to protect us in some degree from evolutionary pressures – as a species, we may actually be regressing.

Not only that, but the habits of 'civilised' humanity are destroying the natural environment. Without it, we cannot survive. The habits, therefore, have to be broken and we have to regain an understanding of how to live within ecological limits – something we *can* do without loss of quality of life (probably enhancing it), something we *have* to do unless we wish to go the way of the dodo.

Pupils need to be put back in touch with the cycle of birth, life and death, with the ways of the seasons, the moon and the stars, and the ways of the plants and wild and domesticated animals. We cannot, of course, just move everyone into the countryside and tell them to get on with it. Education, as always, is the key.

Closely tied in with renewing contact with the natural environment is the need to develop an appreciation of beauty. Like 'cultural heritage', 'beauty' is a term

much misused – especially in the twentieth century – and therefore also in need of a definition. For the purposes of this book, something is beautiful if it has a pleasing emotional effect upon a person as a result of their personal or collective memory and which occasions no deliberate harm to any part of the natural or built environment.

Beauty has been the concern of many of the world's greatest thinkers and teachers. For some it is a quality inextricably linked with 'the good' and 'the right' (that is, 'truth'). Beauty is very much subjective, but being in the eye of the beholder does not make it an arbitrary thing. It is to do with how we view, make contact, and build relationships with the world, along with the opportunities that exist for such activity. The more we can experience through an exploration of our cultural heritage, the more we can understand beauty and the more we can find that is beautiful. The more we find beautiful, the more we are likely to value. The more we value, the less destructive we are likely to be.

An appreciation of beauty, therefore, acts as a stimulus, encouraging the development of many other positive qualities such as sensitivity, tolerance, idealism, love and spiritual awareness. We are not talking overnight conversion here. This is the work of generations, an evolutionary process that will strengthen itself as it grows. The hardest part comes now at the beginning of a new cycle after so many hundreds of years of depredation.

To further appreciate these qualities, pupils need to make contact with what is best. Here again, we are on contentious ground. We cannot dictate our own taste in these things to others. Mutual consent is all important. Pupils must be equipped with the wherewithal to make informed and critical decisions about what they believe to be good of its kind. Part of this process needs to be an exposure to and dialogue with as much as possible of our cultural heritage.

An exploration of ideas is of equal importance. Much, if not all, of our material culture had its genesis in ideas – from the mundane to the erudite. In turn, ideas spring from the inspiration given by material objects.

The formation of new things and new ideas are creative acts, even at the most mundane level. We cannot all be inventors, artists or philosophers of distinction. However, we have all created ideas and objects new to ourselves (even if they are re-creations). The process is made easier, of course, with the more practice we have. But creativity cannot take place in a vacuum – it needs feeding.

We all have vast reserves to draw upon when it comes to creativity. Young people can tap them more readily as it is more socially acceptable for them to do so. It is to the detriment of us all that as we come to adulthood, creativity is meant to be put to one side, used (if at all) for recreation only. Even young people are expected to channel their creativity into certain areas of life (as if it were not possible to be creative within mathematics or the sciences) and more often than not use it in a contextual vacuum.

All life is a creative act – the better we understand that, the better we will be able to direct our lives to our own desired ends. But creative acts, to be fulfilled, have to be backed by an evolving knowledge and understanding of the area in which we are working (including past solutions) as well as the skills necessary to carry those acts to a quality fruition.

In a sense, this is what education is all about. At least, I would argue that this is what education is meant to be about. Current strictures in many places are in danger of turning education back into schooling. The artificial divisions of subject matter and the lack of training in basic skills shut many pupils off from serious consideration of what they and their culture are all about and what they think the world should be like. It will be their world after all and we should be equipping them to make the decisions they will inevitably have to make. In the meantime, the current system can be used to bring something of this about through the medium of visits to as many places as possible beyond the confines of the school.

WHY SPECIAL SKILLS ARE NECESSARY TO USE MUSEUMS FOR TEACHING

Museums – for all that they concern themselves with the collection, preservation and display of examples of material culture – are places of learning. Learning is what informs their very being. Learned people run them and make decisions within their framework. People go to them to learn, to tap into their cultural memory. But, much as they are places of learning, they are *not* schools.

Schools are different types of institution with different aims from museums. This distinction between schools and other institutions of learning cannot be stressed too strongly as it is a distinction that is all too often ignored. Schools exist with the prime aim of educating children and they are wholly structured to that end. Museums, as we have seen, are not structured in the same way, so when groups from schools visit museums, special skills not normally used in their schools are required to ensure that they do learn.

Sadly, there are many groups of pupils visiting museums who get little out of the experience because their teachers do not understand the importance of this distinction. Such teachers use the museum as if it were merely an extension of their classroom and teach their pupils as if they were still at school. This is an ineffective way to teach; a waste of time being in the museum as the full potential of the place is not even close to being realised.

In addition, many groups are also taken to museums because it is assumed that taking them is sufficient in itself; as if some magical transmutation will take place. This is flawed thinking. Just as teachers need special skills to set up, run and follow-up museum work, so too do pupils. They need the skills necessary to cope with working in an environment that is not their classroom, in which all their usual psychological props are missing and in which they have to confront things at first hand which they normally only ever see at second hand.

And then there is the museum education officer. If the museum being visited is lucky enough to have one or more of these experts in the educational uses of the resource, then there is a great temptation to assume that they are going to do all the work, provide all the materials and cope with the children. Even if you do get a museum education officer who has the time to teach your group, you have to remember that it is *your* group being taught. You are responsible for the work they do. You are responsible for their behaviour.

Perhaps the best illustration of the need to adopt different approaches and use different sets of skills is in the way some parents take their children round museums. They head off with their children in reluctant tow, usually following the order set out by the museum and explain it all as they go along. They also try to enforce outdated ideas of propriety. I have seen this happen quite often. Unfortunately, as far as children are concerned, this is the most boring way to spend their time, even if they are deeply interested in the museum and its contents. They want to flit from place to place as their interest takes them, they want to interact with what they see and they want to have someone or something on hand to answer their questions and explain things as and when they want it.

Education is not a one-way transmission of knowledge. This process theory is quite discredited. Pupils construct internal models of the world which they are constantly adjusting and reforming as and when new information and understanding suggest that the current models are no longer sufficiently congruent with their experiences. In any environment, but especially one as rich in stimuli as a museum, pupils are working overtime to assimilate new experiences. They should be assisted in this by being actively involved through constructive investigative work during which their skills and understandings develop. Pupils also learn best when they move at their own pace (for which a great deal of self-discipline is required). As they build up their knowledge of the world and construct their internal models they must not be hurried otherwise the models they construct could well be distorted or incomplete.

And they must have choice. Not all things will interest them equally and they will all be constructing their models in different ways, needing to make different connections and patterns. Imposing a rigid regime working to teacher-time, or imposing a regime that works in one environment on a different environment, will inevitably lead to problems.

Teaching in museums, therefore, requires different sets of skills to classroom teaching. Some of the reasons for this have already been rehearsed in this chapter. There are others.

MUSEUMS ARE MUSEUMS

Museums have aims that are different from those of schools. This we already know. A great deal of what is to be found in museums is, by the very nature of the place, old and fragile. It is also, often, unique and in need of protection from environmental factors that cause decay, such as sunlight, humidity and so on. Even more robust artefacts such as ruins are subject to erosion. And while you would expect pupils to treat any environment with respect, special conditions apply in museums. There, a primary concern is the preservation of that resource. If the resource is allowed to erode, then it ceases to be of use to anyone.

Not all that is collected and preserved is on display but those things that are exhibited are usually the best of their kind and thus they are usually out of reach or behind glass – distanced from those who come to see them. This placing of

objects on a pedestal can often create psychological barriers, making things appear precious for the wrong reasons. This needs to be understood if the artefacts are to be properly appreciated.

Where objects are freely available for use and handling this is because they are more hardy, more common and expendable. That does not mean, however, that they should be treated with any less care or respect than those artefacts on display.

In other cases the artefact is on such a massive scale (for example, a cathedral) that it can be difficult to interpret and difficult for pupils to appreciate (after all, if someone can make a life's work of studying the stained glass windows in a single cathedral we can see that resources of this kind have problems of a particular order). What is more, it is a lot easier to lose a pupil in a cathedral than in a classroom.

YOU ARE WORKING WITH ARTEFACTS RATHER THAN TEXT OR REPRESENTATIONS OF ARTEFACTS

How children learn in a museum is different from how they learn in a school because of the learning base. In school they are faced with the written word. In a museum they are presented with an object. This argument has already been looked at in a different context. It is, however, one of the key concepts of this book and, as such, it will continue to appear.

Specific skills for working with artefacts will be dealt with later. There is, however, another aspect to this question and that lies in the experience of working with such source material, be it a ruined building or the personal belongings of someone long dead. Direct contact of this nature has its own psychological impact. It is an impression that can, if improperly focused, simply remain as a memory of a good day out. If properly focused then it can reverberate a long way into other areas of work and thought.

Working in museums with such source material means that it is important to look carefully at the philosophical basis of what we mean by education and learning. It also means that we need to be aware of the many levels that are at play because working with source material involves many skills. Not least of these are the gathering of information from source material, building that information up, searching for patterns and secondary information, forming hypotheses and finally testing those hypotheses.

The thought processes involved develop skills that can be used far beyond the confines of the mere museum visit. Such skills should be carefully nurtured. In one sense it does not matter how much a pupil learns about specific objects so long as they become increasingly equipped with the practical and intellectual skills to question carefully and to the point, and make good use of the answers they receive. Teaching these skills and guiding their development is no easy task and requires, in turn, that those who teach them have such skills themselves.

WORK IS LIKELY TO BE CROSS-CURRICULAR, INTERDISCIPLINARY AND MULTI-FACETED

Artefacts will not fit conveniently into the notions of subject matter delineated by the standard curricula found in schools. They are not and cannot be confined within a single subject like History, for example, no matter what their historical significance may be. All artefacts have many facets that touch most, if not all, areas of the curriculum. They also touch areas that are not taught in most schools. It is difficult, therefore, to concentrate on a single subject when visiting a museum. It is far better to use the visit in a multidisciplinary way so that it provides stimulus for all sorts of work in all sorts of areas.

In a primary school this is far easier to achieve than at secondary level because of the way the school is organised. It is also second nature for the primary teacher to be working in a cross-curricular way. But the cross-curricular nature of objects also applies to pupils working at secondary level. A successful visit is likely to involve a great deal of co-ordination with other individual subject specialists. For secondary teachers also, there is the problem that they, too, are specialists. This straitjacket has to be cast off at least for the time of the visit if it is to be truly worthwhile.

A DIFFERENT SOCIAL CONTEXT AND STRUCTURE

Pupils are as aware as anyone that a museum is not a school. They will, therefore, have a tendency to behave in ways in which they would not behave in school – positively and negatively. A visit out, no matter how you promote it as a working day, is still going to have the air of an outing. Older pupils may feel that school rules do not apply or that what they are doing is not serious. Younger pupils may be in awe of the people they meet and have to work with. All these changes in behaviour may be extremely subtle but they will nonetheless occur and need to be taken into account.

A DIFFERENT DISCIPLINARY SET-UP

When you move beyond the boundaries of your school, its influence on the behaviour of pupils is diminished. Although they may still be in their class groupings and with their teacher, pupils face the pull of different disciplinary codes. And whereas going home at the end of the day is a clear cut and accepted change from one code to another, going on a visit can cause confusion. It is necessary to ensure that the school has a specific code of conduct for such things that pupils are aware of and in which they are well versed. It need not be draconian. It is sufficient that it exists.

If there is such a code, you still have to remember that you no longer have the back-up you have when in school. The buck stops with you and you need to make contingencies for it. Even if you have a gift for discipline you may find the different setting alters things.

A DIFFERENT ROUTINE

Even if you are only out for a part of the day, the routine of your pupils and of the school will be disrupted to a lesser or greater degree. Although not a severe problem, it must be remembered that children, younger ones in particular, are sticklers for custom. If they normally have food or a break at a certain time, for example, it is wise to try to keep to that timing. Not just for the sake of their rumbling stomachs. Hungry children are fractious and do not work well. They need their breaks just as the rest of us do. And whereas they might be prepared to change the timing of their lunch, younger ones do need to finish their day at the usual time.

A DIFFERENT PHYSICAL SET-UP

It is surprising how easy it is to become dependent upon the security offered by a classroom – even for those who do not much like school. Things are in familiar places – your own desk or table is there, everything is to hand. Working in a different environment can be an unnerving experience. This is true for teacher and pupils alike.

Disorientation can occur even in well signposted environments. Toilets are in the wrong place, doors open the wrong way, the decor is different, the smells are unusual and there are strangers about. Pupils can get lost even if the building they are in is smaller than their school. They can even get 'lost' when they are not separated from the group. The learning environment is also different. Even if teacher and pupils worked in a replica of their own classroom, psychologically it would be a very different experience. This is especially so for younger pupils who may be travelling what appears to them to be a long way from home.

THE DYNAMIC OF THE GROUP MAY BE ALTERED

The changes in working environment, social context and working practice may mean that the social structure of the group you take into the museum is subtly altered, even if only during the visit. The more literate and academic members of the group may find that they do not cope as well as they thought they might. They are more likely to miss the security of their classroom. On the other hand, those who usually have greater problems coping with classroom work may well find that working in a museum suits them much better. This does not always happen as there are many other factors at play, but it is not uncommon.

Such a change in standing within the group may be of little consequence, but it is another factor to be aware of. It is also worth keeping an eye open for it because it provides the opportunity for praising and reinforcing those who are not so frequently in such a position. It also provides the opportunity to see just who might benefit from a more practical approach in school.

WORKING IN PUBLIC

Working in a museum also presents other problems that require special skills – not least of which is the fact that you are liable to attract the attention of a mobile audience. Members of the public, who have as much right as you to be in the museum, will form an ever changing background. This can be distracting in all sorts of ways. Be prepared for them joining in.

Not unreasonably, these people may be curious about what you and your group are doing. And, not unreasonably, children are taught to be wary of strangers. In addition, some members of the public may be wary of children, while others also feel that children should not be in museums getting in their way. Confidence in your right to be there as well as diplomacy are very important factors in your handling of such a situation.

IT IS MORE DIFFICULT TO CONTROL BOTH THE STRUCTURE OF THE DAY AND THE LEARNING

Then there is the type of work that pupils can undertake in the museum environment. They may have no tables to sit at. Text books, databases and the like are all out of reach. And the nature of the work they do is also very different. The methods of working, the artefacts they are working with and the information they are looking for are often quite dissimilar to those they would normally encounter in school. This is not to say that they do not use objects in school or use the particular ways of working. Rather, it is that all these forms rarely, if ever, come together in school.

A museum is not a place designed for continuous, linear, structured learning. Therefore, the way they work has to compensate for the problems caused by the environment at the same time as making the most of the advantages offered. If not carefully handled with preparatory and follow-up work this can lead to problems.

Staying in control of the proceedings in a logistical sense is also difficult. Great care has to be taken over the structuring of a visit in order to ensure that everything runs smoothly, that you achieve all you wish to achieve and that everyone gets home safely at the end of it.

HEALTH AND SAFETY AND THE LAW

As with discipline, the buck stops with you. Once you take a party of children beyond the school boundaries, the sole responsibility for their health and safety is yours. You need, therefore, to make sure you know precisely what those responsibilities are and to ensure that you stick to the official guidelines. Risk assessment and management are considered in detail in Chapter 6.

These, then, are some of the reasons why special skills are needed when you take pupils out to museums. The whole idea must, at this stage, seem a daunting task.

Organising a trip begins to take on outsize proportions, but that is because it is new and untried. The more familiar you become with organising and carrying out such events, the easier it becomes. But you should never allow yourself to become too confident about it. That is when things go wrong.

Before moving on to Part II, in which setting up a visit is considered, take a short break and treat yourself to a day out at a museum – you may well look upon it all with a fresh eye.

PREPARATORY STRATEGIES

ASPECTS OF A VISIT

It is now time to turn our attention to what is involved in the planning, preparation and execution of a visit. This section will, in the main, concentrate on the logistics, since the academic content will be for the individual teacher to decide upon, research and order in accordance with the specific nature of the visit.

Before we can go on to explore the logistics in detail, however, there are important considerations that affect the organisation of a visit which must be explored first. After all, a visit to a museum by a school group is not simply a visit to a museum by a school group. Once you begin to look closely, you will see that what happens is multifaceted and extremely complex.

No educational visit occurs in isolation. They do not (or should not) happen on a whim. They cannot be set up over a cup of tea in the staffroom. Visits exist in an educational, sociological, psychological, temporal and organic context – and not just in terms of the pupils, but also with regard to the museum. Each visit must be tailored to the specific needs of all concerned and it must have specific intentions as a basis.

There are four important facets to any visit that need to be taken into consideration when planning. The first of these is that any visit has a *chronology*. The second is that during any visit there are several *layers* of educational experience taking place, some more explicit than others. The third is that there are many different *types* of visit that can or may need to be arranged. The fourth is that no matter how carefully you plan a visit, the *observed* curriculum will always differ from the *intended* curriculum. That is, there will always be random elements and connections that introduce different outcomes to the ones you had anticipated.

CHRONOLOGY

All visits have a chronology which can be crudely expressed as *before*, *during* and *after*. That is, there are events that lead up to the visit, the visit itself and events that occur after the visit – all of which are facets of a single, homogeneous experience. It may sound absurdly obvious but it is nonetheless true that certain things have to be done in the correct order within that chronological sequence and it is no use trying to do them in any other way. As an obvious example, it is of no use preparing children for a visit two days after they have returned from it.

The actual sequence of events that need chronological consideration is outlined, in the correct order, throughout the rest of this book. By following that sequence it will become clear why certain things are done when they are. There are, however, some general points that can be made here by way of an introduction.

The importance of chronology does not lie only in the need to carry out logistical measures in the correct sequence. Observing a chronology helps to place the visit in context. The surrounding and connected circumstances of a visit give it its relevance and enable pupils to better understand what the visit is all about. Without a context, and a context that is understood by pupils as well as the teacher, the visit will produce poor educational results and will probably damage prospects for future excursions.

There is also the danger with any visit that it can be seen by pupils as a oneoff event occurring out of the blue and not particularly connected with anything else that is happening in their educational lives. This is the result of bad planning. For example, it is of little use taking pupils to a museum unless it is relevant to what they are currently studying. If you are unable to arrange a visit to a relevant venue at the relevant time, do not go in the following term when you are studying something else. If you cannot be bothered to make arrangements far enough in advance then you should not bother with visits at all.

Along with creating a relevant context for the visit, pupils need adequate preparation. This involves careful timing which in turn needs careful planning. There must also be a recognition that there are skills and subject areas of the curriculum that relate to the work of the visit, if not to its subject matter. Unfortunately, many pupils have problems relating one subject with another. A pupil good at mathematics in mathematics lessons may have problems relating its use to geography and may, therefore, be useless at mathematics in a geography lesson. The same occurs when pupils go on a visit. There are those who have problems relating the visit to their work in school and transferring skills they may well have and use competently in school. This can be aggravated by the fact that the visit takes pupils outside of their school environment. Without adequate preparation such pupils will have problems on the day of the visit and, consequently, with follow-up work.

Understanding that there is a logical sequence of events with its own dynamic means that this can be taken into account when planning a visit. This, in turn, means that pupils can be involved in such a way that the visit sits comfortably in its context and in the conceptual framework they have of educational experience.

LAYERS

The whole chronological sequence of a visit has many levels. These fall into four broad layers which mostly come into their own during the day of the visit. These layers derive from the different types of experience that pupils gain from a visit as well as from the aims of the visit as perceived by the teacher. If the distinctions represented by these layers are not taken fully into account then the opportunity for taking best advantage of them will be lost.

To begin with, there is the surface layer or overt reason for the visit; that is, using the resource for study to enhance classroom work. This is, of course, the main reason why visits occur. Despite its inherent problems, this is the easiest of the four layers to organise, control and assess.

The second layer, which is interwoven with the first, is concerned with learning how to learn. This is not unique to museum visits but they do offer an excellent opportunity to promote the practice and understanding of such skills. Some of these will be looked at in detail in later chapters. In most cases the aim of a visit should not be to teach the facts about what can be seen, but to teach how to elicit evidence and interpret it, how to see and understand. Artefacts do not have a fixed, single meaning or interpretation; these aspects depend on why you are studying them. There is no single, authoritative set of facts to be handed on. Therefore, you have the golden opportunity in museum visits to get pupils to learn for themselves and be active participants in the process.

The third layer is the familiarisation of pupils with museums – what they are, their purpose and their importance. It could well be that familiarisation is the prime aim of a visit, especially with very young pupils, but more often than not it will be a subtext to the first two layers. A careful balance has to be struck here. On the one hand it is desirable that pupils are enabled to appreciate that a museum can be an excellent learning resource. On the other hand you do not want visits to museums to become solely associated with school work as they will become imprinted in the mind as 'childish' places – a real possibility when you consider the majority of pupils who visit museums with their schools are in the 9 to 13 year old age range. One of the objectives at this level, therefore, should be to encourage a wide appreciation of museums so that when a pupil leaves school, museums are part of their leisure/learning 'vocabulary' on a par with hobbies, libraries, evening classes, cinema, theatre, television, concerts, sporting activities and so on.

The deepest layer is the so-called 'hidden curriculum' that informs all teaching and all work with pupils. Introducing pupils to new social environments means they have to learn to adapt to them. As with any social situation, there are certain appropriate forms of behaviour and working that are suited to the museum environment. This is not just to do with not behaving in a way that will get you thrown out. It is learning a set of behaviours that will lead to better access to all the positive benefits that can be derived from a visit to a museum.

None of these layers can exist independently of the others. When you make a visit, all these things are happening. What is more, they are interdependent. You cannot become socialised in a contextual vacuum. You have to be working in a social environment. And as you work you learn the skills necessary for learning, just as you become that bit more familiar with museums and what they are.

TYPE

The type of visit you plan depends on what you are studying, the age of your pupils, the reasons for making the visit in the first place and so on. A visit can

have a very broad aim (for example, to introduce pupils to the concept of change over a period of time) or it can tie in with specific curriculum subjects as well as cross-curricular themes. You cannot possibly hope to cover all eventualities with an unchanging basic day of a coach trip, three hours in a gallery, back to school and half a dozen worksheets as a follow-up.

In one sense there are an infinite number of types of visit because there are so many variables to permute. However, there are certain basic types we can look at here. Bear in mind that museums will have made conscious decisions about how they will cope with school visits. They are just as constrained by finance, expertise, policy and so on as schools are. The object is to make the best of what they can offer. The decisions made by a museum will have led them to adopt one of the following tiers of service.

- First tier: At this level are museums that make no concession to education
 other than allowing school groups to visit. There is likely to be no member
 of staff with a responsibility for education usually because the museum is
 too small to have sufficient personnel.
- Second tier: Next are museums which have museum education staff who
 have minimal contact with educational visitors. Their aim is to provide
 resource material for visitors. The person responsible may well have other
 duties within the museum.
- Third tier: At this level there will be a post dedicated solely to education (full-time or part-time). Resource material will be supplemented by the opportunity for contact time with the education officer. They may offer inservice sessions for teachers and lead introductory sessions for pupils. On the whole, however, schools are on their own.
- Fourth tier: Finally, there are those museums that provide sufficient
 education staff to take on the bulk of the work. They will teach the pupils
 when they visit the museum, run handling sessions and special events,
 leaving the pastoral responsibilities to the teachers (who are best qualified
 for this as they know the pupils well). Not many museums can offer this
 level of service.

These different levels can also be differentiated by their orientation. Services may be directed at either the teacher or the pupil. This affects the kind of material produced and the service on offer. A service aimed primarily at the teacher will attempt to equip the teacher with the wherewithal to use a particular museum or exhibition to best effect – much as this book intends. A service aimed primarily at the pupil will aim to produce material and programmes of work for pupils to follow, circumventing in some ways what the teacher might want. In this way, the museum tightly controls what is done, where and how, when and why.

Material produced for teachers may include: practical guidance – such as opening times, costs, facilities available; site information – including plans, guidebooks, contents lists of galleries, background to the museum; information

on activities – for example, programmes of events and in-service training; detailed source material – information on specific subjects, objects or events and the like.

Material produced for pupils may include: worksheets and activity sheets for use on site; follow-up work to consolidate what has been learnt during activities on site; source material such as replicas, books and booklets on specific subjects, objects and events; activities such as games, puzzles, colouring sheets and so on.

Any service aimed at pupils will be necessarily limited and will not be able to fulfil what any given teacher wants. This can be frustrating as it can limit the way in which you as a teacher can use a given exhibition or museum, especially if that museum will only allow visits on its terms. It does have the advantage that whatever material is available has been produced by people who are experts and who can bring out facets of an exhibition that you may have missed. Conversely, a service aimed at the teacher will give you the flexibility to do precisely what you want, thus tailoring everything to the needs of your pupils. You may find, however, that you are lacking in the necessary background knowledge and understanding to make full use of the resource.

As a result of aiming at a specific audience, you get a service that is led either by the museum education staff or by the teacher. Again, each of these approaches has its advantages and disadvantages. In the end, you have to try to strike a balance that brings out the best of each. Certainly, if a museum has an education officer, he or she is the best person to approach. Talk with them, let them know precisely what you want and be prepared to listen to what they have to say. Museum education officers are very dedicated professionals who know a great deal about how to get the best out of the resource with which they work.

If there is a museum education officer in the museum you have chosen then some or all of the following types of service may well be on offer for you to use: resource materials of the various types mentioned above; guided tours; formal and informal talks; handling sessions; activities based on crafts; activities based on events; a combination of any or all of these; in-service training for teachers. To be of best use, these need to be at varying levels of interest and sophistication as well as being relevant to the particular needs of pupils and teachers.

Of course, it is not always possible to make a visit to a museum. Many reasons exist why you cannot move beyond your school's boundaries. This is no reason to miss out, however, because museums can sometimes make visits to schools. They can do this in a variety of ways. Loan materials are the most common and readily used, allowing teachers the opportunity to bring genuine artefacts, replicas or slides and videos into the classroom. Some museums have mobile galleries – a large vehicle fitted out with artefacts and displays that can stay for an hour or a day. You may have the opportunity to book a temporary exhibition that can be placed in your school for several weeks before moving on to another school. Most museums produce publications that relate to their collections which can be used. And finally, museums have staff who may well be able to visit and work with your children. These do not have to be museum education staff. Curators, conservators, designers and other museum staff have interesting and worthwhile tales to tell. Museums

going to schools is no substitute for schools going to museums, of course, but it is better than no contact at all.

Having considered all that, you also have to think of what type of visit best fits the abilities of your pupils and the nature of what they are studying. A class of 6 year olds, for example, may simply need a short introduction or series of introductions to their local museum, perhaps spending some time in a specific gallery with a story-telling session based around some of the artefacts on display. These should be treated in the same way as library familiarisation visits. They should be short, spaced over a period of weeks, and the pupils should meet people, look at things, listen to stories and learn a little about the jobs of the people they have met.

There are many other types of visit. One-off sessions are the most common, usually lasting a day. Longer sessions are possible, especially if you are prepared to travel. A week spent investigating a series of museums linked by your chosen theme can yield spectacular results. If you cannot get away for a week, a series of visits (perhaps as short as an hour each time) to a single site to make a long-term, in-depth study can also be useful. A museum with a comprehensive collection of materials may well become a regular place to visit to follow a whole series of subjects or a very wide field of study. Whatever the case may be, you must be flexible and use your imagination.

In the end, the type of visit you decide upon must be dependent upon the pupils with whom you are working. You must start from where they are – not only in terms of subject matter but also in terms of their familiarity with museums as a working environment and their ability to work well in such situations. To be able to do that, you must become familiar with as many museums as you can. Strategies for this are discussed in Part IV.

OBSERVED/INTENDED

Finally, there are the random elements of any visit that have to be taken into account. No matter how exacting your planning and preparation for a visit, it will never turn out exactly as you envisaged. The observed curriculum (that which actually happens) will never match the intended curriculum (that which is planned). There is so much that is not under your control. This is not as alarming as it may seem at first glance. After all, much of our lives are spent coping with random elements. How well we cope with them is one sign of how well educated we are.

In terms of visits to museums, these random elements fall into two broad categories. Firstly, there are those problems (mostly logistical or disciplinary) which can be solved immediately or taken into account as the day progresses. A good example would be unexpected road works on the route to your chosen venue or a pupil forgetting a packed lunch. A risk management plan is the best way to cope with this.

Secondly, there are those problems which are not readily apparent or which do not manifest themselves until much later. You will quite often find that some artefact or event will trigger in pupils a curiosity or line of enquiry contiguous with or at a tangent to the reason for the visit. This may lead to misunderstandings or contact with areas of learning you had not considered.

When you come to plan your visit and prepare yourself and the pupils for it, you should always include in your reckoning the fact that educational outcomes will never be entirely as you anticipate. You cannot plan alternatives to cover every contingency but being aware that things will not go exactly as you wished will help you to cope when things do go off at a tangent. Devise strategies, be prepared to be flexible and always keep extra work and activities up your sleeve. Careful preparation will help keep pupils focused, but will also allow you to gauge quickly when things are deviating from plan and what the consequences will be for the intended curriculum.

It is particularly useful to remember all this when it comes to considering assessment. It is fairer and more productive to make assessments on the observed curriculum as well as the intended curriculum, finally basing the success or otherwise of the day on what actually happened as well as what you wanted of it. Both assessments are important and, in reality, there will be no great disparity between the two, but unless you recognise that disparity then you will never be in a position to make the best of your follow-up sessions.

PLANNING A VISIT - GENERAL

The success of an educational visit depends to a large extent on the planning and preparation. They are the foundation on which a visit is built. A well planned day for which everyone is well prepared is far more likely to be a success than one that is ill conceived and hastily organised.

A visit should be planned and confirmed before preparation (which is dealt with in Chapters 7 and 8) gets underway. You will find that some aspects of planning and preparation overlap. Distinctions are made here in order to be able to explore each aspect properly.

Planning and preparation act as opportunities to rehearse the visit and make adjustments and alternative arrangements to cope with mishaps on the day. They also allow for a comprehensive educational approach that will ensure the best investigations are devised. But excellent educational forethought will come to nothing if your logistics are flawed.

Even the best planning and preparation will not assist you if you leave things until the last minute. These things take time and the longer you allow the better. After all, there are many hundreds of other teachers who may have the same idea as you about making a visit, especially if there is a good specialist museum relevant to a particular aspect of the curriculum near to your school. It is best if you make arrangements and order materials at least a term in advance. That way, if what you want is not available you can make alternative arrangements and if things go wrong, you will have time to put them right.

STEP 1

The first thing you need to do is to decide whether a visit is necessary. Is a trip actually going to serve any purpose? Can what you want be done any better in the classroom? Given that visits in general are good things (arguments for which we have already rehearsed), that does not mean you should make visits at the slightest excuse. Visits are not good *per se*. Only good visits are good. You will, after all, only be able to make so many in a year. Resources are limited. So choose carefully to make the best of your limited opportunities.

STEP 2

Once you are committed to the idea of going ahead with a visit, get two folders. Mark them clearly with your name and your school's address. When you know the name and address of the venue you are to visit, add those details as well. Keep all your paperwork in one and a duplicate of all your paperwork in the other. One will go with you on the visit. The second should stay in the school office (or remain with a designated member of staff if you are away for more than the period of a school day).

STEP 3

Having labelled your folders, you will then need to ask and answer some very basic questions. Museum and other relevant websites may provide you with what you want to know at this early stage.

- What type of visit best suits your requirements? This will depend on a variety of circumstances – educational, financial and so on – as well as the experience of the pupils.
- When is a good time to go? Does the nature of what you are studying dictate the time of year or do you have more flexibility? One thing you should try to avoid is going when everyone else is out on trips, though this may not be possible.
- How far should the group travel? What distance can you cope with, especially if you are doing the driving? Take into account the full length of what will be a very tiring day a long drive at the end could be dangerous. Or, to look at it from a different perspective, what distance can the group cope with, bearing in mind you may have pupils prone to travel sickness? The cost of the journey is also an important factor for consideration. Can the journey itself be made interesting? You may actually pass places of interest to your particular study or be able to do some other form of work.
- Can your favoured museum(s) be reached and returned from in one day? If not, can you organise a week's work in the area of that venue?
- How long should be spent at the museum? This is very much tied in with the type of visit you are planning. Do not forget to include time for breaks and shopping.
- Could the money involved be better spent elsewhere or in some other way? That is, are there other places you could do something similar but at less cost and with fewer problems?
- Can other things be done or seen at the same venue? If you only want half a day, would other teachers want a half day at the same venue concentrating on some other work?
- Is the sort of venue you wish to visit dependent upon environmental factors?

This applies as much to the journey as to the venue. Weather, tides, holiday season and so on, can all impact heavily on the worth of a visit.

• Can you visit more than one place during your day out? Is that advisable?

STEP 4

Now that you have some of the basic parameters sorted out, you need to turn your attention to what is required of the visit. Aims and objectives will allow you to plan better and, afterwards, judge the worth of the visit. Some aims and objectives will be general to most or all visits and these can be gleaned from earlier chapters. Others, of course, will be specific to the work you are doing. Do not be tempted to make it a major aim of your visit that pupils will learn such-and-such set of facts. In the first place, this is based upon the assumption that the visit is an end in itself whereas it should always be part of a longer term strategy. It also ignores the problems highlighted by differences between intended and observed curriculum. This does make assessment of a visit's worth more difficult, however, if the assessment is just of the visit. If the visit is seen within the context of preparation, visit and follow-up, it makes assessment a lot easier.

STEP 5

Having decided that you want to go and considered some of your basic aims, you next need to finalise your decision about the best place or places to visit. It is now that you must apply the logistical and educational parameters you have delineated to those museums that are within distance. This should include information on transport costs and so on. If there is more than one suitable museum then draw up a short-list. If you are unfamiliar with these museums, it may be necessary to visit each of them before making a decision.

STEP 6

Once you are certain you know where you wish to take your pupils, you need to begin planning in earnest. Make preliminary enquiries of several transport firms about the availability of coaches, their cost and other terms under which they operate. Some coach firms, for example, will take you to your chosen venue and return you to school, but they will not let the coach sit in a car park all day. Make sure they know it is a provisional enquiry — you don't want three coaches turning up on the day. If it is a short journey and you are considering using public transport, check with the relevant companies that the number of children you wish to take can actually fit on one of their vehicles. Even then, be prepared for the fact that you might not all be able to get on the same vehicle on the day — other passengers use them as well.

STEP 7

Armed with travel information, you must now make a preliminary visit to the chosen museum. What you need to consider here falls into two categories. How to assess the museum in terms of preparing for the visit is looked at in Chapters 7 and 8. Risk assessment is dealt with in Chapter 6. The questions you need to ask and answer with regard to planning are as follows:

- Parking and access to the museum. Is there parking for your transport?
 If not, is there a convenient dropping off and pick up point? How far is
 the parking or drop off point from the museum? Will you have to cross
 any roads, walk through busy streets and so on? Walk any such routes for
 yourself and time the sections of the journey.
- What would be the best way to organise your group on arrival at the museum?
- Is there a museum education service? If so, talk to the relevant member of staff, who should be able to supply you with all the information you require. However, it is always worth following this up for yourself. You know your group better than anyone else. Make sure the museum is aware of any special needs your group may have.
- What are the opening times of the museum? Are these suitable for your purpose? If not, will the museum open specially for you? Will the galleries, objects, sites or whatever it is you require be available on the day you require?
- What are the admission charges, if any? Are there concessions for pupils, groups, educational parties and so on? Does a deposit have to be paid? Do you have to pay in advance, on the day or is the museum willing to invoice your school?
- Does the museum meet any legal requirements in respect of accepting children on to its premises and working with them?
- Who do you ask for permission to visit and how do you book? Can you
 make a provisional booking? How much notice is needed? Never leave this
 sort of thing until the last minute. Make a provisional booking at this stage
 if you can, because you can always cancel at a later date. Find out about
 financial penalties for late cancellation.
- How does the museum organise groups or expect you to organise groups? Is there a limit to the number of pupils you can bring? What numbers and adult to pupil ratio can the museum cope with? Are there established rules of conduct? Will there be other groups present at the same time?
- Can the museum separate your group from the public and other schools at any stage of your visit? Are there places where bags and coats can be left in safety? Is there an education room? Does it have to be booked separately?
- Where are the toilets, how many are there and are washing facilities adequate?

- Is there sufficient all-round provision for differently-abled pupils? How far from any stairs are things like ramps and lifts?
- If you are staying all day, is there somewhere adequate to sit and eat? Do
 not assume you can picnic just because it is fine when you make your
 preliminary visit.
- If you are working in the open, is there somewhere to shelter if it starts to rain?
- Is still and/or video photography permitted?

Whilst it might be possible to glean much of this from a museum's website, it is essential that you visit in person (see Chapter 18). Do not rely on your memory. Take notes, make sketches, buy site plans, take photographs and video (if permitted). You will need all this information to hand when you have returned to school.

STEP 8

Some sites are in private ownership and not open to the public in the usual sense of the word. If you wish to visit a site that is not obviously open to public access, check to see exactly who owns it and any access to it. It may be that the site you wish to visit is on private land or that you need to cross privately owned land to reach it. Do not be deterred by this. You must, however, seek explicit permission to walk on or through private property. If this is necessary, now is the time to do it. Ask in writing for permission and ask for a written confirmation of permission by return. Bear in mind that in rural areas, it is better to avoid asking to cross land at certain times of the year (such as lambing and harvest).

STEP 9

Use all the information you have gathered in your preliminary visit to prepare a detailed report of your intended group visit. Include the possible and probable modes of transport, route to and from venue, length of journey, toilet and rest stops, need for packed lunches, preliminary costs, your risk assessment and management plan and so on. Discuss this with other staff involved and with department heads and head teachers as necessary. It is at this point you should discuss insurance, the banking of money collected from pupils, the payment to the museum and the transport company and compliance with all other legal requirements. Your planning must take into account school administration, especially the staffing of the visit, the consequent effect of your visit on the school's timetable and the organising of work for those pupils normally taught by teachers accompanying the visit. Do not present your plans as a *fait accompli*. Discuss them with other staff, offer them benefits and invite them to participate. Having done so, listen to their suggestions and heed their requests where they will not interfere with the purpose of your visit.

STEP 10

Once you are happy with the shape of your plans so far, confirm your booking with the museum. Follow up with a letter (unless the museum has a different way of doing things) and ask for written confirmation. Make sure the museum knows the number of pupils and adults in your party. You must give details of any special needs your group may have. This does not only relate to such things as physical or educational disability but also to cultural and religious sensibilities.

STEP 11

Having confirmed your booking with the museum, you will now need to make a decision about transport. If a company is booked, try to get a commitment to a specific route as well as specific times. This makes it easier to organise the day and it means that you can inform school and parents of the expected return time. Also, if the transport providers agree to a specific route, then you can travel the route yourself and see if there is anything of interest for the pupils to watch out for along the way. If you know the transport company or the driver, it may be possible to arrange to return by a different route. Get confirmation in writing, with details of date, times, size of vehicle and cost. It is always worth keeping the names of other transport companies in your file as a back-up in case of emergencies.

STEP 12

If pupils are required to make a financial contribution (or voluntary contributions can be asked for) you must next cost the whole visit and break it down to a unit cost per pupil. Once that is done, the next stage is to work out how many adults you will need with you on the day. Adult to pupil ratios depend in part on the type of visit as well as the age of the pupil and the nature of the museum being visited. There will be a legal minimum. Your school or governing body should have clear guidelines on this. If not, or you are still uncertain, consult your union representative or office. They will be able to offer you advice.

STEP 13

Now it is time to go public with your plans. Make parents and pupils aware that the visit is to go ahead and obtain the necessary permission, information and money from them. If you are going to need voluntary help on the day, this is also the time to ask for it. To do this, write a letter on your school's headed notepaper to parents and guardians. Your school or governing body may have a standard way of doing this so find out. If there is no standard formula, you will need to write something along the following lines. Bear in mind that the requirements for charging outlined in the second paragraph may differ – this is the required wording for England

Anywhere School No particular Road This town
Teacher's contact number/email address
Dear Parent/Guardian/name
[l/teacher's name] wish[es] to take [my/their] [subject/tutor] group on a visit to [intended destination], leaving school at [time] on [day and date] and returning at [time] on [the same day/other date]
The trip will cost [price]. There is no obligation to contribute and pupils whose parents do not contribute will receive no different treatment from pupils of parents who do.
I would be grateful if you would fill in the form below giving your permission for [your child/pupils name] to go. Return it to [teacher's name] by [date]. Could you also indicate if [your child/pupil's name] has any condition that will require attention or a watchful eye.
During the trip we will need some adult helpers. Please indicate on the form below whether or not you wish to be considered.
Should you require further information, please contact [teacher's name]
Yours [sincerely/faithfully]
[Your name]
I agree to [pupil's name] taking part in the above mentioned visit. I have read the details and agree to them participating in any or all of the activities mentioned.
Signature of Parent/Guardian
Date
I do/do not wish to be considered as a helper on the day. Please add any other relevant information below.

Figure 5.1 Sample letter and consent form

and Wales. (Words in italics should be substituted with appropriate names, places, values, dates and so on – alternative wordings appear in square brackets).

With this letter you should send a single sheet outlining the reason for the visit, the day's events and all relevant details such as times, destination, route and so on. Include details of what pupils may *not* take with them such as computer games, personal stereos and so on, and disclaim all responsibility for loss of any items not specifically required for the trip.

STEP 14

When the permission slips are returned, place them in the folder that is to stay in school when you go out on the visit. With the help of school records, complete two copies of the following form for each pupil who has permission to go and each adult (including yourself) who is going on the trip. One set of forms is to be kept in the folder that is to be taken with you. The other set goes into the folder to be left in the school office.

Name:
Age: Date of Birth:
Class: Class Teacher:
Home Address:
Name of Parent/Guardian:
Address of Parent/Guardian (if different from above):
Telephone number (and name) where somebody can be contacted in an emergency during the period of the visit (give more than one if necessary)
1 2

Figure 5.2 Sample next of kin contact form

STEP 15

When you know the number of pupils going, you will know how many adults you need and can then, if necessary, contact those who have volunteered to help. You may have more volunteers than you need. Contact everybody who has offered their help and explain to any you do not need that this time you already have sufficient help. Be sure to thank everybody who has volunteered. Closer to the date of the trip, you will need to call a meeting of all adults (staff and parents) who are going to be with you on the day. Go over everything that is going to happen, discuss the pitfalls and make it very clear who is responsible for what during the day. It is important that everyone understands that, for them, it is not a holiday. Make each adult responsible for a specific group of pupils. Try to avoid putting a parent in charge of their own child. Split up problem pupils and place them with particular adults (preferably teachers). When composing these groups take into account the fact that certain children may need to work together on the day to complete projects. Do not load your non-teaching adult helpers down with responsibilities. You organised the trip. You are ultimately responsible on the day.

STEP 16

Check that timetables in school are rearranged as necessary and that staff (including peripatetic, special needs and other such teachers) know which pupils and teachers will be absent on that day. Let the kitchen supervisor and any other ancillary staff know as well. Some of your pupils may receive free school meals. Arrangements will have to be made for them to receive a packed lunch to take with them if you are going out for a whole day.

STEP 17

When you have done all this, double-check everything. You cannot be too careful – especially if there is more than one person involved in organising the trip. Never assume that something has been done. Get all organisers to meet regularly. At your final meeting you need to check the following:

- the number of pupils and adults going;
- that each pupil has parental permission to go;
- that everybody has a completed 'next of kin' form;
- that transport is organised and confirmed;
- that the route and any stopping points are agreed;
- that the museum is booked:
- that you have all necessary permissions and confirmations in writing;
- that all money is collected and all arrangements for payments on the day have been made:
- that pupils know they are going and that they have reminded their parents

or guardians;

- that all staff and adults who are going know they are going and what they
 have to do during the day;
- that your head, department head, all staff and others who are not going know that you are going;
- that you know what you are doing.

STEP 18

While you are doing all this you will need to make sure that the pupils going on the visit are well prepared. Just as with your own preparations there are two parts to this. Preparation in terms of skills and subject matter will be dealt with later on. Here we are looking at what they need to be told in terms of practical details for the day. Keep your pupils up to date with things as soon as you know the visit is going ahead. If you are planning a long time in advance, then you need to introduce things to your pupils at the appropriate time. If you do it too soon either their interest will wane or they will get fractious at having to wait so long. Leave it too late and they will not have time to adjust to the idea that they are going out. Prior to the visit, each pupil needs:

- to know where they are going and why;
- a map of the route with things to watch for (if necessary);
- · the name of the bus company being used;
- to know the length of the journey and any stops they may be making;
- to be aware of possible hazards and precautions they need to take;
- to know emergency procedures, particularly what to do if they become separated from the rest of the group or if they become lost;
- to know who is in overall charge of the visit and who is in charge of them for the day;
- if they are being taught by museum staff, the name of those staff;
- to know what to wear on the day;
- to know how much money they will be allowed to take;
- to know what other things they will *not* be allowed to take;
- to know general rules of conduct for the day (litter, no glass bottles and carrier bags, the Country Code and so on);
- · to know specific rules of conduct for the day;
- to know disciplinary measures for the day.

Concerning the final point, you might consider drawing up a simple contract for your pupils, though being barred from the visit should not be used as a sanction for bad pupils in the run up to the visit unless they are exceptionally disruptive. Visits are, after all, a socialising influence. Pupils with behavioural problems should be kept under special supervision.

STEP 19

If at any time during your planning, changes occur in the number of pupils, times or modes of travel and so on, contact the museum and the travel company immediately. They may be able to accommodate your changes, especially if those changes are small and you give plenty of notice. Large changes or those occurring close to the time of the visit may present a greater problem. Most problems, however, can be solved.

If you follow the above steps you should cover most eventualities. There will, no doubt, be special circumstances that need special arrangements, especially if you intend to be away from school for more than a day. However, they will fit within the overall pattern suggested. The important thing is to be methodical, keep a check on what you have done and not be tempted to cut corners.

PLANNING A VISIT – RISK ASSESSMENT AND MANAGEMENT

Risk assessment is exactly what it claims to be – the systematic assessment of the entire visit in order to identify potential hazards and ascertain potential risks to students. Risk management is devising strategies that dispose of or mitigate the risk by informing pupils of them or guiding them away from them. It sounds more dramatic than it is, for the most part, but it is nonetheless an essential part of planning a visit.

Statistically (in the UK, at least), educational visits are one of the safest environments for pupils. However, in recent years tragic and high profile cases have led to official enquiries emphasizing the need for formal procedures to be put in place that ensure the chances of such tragedies recurring are kept to an absolute minimum. Whilst accidents can never be wholly ruled out, it is possible to assess and manage risks during an educational visit. Indeed, the good safety record suggests that this already occurs and has done so for some time. Now, however, many educational authorities require that risk assessment and management are carried out on a formal and systematic basis with the results recorded.

As a teacher it is incumbent on you to know the general principles of risk assessment and management as well as the specific rules and requirements of your employing authority. If they do not have a risk management strategy in respect of educational visits, it would be prudent to devise your own based on best practice and to lobby for this to be adopted.

Teachers have always carried out risk assessments and devised plans to manage risk. They do it on an informal basis in their everyday teaching as well as during educational visits. What has changed in recent years is that the process has been formalised. Some see this as yet another layer of bureaucracy with yet more paperwork to validate something that is already done successfully. Whilst this argument has some truth, the formal exercise need not be time consuming and it can be used to enhance the educational aspect of the visit for students.

Museums and other venues may have produced their own risk assessment statements. These are useful as a basic guide, especially if they are validated by an external body. Museum staff know their buildings and sites better than you. Some education authorities may insist that these are the only establishments you patronise. However, such statements cannot take into account the individual

circumstances presented year on year by different groups of pupils and specific individuals within those groups.

The safety of the students in your care is clearly the prime motive for carrying out risk assessments and following up with risk management plans. But there are other equally worthy reasons for doing this. To begin with, it may be a legal requirement. This may seem a *fait accompli*, but given there are legal requirements it is at least worth considering what they are and why they are in place. Perception of risk and a visible means of demonstrating you take it seriously may help in garnering support for more educational visits. And the legal status (if such there is where you teach) is there for your protection as well as for the pupils.

Then there is the question of professionalism. It might be a cliché to say that if a job is worth doing it is worth doing well, but that doesn't make it any less true. Carrying out a risk assessment and formulating a management plan is, of itself, worth doing. But as part of the overall planning process it also increases a teacher's ability to create an efficient and enjoyable programme of work. To perform a risk assessment you need to look closely at the whole working environment presented during the visit. This level of focus inevitably highlights educational aspects and opportunities and, in creating a management plan, makes you consider how best to achieve your educational ends whilst keeping risk to a minimum.

In essence, assessing risk and subsequently creating a management plan is very simple. It requires focus and the application of common sense and it is worth spending extra time on the first phase, especially if the venue is new to you. There are four, sequential elements.

HAZARD IDENTIFICATION

Hazard identification requires you to assess the whole trip from the moment students gather at school to the moment they return. This may seem daunting if regarded as a whole, especially when you are considering so many other elements of the visit at the same time. Once you begin to break the trip down into sections, then consider and note down the hazards one by one, the task becomes a great deal easier. It is clear that identifying potential risks can only be done during a walk through of the visit. Not only does this ensure you miss nothing, it allows you to consider the actual sequence and assess where and how certain hazards group together (for example, if you have to get a group of students through a crowded thoroughfare and across a busy road). It also allows you to consider and note down alternatives routes and strategies, essential in making contingency plans.

This is the most difficult part of the exercise. Not only do you have to incorporate this with other demands of your preliminary visit, you have to strike a balance between assuming students have the sense to avoid more obvious hazards (which is not always likely if they are in places with which they are not familiar) and noting down every last possible risk, no matter how small. It is, of course, better to err on the side of caution.

Some of the more obvious hazards include: getting on and off public transport, moving through crowded spaces and crossing roads (all of which contain the potential for harm, for losing individuals or for the group being split); behaviour of students (trips induce excitement, especially in younger students, as well as presenting opportunities for those inclined to experiment with moral behaviour away from a normal setting – pilfering from shops is a specific example); stairs, high places, water, narrow spaces, poor lighting and other physical hazards at the venue; and so on. Many more that are specific to the journey you make back and forth (and students will be tired on the return journey as well as distracted by their experiences) and the venue you visit will present themselves as you investigate.

Keep in mind the fact that risk assessment doesn't finish once the paper exercise is complete. This provides you with a planned framework for the day, but you need to be monitoring students and events at all times during the visit. Expect the unexpected. Something, no matter how minor, will invariably happen that has not been planned for. Which is why having back-up strategies at the ready is essential. You cannot plan for every eventuality, but having a Plan B (and even a Plan C as well) provides peace of mind and allows you to concentrate on the task at hand.

PERSONS AT RISK

Risk management is about people, not objects. So, for each hazard you have listed you need to identify who might be at risk. In most cases it would be impossible to single out any individual so it should be noted that this is a hazard for the whole group. However, there will always be individual students more susceptible than others to specific hazards. Tall students and low doorways, for example, or those with mobility problems and stairs are more obvious and straightforward illustrations. It is not just physical hazards or risk of accidents that need to be considered. It has already been mentioned in passing that students with a less conventional notion of private property need managing in shops and around open displays. There may be students who fear heights, suffer from claustrophobia, have problems with hearing and sight who all need to be considered. It is vital, therefore, that a risk assessment (especially this part) is carried out by the teacher or teachers who best know the students.

LIKELIHOOD AND SEVERITY

Having identified who might be at risk and from what, you need to asses how likely it is that an accident or unwanted event will occur (easily expressed as 'low', 'medium' or 'high') as well as the likely severity of the consequences (again expressed as 'low', 'medium' or 'high' or indicated by using a scale of 1 to 10 if you need finer grading). How likely, for example, is it that a tall student will bang their head on the low doorway and how serious will that be for the student? This will, of course, depend on individual students and how they react in the

circumstances in which they find themselves. Assessing likelihood and severity allow you to pinpoint specific areas of concern and plan accordingly.

MANAGEMENT AND CONTROL

The final element is where all the preceding information is drawn together and measures are devised to obviate the risks that have been identified. There are four major approaches to management which often overlap. The first of these is planning. That is, you devise your programme of work for the visit so that you avoid, or make a feature of, the risk (depending on the nature of your work and the ability of the students to deal with risk). This is not always the most practical option. The journey to and from the venue does not much lend itself to this approach (although boredom can be alleviated with tasks relevant to the day); and at the places you visit, especially outdoor venues, the points of risk often coincide with those of educational interest. It is, nonetheless, worth looking at ways of programming these out (or in), not least because it makes you consider more closely the educational impact of each part of the visit.

The next aspect of risk management is pre-visit work with students. As well as educational preparation, students should be briefed on safety and what to do if things go wrong. In general terms there should be an agreed and appropriate code of conduct to which students are expected to adhere. They should also be given appropriate information about the visit (as should their parents), modes of transport, what they should and should not bring, specific areas of risk (couched in positive terms) and what they need to do if they find themselves separated from the group or otherwise feel themselves at risk. If students know what is going on during the visit and know the procedures, things are far more likely to run smoothly.

Many of the potential hazards to be found on educational visits can be countered with simple protective measures. Suitable footwear and clothing (especially if there are outdoor elements to your visit) are amongst the most obvious. You have to take into account the ability of students to provide these for themselves. Sun protection is another issue. If you are going to be outside for a large part of the day (or days) then headgear or sunscreen (or both) should be provided. Whether or not you would be allowed to administer sun block (let alone such items as aspirin or an individual's prescription medicine) will vary depending on the rules laid down by your employing authority. You need to be very clear on this and be aware of students with conditions such as asthma and epilepsy or who have allergies, intolerances and phobias.

Other forms of protection are less direct, but equally effective. Choosing safe modes of transport and walking routes; making sure equipment is safe and appropriate for your pupils; ensuring there are adequate facilities for resting, shelter, eating; and so on.

Finally, there is supervision. Here there are three interrelated aspects to consider. The first is the ratio of supervising adults to students. Some venues insist

on a minimum ratio, often varying this depending on the age of the students. Other factors need consideration as well, including the maturity of students and the nature of the work you intend to undertake. Safety considerations also have to be balanced with other aims of educational visits which may well include developing a sense of independence.

Allied to the ratio of adults to students, is the deployment of teachers within the group. Not all adult supervisors will have a teaching role. To ensure that students remain focused on their work (and thus have less time to wander into or consider misadventure), teaching staff need to work to a brief that ensures they remain in overall control of the visit and can direct educational work to best effect. A clear command structure should be in place and all adults adequately briefed as to their role and who to go to with queries and problems.

Along with the need for formal risk management of educational visits, more general concerns for child protection have led in some places to strict requirements for the vetting of all adults working with students. Even if there are no legal requirements in place, this is an issue of which you should be aware. You have a duty of care to your students and need to know that any adults working with them are trustworthy and responsible – be they museum staff or voluntary helpers. This is a sensitive issue, especially when it comes to parents offering their time to help during visits. It is to be hoped that your employing authority will have guidelines for you to follow.

All the above information can be collated onto a simple form such as follows.

Hazard	Persons at risk	Severity (L – M – H)	Management and control

Figure 6.1 Sample risk assessment form

This is not only a record of the fact you have completed a risk assessment and created a management plan, but also a handy reference for others. It can be used for briefing other adults about the visit and can be referred to in the future, with generic sections forming the basis of new risk management plans for the venue in question.

Having formulated your plans for the visit it makes sense to go back over them and look for major variables that could effect radical alterations. What happens, for example, if a member of teaching staff (or an assistant) calls in sick on the day? If you are relying on public transport, do you have plans to cope with changes to the timetable? If your visit has an outdoor element, what do you do if the weather is exceptionally hot, cold, wet or windy? Such contingencies are unlikely, but they

can and do occur. Having a Plan B (or, in reality, a series of Plans B) means you can cope with major last minute changes or upsets.

In addition, you need to consider emergency procedures. Rather than variations to the day, these are for worst-case scenarios – accidents, students going missing or seriously misbehaving, major external incidents and other events of that nature. Your employing authority should have established procedures for these, especially in respect of harm coming to your students, and they need to be incorporated into the pre-visit briefing of supervisory staff.

As mentioned earlier, risk assessment and management is not just a paper exercise to feed into overall planning. Anyone who has led or participated in a visit will know that both the group of students in their charge and the world into which they venture are dynamic. Both change constantly as do the interactions between them. The plans you have made will provide a good foundation for the visit, but constant vigilance is essential and many on the spot decisions will need to be made. The firmer and more comprehensive your planning, the easier this will be.

When the visit is over, it is important to review all aspects. In terms of risk management, it need not take long. Informal chat with teachers and other adults on the journey home or over a mug of tea on return will usually be enough to assess how the day has gone and how well the management plan worked. A summation of this assessment can be added to the management plan forms along with any recommendations for changes to be made for future visits.

PREPARING FOR A VISIT - THE TEACHER

Visits to museums, even if they are well planned, can all too easily lack coherence and clear purpose. The reason for this is very simple: the visit has not been properly prepared. Preparation is just as important as planning. A well prepared visit is fully integrated with classroom work and skills, and allows pupils to participate before, during and after.

In order to prepare pupils properly, teachers must themselves be thoroughly prepared. The level and degree of preparation (that is, what you need to know and how much) will depend to a large extent on what the museum can offer and on what you are intending to do. However, there are certain general principles that ought to be followed to ensure you cover the ground properly.

A preliminary visit to the museum you intend to use is essential. This point has already been made in respect of planning. It is equally important in respect of preparation – investigation for both can take place at the same time. To give yourself sufficient time to investigate everything, a preliminary visit is best made over a full day. If you cannot manage a full day or a series of shorter visits, you must at least visit the museum before you take any groups there.

As with all such work, it is far better to work methodically to ensure you miss nothing. The following six steps offer a useful way of assessing a museum that is new to you.

- Introductory. Let the museum know you are there, who you are and why you are there. This is best done in advance as it will give the museum time to respond to your needs. It may be that you have arranged to meet a member of the museum staff if you have, make good use of them. Have questions ready to ask and relevant information about your group to hand. Even if you get most of the information you need from museum staff, stick to the rest of this outline and investigate for yourself.
- Familiarisation: Get to know the museum in a general sense. Do not worry about the specifics of your visit at this time. Enjoy the place, have a good look round, chat with attendants and shop staff to get a general feeling of the atmosphere of the place. Take a whole morning if you can afford it. If there is more than one of you, go round separately this increases the chances of exploration turning up things you may miss if you go round as a unit.

- *Digestion*: Take a long lunch break and digest what you have seen. If there is more than one of you, this is the time to gather, compare notes and discuss the place.
- *Orientation*: Now is the time to think of the logistics of the day. Sort out your group's route around the museum, assess likely problem spots, locate toilets, education spaces, places to leave bags, coach parking and so on all the logistical details dealt with in the previous chapter.
- Focus: Now that you have worked out the logistics you can focus on the reason for the visit. Based on the morning's familiarisation, decide on which areas you want your group to concentrate, study the displays and artefacts, and work out what supplementary material you might need.
- Conclusion: Sit down and check that you have all the information you need. Make a list of questions still to be answered. See if you can get them answered by a member of staff before you leave the museum.

In addition to the information you require for planning the day, there are other logistical considerations to be made that relate more to preparation than to planning.

To begin with, some museums require teachers to make a registered preliminary visit or attend a certificated induction course before allowing them to bring school parties or use loan material. If this is the case then get yourself registered as soon as possible. Do this even if you do not immediately intend to take a group. Even if the museum is not so strict about educational visits, it may run general in-service courses for teachers. Take advantage of these as they offer an excellent opportunity to establish contacts with museum staff, explore behind the scenes and discover any hidden educational treasures.

Familiarise yourself with the layout of the museum as best you can. This is more than just finding out if there are toilets. It means knowing where they are and how to get to them from any part of the building or site. This is especially valuable in large establishments that have many galleries, but do not assume that small museums are any less of a problem. Neither you nor your pupils are on familiar territory and it is easy to get lost. That is why a morning spent wandering about is so valuable. It decreases your chances of becoming disorientated when you have a group with you. It also makes it easier to deal with emergencies.

In your planning, be prepared for such things as the presence of the public and other school groups, artefacts you wish to work from having been removed, whole galleries closed and so on. Even if you check on these things, the unexpected can still happen. It is easier for museum staff to appreciate why you require access to specific areas or objects if they are well briefed about your requirements and objectives. Liaising with museum staff is always to be recommended. They know what they are talking about and they want your visit to run smoothly – if only for their own convenience. If they know what you want they can warn you of problems if they arise and point out resources you may have missed. And if they give you something to read, read it and act accordingly.

Despite all the assistance that museum staff can give you, you are the one who knows what your pupils are capable of. It is up to you, therefore, to assess museum produced educational materials and the displays and interpretation that your pupils will be working with. In particular, labels and other such explanatory texts in the museum need to be looked at carefully to see whether or not pupils will be able to make use of them. The same is true of interactive displays and computer technology which need very careful investigation prior to use by pupils if they are not simply to be played as games. As a general rule, use computers for follow-up work – use museums to teach and practise other skills.

When assessing the museum it would be useful to ask and attempt to answer for yourself the following sets of questions. Not all of them are relevant to all types of museum. Not all of them will be relevant to all visits. Not all of them will be relevant to the age of the pupils involved. Taken together, however, they provide for a reasonably comprehensive survey of the museum.

- Could you use the museum to teach any subject or topic other than the one you intend to use it for? How does it fit in with the cross-curricular subjects, skills and themes?
- Is the museum stimulating? That is, will the museum, of itself, stimulate pupils in the way you want? If not, can it be made stimulating by careful preparation? If so, how?
- Will your pupils be able to see what you want them to see? Are artefacts displayed at an appropriate height? Is there enough room for the whole group to see things or will they need to be organised into smaller units? Are there better examples elsewhere in the museum? Is the print on labels and text large enough?
- What is the reading age of any text you might want to use? Is it entirely appropriate to your needs? Does it contain vocabulary to which pupils need to be introduced?
- Is there an appropriate balance between text, illustration and artefact? If not, what can you do to counterbalance the effect?
- Are there any alternatives to the museum text, such as audio-guides or guidebooks written for children? Would such alternatives be practicable?
- Would you rather avoid investigation based on museum text? What alternatives are open to you?
- Will pupils need knowledge of specialised techniques such as archaeology, conservation, metal-working, architecture and so on, in order to understand the museum?
- Are artefacts in the museum displayed in chronological order? If so, can this be used to introduce and consolidate the concept of chronology?
- Are other concepts such as cause and consequence, continuity and change, dealt with in any way? Would it be possible to use the museum to look at these?

- Does the museum make extensive use of real artefacts, documents and so on? Is it clear when and why replicas and facsimiles are being used instead?
- Have the artefacts on display been set in any kind of context? How has that context been created? Does it enhance or obscure the artefacts in question?
- Is there a single approach to the way in which the museum displays and interprets artefacts or have different approaches been used? Which of these approaches would you prefer your pupils to work with? Do you have a choice?
- Is the content of the museum explored from a variety of perspectives? That is, does it look at more than one of the cultural, social, spiritual, religious, aesthetic, scientific, historical, archaeological, technological, political and economic facets of an artefact or collection?
- Does the museum assert or does it question? That is, does the museum simply offer a single interpretation or does it offer choices and question current ideas?
- Are issues tackled or does the museum stick to facts and events? If issues are looked at, are different perspectives employed? Is any attempt made to distinguish between facts and opinions?
- Does the museum try, in any way, to show how objects can be used as
 evidence and how they can be investigated to increase knowledge and
 understanding? If not, could it be used in this way with appropriate
 preparation?
- Is the museum honest about the extent and nature of the evidence upon which it makes its interpretations? Does it make clear that interpretations evolve as new evidence becomes clear and that sometimes competing interpretations exist?
- Does the museum itself look at the workings and the role of museums? Could the museum be used to consider these issues?

Although these questions cannot cover every angle, their intention is to get you to explore the resource thoroughly. For that reason they should not be neglected, even if you think you know the answers. There will, no doubt, be more specific questions that you wish to ask about the museum. Most of these will relate to the specific work you intend to do. However, other more generalised ones may occur to you, especially in respect of the methodology of specific subjects.

Once you have satisfied yourself that your exploration of the museum is sufficient to the task ahead of you, you can begin to prepare the work that will lead up to and be carried out on the day, along with an outline of the sort of follow-up you want done. Once again, the specifics are dependent upon what you are studying, but there are some general points worth remembering when you are making your preparations.

Keep in mind the level at which your pupils are and prepare accordingly or, if you intend to use the visit to bring them up to a new level, give yourself sufficient time to do this. If you rush your pupils, the lessons to be learnt on the day could well be lost because they are insufficiently equipped. It is, therefore, wise to try to build a series of evaluations into your programme of work so that you can monitor effectively whether or not pupils are adequately prepared for the visit.

Be clear, also, about the content of the day's activities and what you hope to achieve. You cannot afford to be vague otherwise the day will have no shape or impetus. If you do not know what you want then you cannot expect pupils to know. The best visits are tightly controlled. Tight control can, however, leave plenty of leeway for pupils to explore on their own.

No matter what wonderful things a museum might have, do not be seduced into using them just because they are wonderful. If they are not relevant then forget them. You must start from the work the pupils are doing and use only that to which they can relate.

The work that pupils are doing is not necessarily under your control. Secondary teachers should liaise with staff in other subject areas who may wish to have an input in the visit. Many subjects and aspects of subjects can be covered without intruding upon your reason for taking them out. For example, ask the English Department if there are any pieces of literature relevant to the museum you are visiting or the topic you are doing; perhaps the Geography Department would like pupils to do an orientation exercise during the trip there and back; and so on. Primary teachers should not forget to consider other aspects of the curriculum either.

Remember that what you are best able to do on a visit is look closely at the evidence that will enable students to undertake a reconstruction of objects, events and motivations. Do not overload the day with text based exercises. Try to stimulate all five senses and get pupils to use them to gather information. Collect as much raw data as you can so that you have plenty to follow-up with when you return to the classroom. Make the work activity and discovery based and do only what can be done at the museum. Work that can be done in the classroom should be left to the classroom.

Do not try to force your way of working or your idea of what should happen on your pupils. Children get little or nothing from working to adult conceptual frameworks. You must let them explore and answer the questions they have. Be prepared to teach less and share more — particularly the pupils' observations and ideas. The best way to accomplish this is to allow pupils to design their own investigations to be carried out during the visit and followed-up in the classroom afterwards. Not only will they get a great deal more from it in educational terms but they will also have a vested interest in the success of the day.

For all that you want a well structured day with lots of activity, leave your pupils time to appreciate where they are and what they are working with. Give them time to look for themselves, time to explore and make the connections that are important to them and their scheme of things and time simply to contemplate. Contemplation, after all, is as legitimate a working activity as reading, writing,

calculating and making. Remember, though, that pupils will have to be taught how to do it just as they have to be taught how to read, write and so on.

As well as allowing space in your structure for contemplative activity you must also ensure your structure is flexible. That is, you must allow for spontaneity, but this does not mean loosening your control over the day. You should not allow spontaneity to railroad your objectives any more than you should let the structure stifle interest. Like all balancing acts it requires constant monitoring.

Give pupils an opportunity to forge an emotional and imaginative link with what they are studying. Once hooked, they will, increasingly, wish to learn more and will allow their imagination to be disciplined by the evidence they gather. You only have to think of children and dinosaurs. Imagination is what captures them – some then go on to absorb and understand an incredible (sometimes formidable) amount of knowledge.

Be selective. Focus on particular things. You will not have time to explore a great deal in depth. It would be far better to spend part of the day constructing a context so that the rest of the day can be devoted to an in-depth look at one or two narrowly defined aspects of your field of study. If your pupils have been designing their own investigations, you can cover a lot of work. It will then become a part of your follow-up for pupils to report to others what they discovered during the visit.

Try to build quiet times into your visit. These are especially useful if there is a lot of activity going on. You can call the group together at various times to monitor what they are doing and to calm them down. This will help you to keep control of all aspects of the day. It also means that pupils work at a reasonable pace for the day and do not tire themselves out before they have finished what they set out to do.

Finally, aim to make the day a joyful one.

PREPARING FOR A VISIT - THE PUPILS

Pupils also need to be prepared. You cannot assume that they will automatically get a lot out of a visit simply because it is a visit. If you do assume that learning will happen then you may fall into the trap of doing little or nothing to make it happen. What is more, you cannot visit a museum in the belief that children will understand merely as a result of the visit. Museums are not that type of place. Museums are places that contain the evidence pupils need to help them understand. Preparing pupils for a visit must, therefore, be much more than a brief orientation exercise.

As with your own preparation, there are two basic areas that need to be covered. To begin with, pupils will need to be made aware of the practical elements of the visit required on the day. That is fairly straightforward. Preparing them to cope with the work that needs to be done during the visit is much more difficult. This is not because the work you are going to set will necessarily be complex. It is just that there are so many aspects to that work for which they have to be prepared.

The content of the work you intend to do is, of course, something that cannot be covered by this book – you are on your own there. When it comes to the ways in which you can approach that work, however, there are guidelines that can help you prepare a successful programme, one in which the educational use of the museum is developed sensibly, holistically, comprehensively and in accordance with a basic structure. This ensures that projects within the programme occur in a logical sequence and provides a definite set of objectives against which progress can be measured.

Inherent in the programme of work you devise should be three underlying aims. Firstly you should try to instil in pupils a proper reverence for museums. The emphasis is on the word 'proper'. Museums should not be revered simply because they are museums. Secondly you should try to provide pupils with the requisite skills for using the museum to its fullest extent. It is of no use visiting museums unless pupils are first taught how to use them effectively. Finally you should be aiming to provide pupils with the confidence to use museums, not just as pupils but as life long users.

Education is a condition of human existence. It does not take place only in formal, guided sessions. Every aspect of a visit to a museum has educational potential – from finding the building to visiting the souvenir shop before leaving. Every aspect of a visit should, in that case, be given careful scrutiny to ensure that where educational potential exists, it is fully realised in accordance with genuine need.

The visit should not be pushed upon pupils in an aggressive manner. Too much attention on the visit itself will falsely distort it, making it seem the be all and end all of their learning. It is a very important component and you may well be basing a whole term's work around it. However, if you push it too hard it will be at the expense of classroom work. At all times, the visit should be seen as an integral part of the programme of work you are doing.

Pupils should also be encouraged to feel comfortable with the idea of making a visit. For some it can be such an intensely exciting experience that they are unable to maximise its educational potential. For others it is merely a day out of school. In all cases it needs to be brought into the mainstream of their educational experience. Not only will this help to dispel something of the mystique of museums, but it will also broaden pupils' educational base.

One of the major objectives of any preparatory work is ensuring children can work with material other than the written word. Specific skills for this will be explored in the next section of this book. At all times, however, you will need to rid pupils of the creed that something is true because they read it in a book (surprisingly prevalent – even in our decreasingly literate society). The obvious approach is to investigate how the author of any book gathered his or her information. Ultimately, the author is working from experience, either as a witness or by exploring the material world. In other words, your pupils are going to have to become explorers and witnesses.

To do that they may need to do a lot of ground work. As always, start from where they are and work towards where you want them to be. This will involve various levels of readiness, some an extension of normal school work and others an introduction to new skills. These should bring them to a level of readiness to conduct the visit; to do the work during the visit; and for follow-up.

To begin with you have to ascertain whether your pupils have appropriate levels of skill in language, basic mathematics, information gathering and recording, information processing, problem solving, organising work, communication and social skills sufficient to the task. If they do not, how do you intend to improve them in time for your visit? Or perhaps you are taking them to help improve these skills? Whatever your intention, it is important to remember how much the success or otherwise of your visit depends on them.

As well as the skills that are relevant across the curriculum it is also recognised that certain areas of different subjects have much in common and can be considered as cross-curricular themes. Some of those that have been suggested are economic awareness, consumer affairs, health education, politics and current affairs, information technology (as a social phenomenon), media studies, careers education, industrial awareness and environmental issues. Once again, you need to consider how these relate to the work you plan and whether or not your pupils are capable of appreciating them.

In addition to the curricular skills they will need, to what extent are your pupils prepared for working in the field? Even if they have been on trips before,

this does not guarantee they have the skills they may need for what you have planned. For example, have they ever had to work on clipboards before? This is not a major issue, but if they have not then they will need practice before they can do it effectively. You only have a short amount of time at the museum you are visiting and you cannot afford to waste any by having pupils fretting over unfamiliar working practices. The same is true for making field sketches, recording information, filling in worksheets and so on.

It is important that pupils have some understanding of what a museum is. The reasons are the same as those we have already considered. In your case it was to explore more precisely what you may already have vaguely known. For pupils it may be a much more basic exercise and something they may never have considered before. This is not to say that you should, in the first instance, attempt any degree of sophistication in their understanding but it is important that they can distinguish between what is and what is not a museum and why it is that some things have been thought worthy of preservation (indeed, that those things are the 'real thing'). In the same regard, many of the other questions I have suggested worth considering should also be addressed by your pupils.

As an extension to this, do your pupils know the basic principles of archaeology? As for that, do you? If you do not, go and find out. Much of what you encounter at a museum will have an archaeological context and your pupils will have questions that can only be answered from an understanding of archaeological principles. This does not imply you must have a degree or field experience in archaeology. But you should know something about locating and surveying sites, techniques and features of excavation, stratigraphy, finds, recording, environmental evidence, analysing artefacts and dating.

Archaeology is a good example of a cross-curricular subject as it provides an excellent basis for work that interests pupils while bringing together aspects of a great many subjects. It combines the sciences, humanities and arts; the exercise of intellectual and intuitive faculties; practical and theoretical work; and provides the opportunity for pupils to be involved in work that is original and which provides concrete results.

As well as preparation in educational skills and educational content, pupils need to be prepared for the practicalities of the day. Give the group a number of briefing sessions before the visit. Make sure they know the details of the day and the rules and regulations to be observed. Keep these sessions simple otherwise they will become confused. Keep rules as few as possible and as simple as possible for the same reason.

As with field skills, make sure your group knows how to do basic things like walking in twos, gathering as soon as they are called, conforming to socially acceptable standards of behaviour and so on. You also need to have an agreed procedure for crossing roads. These are easily practised in and around school.

Details of what pupils should bring on the day should be given several times and written down in a letter for their parents or guardians. Again, keep this as simple as

possible. If pupils have to take too much they will fuss about it during the visit, thus decreasing their capacity for work. Although details will differ from visit to visit, pupils should be encouraged to bring:

- sensible/appropriate shoes sandals are no good for a farmyard, wellington boots no good for a stately home;
- sensible clothing a waterproof is a necessity (even if your visit is taking place in the longest drought on record remember Murphy's Law);
- one sturdy bag for hand luggage such as lunch, a waterproof, a pullover and so on discourage the use of plastic bags.

At the same time you should stress that there are certain things that pupils must *not* take. Do not allow radios, personal stereos, computer games, binoculars, expensive cameras (still or video) and so on. Insist that mobile phones and PDAs remain in their pockets. Disclaim all responsibility for all equipment not specifically required for the visit. You should also discourage children from bringing breakable thermos flasks and eating food or drinking at any time other than the specified meal time(s).

Finally, encourage conservation. Museums, by their very nature, are sensitive. Make sure all your pupils know the Country Code; that the taking of 'souvenirs' is forbidden; that climbing on ruins can cause damage to ruin and pupil; and that the throwing of things over parapets or bridges is highly dangerous. Do not simply lay down the law. Encourage pupils to discuss such matters and come to their own conclusions. In that way they are more likely to remember and understand why these restrictions exist.

If and when you decide upon a 'Code of Conduct' for pupils – be it through discussion or unilaterally – you might want to consider drawing it up in the form of a contract that pupils have to sign. If they keep to it they go on the next visit. If they break it they are under review (although, as I have already mentioned, be wary of withdrawing a place on a trip as a sanction). Make any such contract appropriate to the age group going on the visit, the work they are doing and the place they are visiting. After all, it would be a wasted exercise if you produced a set of rules that it was impossible not to break.

THE VISIT

Having made all your plans, completed all your preparations and having brought your pupils to the correct level of readiness, the day will dawn when you actually make your visit. To keep best control over the day's events you should ensure that everyone knows exactly what they have to do. This will leave you free to conduct events and keep your eyes and ears open for the unexpected. The best way to keep control of the situation, of course, is never to let anything get out of control. That is far easier said than done, but it is possible and with experience it will become easier.

If you are new to your job or your career, make sure you have, if at all possible, an experienced member of staff with you. This is an extra piece of insurance and it may be one that your school insists on during your first year of teaching. Once you become experienced at visits you can turn this round and ask that new members of the profession accompany you so that they might gain the experience and confidence to conduct their own visits.

Your role on the day, with the help of the other adults, is threefold: organisational, disciplinary and developmental – in that order. That is why planning and preparation are so important. If you are being taught by museum staff then your disciplinary role is expected to be 'back-up', not interjectory. Let the museum education staff get on with their job. They do know what they are doing. Above all, show an interest – your pupils can tell if you do not. Participate in any activities but keep quiet unless *you* don't understand. And no matter how uncharacteristically quiet they may be, do *not* feed answers to your pupils.

Finally, a note about responsibilities. You know the students, the museum does not. Although museum staff may undertake to provide various services, even teaching, you must be clear that responsibility for pupils rests ultimately with you and the other adults in your party. The aim is to ensure that you and your group benefit fully from your visit while ensuring that other visitors to the museum (as well as the museum's non-teaching staff) are not incommoded.

For a smooth running day, the following steps are suggested.

1

Identify all pupils who require medication or attention during the day as well as those who are prone to travel sickness. Before you leave school, gather all the pupils who are going on the visit in one room. Ensure that those who require medication for

travel sickness have taken it or take it now. Do not leave this until you are about to get on the coach as such medication needs time to take effect. Make sure, especially with younger pupils, that they have been to the toilet before you set out.

2

Check that everyone is present from your list of those who have permission to go. If there are absentees, remove their 'next of kin' forms from *both* folders and write across them, in red, 'Absent on day'. Place these in an envelope and leave with the folder that is to stay in the school office. At the same time, cross out the names of absentees on your master list and the lists of those in charge of the children on the day. Make sure everybody is aware of the final numbers.

3

Take the duplicate folder of paperwork to the school office and hand it *personally* to whoever has agreed to be responsible for it for the duration of the trip. Do *not* leave it on their desk or ask someone else to pass it on for you. If you are going to be away for more than a day the person nominated must keep the folder with them at all times and you must have a way of making contact 24 hours a day. The first page of the folder should be an abstract of information – where you are going, how, when you expect to return and so on. The second page should be a list of all pupils, teachers and other adults accompanying you. This should be followed by next of kin forms.

4

Return to the group. If you are going to use them, distribute name badges and make sure everyone is wearing one. There are arguments for and against this. They can make young children vulnerable to unscrupulous adults. On the other hand, museum education staff can make instant contact with pupils if they know their name. The use or otherwise of such forms of identification may already be a matter of school policy. Discuss it with senior staff before deciding.

5

Make sure you have with you the following things:

- A bucket, a packet of paper towels per class, disinfectant and some damp cloths in a plastic bag in case anyone is travel sick during the journey (if you can stretch to it, a container of water is useful as well);
- a first-aid kit;
- packed lunches for those on free dinners;
- your trip folder;
- sufficient money (or sufficient cheques make sure they are signed) to pay anyone who needs to be paid during the day;
- plenty of loose change for toilets, telephones and such like;

- dustbin liners for litter;
- an emergency kit containing safety pins, string, safe scissors, adhesive tape, housewife, tissues and, if you have pubescent girls in your group, it is wise to be prepared for those whose menses take them by surprise;
- your own packed lunch, waterproof and so on;
- a large-scale map of the area you are visiting (this is optional but can be useful);
- mobile phone (make sure it is fully charged).

6

If you have hired a coach, make sure that each person knows where they are going to sit before they get on. Travel sickness sufferers should be at the front. Be sure all pupils know that they should get on and off the coach or other forms of transport in an orderly fashion and that when they get off they go first to their group leader to be counted and then, when told, they line up in whatever order you have arranged.

7

While on the coach make the opening of ashtrays, ventilation ducts and emergency doors, playing with lights, and eating and drinking absolutely forbidden.

8

During the journey, make sure that pupils stay in their seats. Moving about is dangerous and can cause travel sickness. If someone is sick, try not to make a big deal of it – it is psychologically infectious.

9

Make sure that pupils have something constructive to do. Observation games (of which there are many variations) are best. Although singing is a favourite, check with the driver and, in any case, save it until the end of the day. On the outward journey it can set the wrong tone for a hard day's work.

10

Time the length of the actual journey. If it is much longer than you had planned for (because of unexpected road works, for example) you may need to leave earlier to get back to school on time. If you cannot, because the coach was pre-booked for a set time, for example, then telephone your school and advise them of your new expected time of return.

11

On the day of your visit, try to be as prompt as possible (and as traffic will allow). Some museums work to a tight schedule and need to start on time, especially when they have more than one school on site. If you are walking at any stage of your journey, allow plenty of extra time for this.

12

When you arrive at the venue, unload and check with the driver of the coach where and when you are being collected. You may have checked this with the company, but it always pays to check with the driver as well. If there is a problem it gives you time to sort it out. Remove all your belongings from your transport unless you have made prior arrangements with the travel company.

13

Never, at this stage, say, 'Does anyone want the toilet?' They all will and at least half an hour will be lost. Deal with the desperate ones on an individual basis.

14

Once the group is counted, lined up and you have double checked that everyone has their belongings with them, move the group to your starting point for the day. If you are lucky, this will be a room where the children can leave their belongings while they are working.

15

If you arrive early for an appointed start or you are not met on time, do not let your group drift to the nearest swings, sweet shop or piece of shade. Make provision for such a hiatus.

16

Before you set the group to work, remind them of their responsibilities (for example, not going anywhere without the consent of an adult); remind them of emergency procedures for the day (for example, what to do if separated or lost); and remind them of what time and where they are to reassemble.

17

Set the group to work. Ensure that pupils can be observed by an adult member of the party at all times. Make sure you break the day into distinct sections so that you reassemble several times. This makes things easier to control and allows you to check progress and assess how the day should move forward if you have some inbuilt flexibility.

18

Stick to your timetable for the day. Make frequent checks on numbers, on everybody's progress, on behaviour and on any equipment you may have brought with you or borrowed at the site.

19

When you gather for lunch (if you are staying that long), give pupils time to eat and digest, time to use the toilet, go to the museum shop and let off steam or relax. If you do not allow them this time, afternoon work will be much more difficult.

20

Make sure that any litter your group produces during the day goes either into receptacles provided at the museum or into a large rubbish bag of your own that can be taken away and disposed of elsewhere.

21

If students are making use of a room within the museum for lunch, confine them to that room and the toilets. Do not allow any food or drink out of that room under any circumstances. Make the rest of the museum out of bounds for the lunch break.

22

If pupils wish to visit a shop, keep them in small supervised groups and do not allow them to take bags in with them. Shoplifting by pupils is a sad fact of life. This does not mean that your pupils will do this, but it is expedient to reduce the opportunities for them to do so.

23

Try, if you can, to make the afternoon session of a full day trip shorter than the morning one. Also, try to make it different in tone. Perhaps, if your pupils have been following very structured tasks in the morning, the afternoon can be given over to a more fluid structure in which they can follow-up things of particular interest discovered earlier in the day.

24

Before you leave, make sure that you and the group thank their hosts. If there is no one present to thank when you leave, a letter or letters of thanks would be most welcome. Make sure that everyone is on the coach along with everything you brought with you.

25

When you arrive back at school, make sure that you and the group thank the coach driver and any adult helpers.

26

If you return to school later than normal dismissal time, make sure that every pupil can get home safely. If prior arrangements have been made, make sure that they are all fulfilled. Do not leave until you are certain everyone has gone safely on their way.

27

Go home, put your feet up and have a cup of tea. You will have earned it.

This completes Part II. By now you have been introduced to most of the skills necessary to plan, prepare and carry out a visit to a museum. Before moving on

to the next part in which we look at ways of working with what you are likely to encounter during a visit, choose a museum that you have never visited before and spend as long as you can there — all day if possible. As before, use the opportunity to look at the museum with new eyes and begin to think about how you can work to best effect with what you see on display.

USING THE RESOURCE

WORKING ON OR WITH A SITE

Working on a site and recording as much relevant information as you can in a given amount of time for use in follow-up work, is an approach to understanding the past in which pupils can be actively involved and actually contribute to the pool of knowledge and understanding. Observant children have been known to spot things that archaeologists and others have missed.

A site is a defined, open area that is the location of a place or event of historical or social significance containing physical remains of interest. It can vary in size from a few square metres to a whole landscape, in age from decades to millennia and in complexity from a Bronze Age barrow to a town in continuous habitation for the past two thousand years. Sites can also be dormant or actively under investigation by archaeologists and other such professionals.

There are, of course, complexities and overlaps. An earthwork surrounding a hilltop is obviously a site, but there are others that are not so well defined. This may be, for example, when a site or part of a site is so sensitive to the elements that it has to be protected by a large modern structure or building. Sites may also contain buildings in various stages of decay. Working with such structures, whether ruined or complete, is examined in the next chapter, but they cannot be fully understood without a consideration of their physical setting. Archaeological sites may well also have yielded finds that are displayed elsewhere. These artefacts should also be looked at as part of working with a site.

Archaeological or historical sites can also present specific problems connected with the scale of the resource being used. Small group work plays an important part here. Indeed, it probably makes more sense from a purely logistical point of view than trying to keep a large group together in one place. In respect of information gathered, it is much more sensible to have several groups working on different aspects of a problem or covering different areas of the site. Not only do you cover more ground – metaphorically and literally – you are also establishing the basis for sound follow-up work. Groups will have to report back to one another and the information they have gathered will have to be collated to create a larger picture than any individual group could have created.

There are many elements to a site that can be considered by individual groups. Environmental aspects influencing why a site and its contents are where they are, its layout, changes over time, the sources of building materials and the sources of materials such as food to sustain the site (assuming it was a place of habitation),

can be partly investigated on site. Theories with regard to these things can also be tested. Archaeological excavation will normally be outside the scope of what you should be doing. But the excavations of others should be looked at. If you are lucky, there may be an excavation taking place on the site you wish to visit. If so, try to make arrangements with the director of the dig for your group to have a closer view of what is taking place. And, whatever else you might do, you should always consider surveying the site and recording your finds.

When it comes to deciding whether or not you want to go for site work and, if so, what sort of site will best suit your needs, there are no easy guidelines or hard and fast rules to follow. You will have to learn what is best from experience although others, such as staff at your local museum, may have useful advice. Ultimately, the decision will rely more on the nature of the work you are doing than on the nature of what you are working with. It is, therefore, wise to approach a site with more than just the skills outlined in this chapter. And to begin with it is best to go for those sorts of site where you can keep tight control of your group and of the investigative work you set out to do.

Given the complications inherent in working on an outdoor site, it might well be asked whether it is worth the effort. All sites have their merits and drawbacks, but in the end the answer can only be yes. After all, not all sites are inaccessible, large or difficult to interpret. A consolidated ruin that has a good surviving ground plan has the potential to provide a wide range of work and a great deal of information for follow-up. Sites like battlefields should be used with more experienced pupils as they require considerable skill and experience to interpret.

Site work can involve all sorts of approaches depending on what results you seek. In essence site work is a discipline that brings many individual subjects to bear on the task in hand as well as tying in with other cross-curricular approaches such as environmental studies. It involves pupils in thinking and problem solving, hypothesising, testing their hypotheses, using abstract concepts and concrete ideas, doing paperwork and practical activities together in a field of study that combines the sciences, social sciences, humanities and arts, and which blends the physical, intellectual and intuitive in a well balanced, synthetic and productive way. Such a discipline appeals to pupils because it is in the forefront of satisfying their curiosity about the past; the techniques involve skills and understanding that draw from and feed back into all areas of the school curriculum; and the whole discipline develops important life skills such as the 'seeing' eye, the ability to ask the right sort of questions and the ability to interpret evidence in a sensible but imaginative way. Visits to sites – in both content and methodology – are also of great potential value in the social development of pupils of all ages.

On top of all that, site visits make other visits to investigate objects and collections much easier for pupils and staff as they provide a context in which to place those artefacts. Not that the purpose is to produce a group of archaeologists. You don't teach Mathematics to produce mathematicians any more than you teach Religious Education to produce religious converts. The aim should be to pass on

an understanding of how to investigate and make some sense of what has been left by past generations.

However, as your time on any given site is likely to be limited (unless you are lucky enough to work in a school within walking distance of one), your main aim should be to document as much of it as you can. This may involve giving different tasks to different groups of pupils and pooling your results. But whatever else you do, you must bring back with you all the raw data necessary to reconstruct those parts of the site you need to understand in order to solve the problems you have set.

In using sites and associated work you should also be thinking longer term. Over a period of time with a group, amongst other things, you should aim to do the following:

- Look at how evidence is elicited from fieldwork and excavation, and how such information and materials are placed in context.
- Emphasise the importance of recording because of the ongoing destruction
 of much of the evidence of the past through natural processes, the
 depredations of 'progress' and the unavoidable destruction of evidence that
 occurs during archaeological excavation.
- Give scope to students to apply their imagination to problem solving as well
 as giving them the opportunity to argue the relative merits of conflicting
 interpretations of past events.

In a sense, all study of the past – be it through artefacts, sites, ruins, texts and so on – will do this but fieldwork directly involves the pupil in these processes and their active involvement leads to a much better understanding.

If all this seems overwhelming – so many new skills to learn – then it is better to turn it on its head and consider site work not as a single subject but as the nexus of many. That is the beauty of site work. If it is taken as a central theme it pulls in the following skills (along with many others) that are already in use or being taught within the normal school context:

- History—which introduces the context in which fieldwork and archaeological finds are interpreted and provides a complement to them, in turn providing an extra dimension to the study of history.
- Geography a study of geomorphology provides an understanding of how
 to differentiate between landscapes formed by the actions of nature and
 the actions of people. This and other aspects of geography combined with
 fieldwork lead to an understanding of how environment affects settlement
 patterns and settlement patterns affect environment during various periods
 of a culture's development.
- Mathematics surveying (measurement with a variety of instruments), accurate recording, graphs and three-dimensional plotting.
- Science looking at processes of decay and preservation, the characteristics
 of materials, the strength of structures and scientific techniques involved in

fieldwork and excavation as well as follow-up work.

- Design and Technology working out what technologies must once have existed to have produced what was used in the past, understanding materials and their use and also looking at the technologies available to archaeologists in their work today including the ubiquitous computer.
- English developing reporting skills (oral and written), accurate description, imaginative and creative responses, to say nothing of expanding vocabulary.
- Languages in studying place names and how they have derived from various influxes of peoples and how those names can give clues to past settlement. There is also the study of how the languages of conquering peoples have come to affect the evolution of languages.
- Art knowing that there is more than one way of making a visual record
 of an object, developing skills of draughtsmanship and measurement
 and learning to discriminate what is important about aspects of an object
 depending on what is required of the record of it.
- Environmental studies looking at the ways in which people have related to their environment, how they have adapted it to their own needs and the consequences of those actions.

Again, much of this applies to the other forms of work described in later chapters. The applications will be obvious as you look at those specific skills. At this point, however, we need to consider some specific skills that are needed to make a visit to a site worthwhile in terms of information gathering and understanding what it is you are studying.

Before visiting a site you must know why you want to take pupils there. If it is primarily an information gathering exercise then you must know what you want your pupils to do with that information. It is no good turning up on a site and measuring things at random. Knowing what you want your pupils to do means that you can devise specific tasks to be undertaken during the day. You should prioritise these tasks so that the important ones get done first. Never start any investigation by asking your pupils, 'What was this site used for?' Rather, get them to examine detail, gather evidence and *then* consider the possible functions.

As sites come in a large range of varying complexity the first thing you must decide is which site is best suited to your purpose or, if you only have one site, when it is best to use it and for what purpose. In general, no matter how you might tie this work in with other subjects, the seven key areas of concern when doing site work are:

- 1. Map work both in preparatory work and in the field relating landscape features to their symbolic counterpart.
- 2. Orientation direction finding with and without a map.
- 3. The importance of topography and individual landscape features.
- 4. Supply, trade and communication routes how does the site appear to fit in with settlement patterns?

- 5. Change is the area now deforested, drained, built up, deserted and what factors have been instrumental in the changes?
- 6. Sorting out ground plan measuring, surveying and placing the site in context with the area in which it exists.
- 7. Relating the purpose of the site to its design and/or deducing its purpose from the design.

Preparation of pupils is all important. Sites can be the most difficult of things to work with. They can be extremely abstract and are usually poorly interpreted (although this can be a good thing as it means pupils have to work it out for themselves). The first thing you need to do on arriving is to orientate your group. Until they are familiar with the layout, orientation and boundaries of the site they will not make sense of any other work.

Orientation can be achieved in several ways. The study of maps and plans during preparatory class work will be a great help as pupils will begin to understand the relative positions of parts of the site. However, this will not ensure that they will immediately be able to find their way about the site when you get there. A quick guided tour is always useful as walking a site gives a feeling of its size and three-dimensional shape. It also helps pupils to ground themselves and store a few mental signposts so that they can find their way about. The length of this exercise depends on the size of the site and on what you plan to do on the day. If you have a smallish group (no more than 20) there is no reason why you cannot make this a major part of the day, examining specific features and discussing them before splitting up for other projects.

Once the group is orientated and before splitting into working groups, set up a base. Try to do this in a spot visible from all parts of the site. Keep this base occupied at all times by an adult. Not only does this provide a point for pupils to return to for whatever reason, it is somewhere safe to leave items and materials. It also provides a means of keeping an eye on all the working groups. If your site is particularly large and you are likely to be away from this base, you may wish to consider using two-way radios to keep in touch with group leaders.

One of the better ways of starting site work is to survey and record a graveyard. It is non-destructive, may never have been done before and can, therefore, be offered to a public records office when finished. A great deal of measurement can take place on a finite site. And, as well as generating material for analysis and plotting, the wording on the gravestones and monuments can be recorded and analysed as documentary material. It is also the perfect opportunity to consider such issues as respect. Whilst it is an interesting resource, it is also the final resting place of people who may still have living relatives.

Whichever site you choose to work on, plan well in advance. The time of year is important. Low foliage and leafless trees in winter give better views but this must be offset by worse weather and shorter working hours. Do not let bad weather put you off. Part of what is to be gained from site work is experiencing the worst as well as the best, allowing pupils to better evaluate what conditions were like for

the original inhabitants. You will also need a fair amount of equipment on which some, if not all, pupils will need practice.

The importance of getting permission to cross or work on private land has already been mentioned. Make sure, also, that you have permission for what you are going to do – especially if the site is environmentally or culturally sensitive. Do not tell the custodian or owner that you are making a visit (which may imply to them you simply wish to look round) when you actually intend to carry out a full scale survey with theodolites, poles, lengths of tape and so on. Explain precisely what you intend to do and do no more than that for which you actually get permission. Involve custodians or curators if you can as they may be able to help. If the site you are working on is overlooked or adjacent to residential, farming or other such property it would be politic to write to these people and explain what will be happening, especially if you intend to make a series of visits or if the site does not normally get visited.

During your preliminary visit, a risk assessment is vital. Look especially for water and unguarded drops. Also look out for overhead cables (power or telephone) if you are going to be using surveying poles and the like. If your site is a graveyard, count the stones and seek out those that have fallen or are hidden by growth. Make some preliminary sketch plans of the site for use during surveying. Advanced groups can make preliminary sketches for themselves.

To survey a site properly you will need:

- Up to date large scale maps of the surrounding area 1:10,000 is a useful scale.
- Any other large scale maps or plans that you can find. Old maps are useful for showing change of use.
- Markers all markers should be either free standing or capable of being stuck in the ground. Never stick anything to stones or remains of any description. Free-standing markers numbered on both sides and placed on the ground by each stone or feature to be recorded are useful. Remember: always place them in the same position in relation to the object.
- Photograph marker (a small blackboard 30 cm x 20 cm with measured sides painted in black and white 5 cm divisions, with integral prop), chalk and duster these can be used to label what is being photographed as well as providing a guide to its size.
- Two 30 m tapes.
- Ranging poles (2 m poles painted in black and white 50 cm divisions).
- A 1m measuring rod painted in black and white 10 cm divisions.
- Twine cut into 100 m lengths and marked into 10 m subdivisions.
- A good quality compass.
- Wooden marker pegs (similar to tent pegs).
- A mallet.
- Basic surveying equipment sufficient to measure horizontal and vertical angles.
- Squared paper, pencils, erasers, clipboards and a portable table.

 Individual record sheets appropriate to what is being recorded and the information you require.

Accuracy of recording is all important – measurements, angles, inscriptions, markings, condition and so on – as this information forms the basis of all further analysis. Always make your records as you go. It does not matter if they are not very tidy as long as they are legible and it is clear what each value recorded refers to. Records can always be copied out neatly or entered on to a computer at a later date. Always keep your originals, however, as you may need to refer to them.

Field sketches should be recognisable (even if in rough) and labelled. Any object or feature should be recognisable from its sketch. This does not mean everyone must have perfect drafting skills. What it does mean is that if, for example, a pupil draws three windows, the labelling should clearly identify the exact position of each window and the sketches should show the peculiarities of each window, with any notes thought necessary to clarify the sketch (including colours). Sketches can record a detail that may be lost in a photograph, especially if you do not have sophisticated camera equipment – and remember, professional archaeologists still prefer sketches and drawings to be made as these can concentrate on the required detail. This applies to all types of visit and study.

Having gathered your equipment and stressed the need for accurate recording, you can set out to survey your chosen site. There are three basic methods of surveying. All three require establishing a baseline from which all subsequent measurements are to be made. This line should, if possible, be orientated either north-south or east-west, depending on what is most convenient. Some sites do not make this possible and other orientations are required. Try your best, however, to make the orientation a round number of compass degrees so as to facilitate later calculations when drawing up a site plan or relating your plan to other maps and plans.

METHOD A

This is the simplest method but it is more difficult to achieve accurate results if the survey includes much fine detail. In essence you are plotting a graph, placing the parts of the site you wish to record onto a grid by measuring their distance from both a vertical axis and a horizontal axis.

To begin, set out your baseline along one edge of the site. It does not have to correspond exactly but make it as close as you can. It needs to be marked physically so that measurements can be made from it at any point along its length. This can be done by placing pegs along the length of the baseline at approximately 10 m intervals with string stretched between them. Make sure the string always passes along the same edge of each of the pegs.

The baseline corresponds to the horizontal axis of your graph. The vertical axis can be marked out in the same way running at 90 degrees to the baseline and starting at one end of the baseline. Once you have established these two lines you

can either make measurements and record them so that objects can be plotted later on, or you can plot objects directly on to a plan as you work. In either case, the distance to both lines from a series of given points needs to be made.

Each point to be plotted should have a unique registration reference which needs to be agreed beforehand. This may involve dividing the site into areas, giving each building or ruin a specific code and so on. How this is handled is up to you but simplicity is of the essence. Each reference can be recorded on sketch plans so that everybody knows where any given point is in relation to all the others. Each reference can also be kept in a book in which all measurements are recorded for future analysis.

Each axis also needs a unique identifier. These may simply be 'NS' and 'EW' or whatever you choose as most appropriate. The point is, everybody must be aware which is which or confusion will ensue. To avoid that confusion it is helpful to label each axis on site or to use coloured twine and pegs.

Having identified every point, each has to be plotted. This is done by running a measuring tape from that point to the baseline (or horizontal axis), ensuring the tape strikes the baseline at 90 degrees and measuring the distance from point to baseline. This is then repeated, measuring the distance from that same point to the second baseline (or vertical axis), again ensuring the measuring line strikes the axis at an angle of 90 degrees. These two measurements provide the coordinates that allow the position of an object to be plotted on to a scale plan.

METHOD B

The second method is much the same as the first except that it allows for more accurate measurements in a situation where many measurements have to be taken (for example, a densely used graveyard or where there are many small things to be recorded).

To begin, the two baselines are marked out as before. Once that has been done, they are each subdivided into 10 m sections and from these, 10 m squares are constructed. All the positions within each 10 m square are then plotted as in Method A and the overall picture is reconstructed at a later date.

METHOD C

The third method is much more suitable for large sites with less detail to record. This method only requires one baseline of known length and orientation. Once this is established, a theodolite is placed at each end. Each object is then plotted by triangulation. That is, the baseline is the base of a triangle and acts as a constant since it is always in the same place, always the same length and always on the same orientation. The object to be plotted acts as the apex of the triangle. Its position is found by marking it with a ranging pole, sighting along the theodolites at each end

of the baseline and recording the angle between baseline and line of sight. The two angles are recorded and allow for accurate reconstruction on a plan.

When surveying a site, record:

- the shape, boundaries, entrances and so on;
- · footpaths, tracks, roads;
- streams, rivers, still water, coastline:
- trees, bushes, hedges (with approximate age);
- the position of other natural landmarks such as outcrops of rock;
- buildings and other human-made structures their size, ground plan, position and orientation;
- anything else that you have specifically come to record.

Buildings and other human-made structures can be surveyed in greater detail and to a larger scale than the rest of the site if so desired.

Settle upon an agreed way of plotting these features on your site plan. There are accepted symbols and forms used by cartographers and surveyors. These can be investigated by pupils and adopted for use or you can devise your own system (and perhaps compare it with standard systems later on to see to what extent they match).

Surveying, however, is not the be all and end all of site work. Although one of the main reasons for a site visit is to generate documentary material, you need to come away from a site with more than a mathematical record of your visit. Photographs can be taken but should not be used as a substitute for making field sketches. Use photographs for the larger view to show what parts, or the whole, of the site looked like.

You can also test theories you may have formulated in preparatory work. These can lead to many forms of fieldwork not dependent upon measurement. Simply visiting a site and experiencing the three-dimensional reality of the place can provide much insight into the motivations of and the conditions faced by the original inhabitants. Approaching a heavily fortified position, for example, can make pupils better appreciate how strongly people must have felt in order to undertake an attack on such a place; seeing the abundance of wildlife and raw materials in a lowland nature reserve can help them appreciate why people chose to live in marshland.

Finally, try to combine your work on site with an opportunity to appreciate the surroundings. For many pupils such a visit may be a first – their first time out of their neighbourhood, their first time in the countryside. Give them a chance to enjoy it.

WORKING WITH A BUILDING

As with sites, buildings present specific problems connected with the scale of the resource being used. Small group work again plays a large part here and the production of information that can be tied in with the researches of others is of great importance. Environmental concerns such as why a building or group of buildings are where they are, their layouts, changes over time, sources of materials, purposes for building and changing use and so on, should all be looked at.

There is no need to look for anything exotic. Everything you need is, quite literally, on your doorstep. A survey of buildings in the main street of a town can uncover a wealth of architectural styles, use, change and so on. This in turn can be related to the wider issues of the growth of the community.

If you cannot, for some reason, leave your school, then use your school. Even if it is brand new it can be an excellent starting point – leading to a permanent and evolving exhibition on its history. The extra value in using the school building itself is that it will invariably point out to pupils that no matter how familiar they think they are with a structure, that familiarity is usually superficial – sufficient for them to work within its space but no more than that. Once they begin to investigate, they will understand that there is much more to a building than ever meets the eye. Take pipes as an example. Pupils may be aware that in the corner of a room there are pipes. But do they know what is in them and where they have come from and where they go to? What is more, some parts of the school will be a mystery to them. Have they ever been in the staffroom, the cleaner's cupboard, stock rooms and so on?

If you are very lucky (in terms of investigation) and work in a very old school, then you will have a great wealth of material to investigate and accumulate, especially if you can find a source of photographs and old school records. However, a new school contains an equal (if different) wealth to investigate. Even if it has only been open for two weeks, you can investigate why it was built, who designed it and why it was designed in this particular way, who did the building work and so on. In this case you are starting a record that a teacher in a hundred years' time will thank you for because you will have provided the documentary material that you wish you had from a hundred years ago.

Investigating your own school in this way is also an ideal opportunity to start your own school museum. The ins and outs of this will be introduced in Part IV as a long term strategy that you could pursue.

Exciting as the prospects are, working with buildings can offer special problems over and above the problems of scale, especially if you are not working with your school building. To begin with buildings are often in urban areas and you have to mix with traffic and other people. Building surveys under such conditions need to be carefully considered, especially with younger pupils. In this respect, pedestrianised centres are exceptionally useful, especially as you can then make a comparative study, from photographs, with the same area before pedestrianisation. Secondly, you cannot gain access to the interior of most of these urban buildings – buildings open to the public are in the minority. This restricts your work to surveys of the fascias and estimates of their present use. This can always be supplemented with study of large scale maps. Finally, where you *can* gain access to a building it may well have had its interior altered to facilitate public entry. This is as true of old buildings that now house museums as it is of large country houses. They too have their public and their private rooms.

None of this should discourage you, however, as even these changes are worth studying. Gaining access to examples of everyday houses from different periods is not a problem unique to teachers and their pupils. Your local museum and records office will be able to advise you on this. And there is, of course, that other resource – your pupils. They all live in buildings of one form or another. If they come from an area where living conditions are poor, then this is an excellent opportunity for them to become aware of the problems from a wider perspective, study the history of the problems and even explore solutions that can be put into practice.

As with all other aspects of this book, the content of your work (that is, the specific reason you are studying a building or set of buildings) is contingent upon the curriculum you teach. What is offered here are general ways of approaching any building to make sense of it and record what information you can. Again, do not stick solely to the mathematical, analytical approach. Branch out and use all aspects of the curriculum. Buildings, like sites, are great subjects for art and literature, the sciences and the social sciences.

STUDYING

Physical Features

Start with the physical appearance because anyone at any age or level of ability can investigate this, especially if you have a ready prepared form to be filled in. Such observations prompt many other questions and lead to other areas of investigation.

The first thing to consider is the general appearance of the building. Is it dirty, clean, smart, untidy, ornate or plain? What feelings does it evoke – is it imposing, friendly, spooky, grand, humble and so on? This is somewhat subjective but nonetheless important as it leads to discussion about architectural features and forms and their associations.

Next to be considered is the size of the structure. Is the building large, small, tall, short and in comparison with what? How many storeys does it have? Is it intrusive or does its size blend in with its surroundings (either buildings or the countryside)?

What is the shape of the building? This has two aspects. The first of these is the two-dimensional ground plan. Is it rectangular, square, polygonal, curvilinear, T-shaped, L-shaped, U-shaped, irregular, symmetrical, asymmetrical? Are there enclosed courtyards or other spaces? The second aspect of shape is the three-dimensional space occupied by the building. This is more complex but is well worth pursuing as it leads to a study of theories of design and aesthetic proportions as well as an understanding of three-dimensional space.

How buildings are massed is also of importance in understanding their form and function. Buildings can be single detached, semi-detached, part of a row (end or middle), terraced (end or middle), attached but irregular and apartment buildings of different form (for example, terraced, attached and so on). These smaller groupings are then clustered in particular ways. Villages and small communities are easier to study at this level, but it is possible to get an idea of how such clustering occurs in larger communities — again by studying large scale maps. Well established communities have histories reflected in their street plans. It is sometimes possible to pick out the street plan of original communities nestled within later accretions and trace the probable causes of such developments — such as industrialization, the arrival of a canal or railway line and so on.

The location and aspect of the building need to be considered as well. Its location is very much tied in with its relation to other buildings and how they are massed and clustered. It is easier to think about location when the building is isolated, part of a small community or a ruin. Why was it built where it was and what is access to the building like – is it easy or difficult, approached via a long drive or does the front door open straight on to the pavement? The purpose of the building is considered in depth below but initially it can be looked at in relation to its geographical location and its aspect – that is, the orientation of the building.

Consider whether the building is complete or not. This is not as easy as it may seem. Most buildings, of course, are complete. But some are never finished and others have parts removed. It may also be that the building has been altered or adapted for a use other than that for which it was originally intended. It may also have been repaired or subjected to conservation or considerable rebuilding to mitigate the effects of old age, because of the desire to 'improve' or because of damage caused by the effects of nature or people.

Finally, in this section, you need to ask whether or not the building is inhabited. What type of habitation is it at present and what has it been in the past? Can you discover anything of the previous and present inhabitants? Care has to be taken here if the building is a private residence, but a building can be chosen because it is known that the present inhabitants will be willing to help with your investigations in some way.

Construction

The outward appearance is not the end of the story, of course – partly because the outward appearance so often depends on the building materials available. Nowadays, materials can be transported great distances or faked. It is, therefore, possible to build a log cabin hundreds of miles from the nearest forest. Whether or not it then looks right is also a question that should be considered. But before you can do that you need to investigate more closely the construction of the building or buildings you are scrutinising.

In the first instance it is worth looking at the materials used in the construction and the likely source of those materials. Are individual materials naturally occurring (stone or wood) or are they manufactured (glass or plastic)? Of the naturally occurring materials, how many of them have been crafted in some way before use (dressed stone, sawn wood) and how many have been subjected to processes that transform them (the baking of clay to make bricks, the making of cement)?

How many different materials are in use? It is highly unlikely that you will find a building constructed of a single substance, although they do exist. List the substances and see if you can estimate their proportion one to another. What are particular materials most often used for and are there substitutes? Have these uses changed over time or are some materials still in the same and best use after hundreds of years (for example, wooden floor joists)? What are the comparative virtues of modern and traditional materials?

The colour of the materials and the colours that have been applied to them also have an impact. Why are some buildings traditionally coloured in a certain way? Do these colours blend in with the landscape (like building materials from local sources) and do modern buildings jar the eye and the sensibilities because they do not pay heed to their surroundings? What if their surroundings are other buildings?

Having considered the materials and their source, form, colour and ecology, it is important to look next at the method of construction. To begin with, was the building constructed by professional builders or by the person who wanted it built? Does this make a difference to the outcome and how far back in time do you have to go before the majority of buildings were not constructed by specialists?

Was the building made entirely by hand or were machines involved? How were heavy weights lifted and how did people work on the outside of the building if it was more than six feet high? What other tools were available to the people who built it? Were any sections prefabricated and then taken to the building site – and how far back in time has this method been used? Was the building constructed in one go over a short or long period of time or was it built in stages with sections added at later dates? How many people were involved in the construction? What construction methods were used (for example, is it bolted together, cemented or does the whole thing hold itself together by its own weight and counterbalances)? Do new materials come with new methods of working or is there a period of

transition? For example, the iron bridge at Ironbridge in Shropshire was made of cast iron, but put together using joints and fittings inherited from carpentry.

Is the building connected to any of the major utilities (that is, water, gas, electricity and sewers)? Were any of these available when the building was first constructed? If not, how did the inhabitants cope with providing for themselves what we now take for granted will be provided by the utility companies?

Function

The appearance and construction of a building are, more often than not (and certainly so in the past), a result of its function. It is, therefore, sensible to investigate next what the intended function of the building was. Was it to be lived in and by whom? Would it have been suitable to their needs? Was it intended as a place of work (and this is not incompatible with it being a place to live – consider farms, shops, dwellings with looms, terraces with a factory in the attic)? Has it a specialist nature that generally precludes other use (for example, a place of worship, a school or a hospital)? Was it built as a place of pleasure (theatre, cinema, pier and so on)? Was it intended as a place of storage or for non-human habitation (for example, a barn)?

A building constructed for one purpose does not now necessarily fulfil that function. Buildings change their use over the years and are converted to fulfil other roles. Schools become houses, farm cottages become animal shelters, hospitals become schools and so on. In some cases this conversion can be effected with little or no change to the structure. In other cases (for example, large house to offices) an entirely new building can be constructed behind the façade of the original simply to retain the visual coherence of a street or district. Such changes of use often lead to imaginative utilisation of space and inventive changes to the interior of old buildings which are worth investigating.

Design

When you have looked at the building's function and any changes that have occurred over the years, you can consider its design and see how the function, form and materials can affect the decisions that have to be taken when designing a structure.

To begin with, was it built in accordance with a design, a style or a tradition? That is, was it the creation of an architect or other professional designer working to their own or someone else's ideas? Was it built by a builder to the instruction of an owner without intermediate design work (perhaps constructed from a pattern book)? Or was it built by non-professionals according to a traditional design (for example, an agricultural worker's cottage)?

Is the particular building you are studying well designed? That is, does it make good and sound use of appropriate materials; is it aesthetically pleasing; does it make good use of available space; does it meet the needs of those who must use it

(is it economical, warm, comfortable and so on); does it fulfil all its other functions efficiently; is it decorated (the whole concept – not just wallpaper and paint) and if so, how and why?

Value

This aspect of the investigation of buildings is by far the most difficult as it involves some very subjective decisions being made. It should not be avoided, however, for such decisions can be based on information gathered as well as on personal opinion. It is, therefore, a way into analysing and using the information generated by earlier investigations and by other agencies.

There are, of course, many types of value that attach to an individual building, some of which are much easier to categorise and place than others. The market price, for example, can be discovered fairly easily. This measurement of monetary value can be compared and contrasted with the original cost of the materials involved, the area in which the building stands, the time it took to build and so on.

Thereafter, valuation becomes more difficult because buildings also have other forms of value, such as the following:

- Symbolic value (for example, a castle is a symbol of power and the way in which it is built and sited can increase or diminish that particular role).
- Sentimental value (if you have lived in a house for thirty years and had nothing but good times there then it is worth more to you in sentimental terms than it is in monetary terms except of course that sometimes, monetary pressures force us to part with things of great sentimental value).
- Social value (hospitals are buildings of great social value and on many layers for not only are they places of healing, but they also employ a large number of people).
- Economic value (factories, power plants or railway stations are good examples of buildings of economic value – the reason they become targets during armed conflict).
- Historical value (any building where significant historical events have occurred, where people of historical significance have lived or which are of themselves outstanding examples of their type).
- Spiritual value (and this may be in the standard religious sense of a church, mosque, synagogue, temple or other place of worship, or it may be in the sense of a non-denominational building that is a place of peace and contemplation).
- Cultural value (museums, art galleries, theatres and the like spring immediately to mind).

This comparative study of values needs to consider past and present attitudes as these can affect the value of a building in some sense. And if there has been a change in perceived value, what has brought that change about? And finally, is

there a difference in value between a building considered as a single building and a building as part of a built community?

RECORDING

When recording buildings it is essential to be uniform in the way you do this so you can extract information consistently. The best way to do this is to design a building survey sheet. This should contain space to identify the building and its location, all the major features you are looking for so they can be entered easily and plenty of spaces for the inevitable oddities that do not fit your chosen categories. Not only should such forms be filled in as comprehensively as possible, but field sketches should also be made to better illustrate certain aspects of the information on the survey sheet. As an example, a building that is damaged or in a state of collapse should be sketched so as to show how bad it is and how it is collapsing. If at all possible, the layout of rooms should be noted. If this is not possible, it is a good exercise to try to work out possible internal layouts from external clues such as doors, windows and chimneys. If you are very lucky, you may be able to study architects' drawings or professional surveys done by those concerned with recording and preserving buildings.

Look out for photographs, paintings, sketches, newspaper reports and other documentary material relating to the building. These will give you information about how the building has changed (or not) over a period of time. Old visual material can be compared with modern photographs, especially if they are taken from the same or a similar viewpoint. Not only are these useful records but they can also be studied in the comfort and safety of the classroom after your initial survey is over.

Look also for records relating to the building (street directories, planning consents and so on). These, too, offer a great deal of information that is not obvious or apparent from visual surveys.

If the building you are studying is a ruin or has been substantially altered, see if you can track down any bits that have been removed. These may be in your local museum or the museum may know where these bits have gone. Window glass, original furnishings and furniture may be available for view in other places and can offer much information about the original condition and function of the building as well as the status of those who lived in it.

As always when studying something there can be a danger of over analysing so that the original impact of seeing and appreciating the building as a whole is lost. It is most important that information gathered is synthesised so that the building can be considered again as an entity. What is more, make sure you do not lose sight of the human connection. Buildings are built by and for people. Their part in the life of the building is what makes it whole. It is useful, therefore, to write the history of the building *and* its inhabitants – a kind of biography of the interaction of people and their immediate built environment but done from the building's point of view.

A good three-dimensional response to such work is to construct an accurate scale model or models of the building to show its original state and changes that have since been made to it. This can be extended to making scale models of buildings in your town centre showing how that has developed in the period that records are available to you. If you are really ambitious you might try, on a different scale, to show how the town your school is in has developed over the years.

Whatever else you do, it is important that pupils are given the opportunity to use the information they have gathered to think about and discuss the built environment in which they live. The better they understand what factors have led to its being what it currently is, the better they will be able to participate in the future of their neighbourhood.

WORKING WITH OBJECTS

Whatever other form of study you are likely to undertake with your pupils, working with objects will probably be the activity you undertake the most. There are two reasons for this. Firstly, objects are what you encounter when you visit a collection, a site, a building and so on. Large or small, they will be there, in their greatest abundance in collections. Secondly, objects are easiest to gather in the classroom for long term study. Most museums have loan collections and handling collections and most people have relatives who possess old objects that can be borrowed. We are surrounded by such things because ours is primarily a material culture.

The fact that objects are so abundant does not mean they are any easier to work with than sites, buildings, pictorial material or documentary material. On the contrary, because most people are surrounded by objects they are more inclined to treat them with the contempt that familiarity helps to breed. Buildings and sites have a touch of the exotic about them (even if only because they are outside the classroom). As a result, they have an added attraction that encourages investigation. Objects, unless they are unusual, need more work done with them to get past the barrier of familiarity that prevents close and impartial investigation.

When you start working with objects it is best to choose things that your pupils are unlikely to be familiar with – even if they are domestic and none too ancient. It is also best to start with relatively simple objects as the information they can yield is easily extracted, encouraging in pupils the idea that you can obtain facts from the inanimate. Your choice of objects is, therefore, of crucial importance. Short practice sessions that simply examine one-off objects for half an hour with the aim of extracting as much information as possible are well worth the time. You might try introducing these sessions with some extracts from Sherlock Holmes stories in which he deduces seemingly impossible amounts of information from careful scrutiny of personal belongings. You must, therefore, choose objects for their maximum in potential explicit information *and* the maximum of skills they promote.

A new object can be used for historical ends just as an historical object can be used for contemporary ends. Objects do not need to be 'valuable' or museums pieces, though learning to work with museum pieces and objects of worth has a value in itself. All objects deteriorate at varying rates and due to various causes such as light, air, humidity, acidity (on fingertips and in materials), handling, movement, dust and so on. People can cause terrible damage merely by their proximity, even to massive monuments.

When choosing an object to work with, you need to be very clear in your own mind what you wish to achieve. Simple, undecorated, uniformly shaped objects can be easy to describe but it can be exceedingly difficult to determine much else about them. Familiar, everyday items are useful to demonstrate how easy it is to look at things without actually seeing them. There is much to be discovered about things normally taken for granted. Old, broken and worn objects are useful when considering wear and tear. They also present the opportunity to see the interior of objects you might not normally be able to see inside. Markings, writings, pattern and so on are all important evidence that can be investigated – however, don't worry about the history of an object to the exclusion of other aspects. Make use of what you can find out from personal investigation before going to outside authorities to fill in the gaps and extend what you know.

The choosing of objects is also a legitimate area for pupils to investigate. After all, why do museums display what they do? How would they go about choosing objects for a display? In particular you can look at the relative merits of the use of replicas or originals. There are arguments for and against both. Originals may need careful or no handling but can provide information that replicas cannot. They are also the real thing which can provide considerable psychological impact. To be allowed to handle and examine something that is hundreds or thousands of years old is an experience that all pupils should have. Replicas, on the other hand, are robust enough to allow much handling, can be replaced and can lead to discussions of accuracy (especially if you can compare a replica with its original), of methods of reproduction, materials and so on, and what is thought to be worth reproducing and why.

As mentioned earlier, objects that are not immediately identifiable can evoke more response and investigation than known objects. The important point is that pupils learn the skills required to investigate an object. With those skills they are able to engage their curiosity and follow many paths of investigation. As long as a pupil's curiosity is engaged, learning continues. If you simply show pupils an object and tell them what it is, their curiosity is closed off.

But knowing how to fire the curiosity and lead it on is only the first step. When pupils have the skills at their fingertips and they have sufficient experience to realise that the application of those skills can lead to results, the second step is to get pupils to apply them to familiar everyday things. In more cases than not, pupils will begin to realise that they know next to nothing about many of the things they take for granted in their lives – how they work, how they are constructed, who invented them, how many people have them, whether there are other ways of doing the same thing, whether a 'labour-saving' device is just that or whether in fact it creates more work than it saves, the source of raw materials and so on. The trail is a long one that goes through many areas beyond history (and, in any case, need not start there) and opens up many questions of economics, ethics and so on that are not normally addressed. Objects are loci. You can go in many different directions from them and, in the process, develop skills of close observation, questioning, discussion, description, documentation, comparison, making links and connections.

Having followed these more complex trails with familiar, everyday objects, the same questions can be asked of much older objects. The answers are, of course, much more difficult to come by the greater the age of the object. Questions of working conditions for Neolithic flint miners can be addressed in physical terms (it takes little imagination to realise it was a dirty, cramped and dangerous job), but the social pressures behind the work can only be guessed at. Was it well rewarded work or were the miners bonded to others for service – were they slaves? We can attempt answers based on what we do know but, as with much of history, one of the most important lessons we can hope for pupils to learn is that we do *not* know all the answers and we *cannot* know all the answers. Secondary to that is that we can, however, make educated guesses. That is, we can base hypotheses upon good, hard information. After all, we do not see anything as it is or know anything about it other than through the questions we put to it.

But just how do we get that information, especially from inanimate objects and without recourse to very expensive laboratory equipment? All the equipment you really need to start such an investigation is a series of questions that will yield more and more information to enable the construction of an ever more complex understanding of the object.

Do not, at this stage, worry about 'labels' or 'correct' names. Specialist knowledge is not essential to learning from objects. More often than not, 'correct' names and specialist knowledge can get in the way of investigation. Answer basic questions first – worry about what the thing is called at some later date. When you do get that far, one useful activity is to get pupils to invent names that seem appropriate for the object they are investigating. The names that pupils have invented can be compared at a later date when you introduce them to some of the basic reference works for identifying objects.

WORKING WITH A SINGLE OBJECT

In one sense it is a false situation to work with a single object as no object exists in isolation. Its historical, social and other contexts, as well as its relation to other objects, are all of prime importance in fully understanding the object. It is possible, however, to gain a comprehensive degree of understanding by looking carefully at an object on its own – even if that understanding is simply of how to look carefully at objects. Furthermore, the information gathered from a series of single objects can be used to form hypotheses about objects and their contexts which can then be tested against what is already known of these things.

There are established ways of 'questioning' objects which can provide a surprising amount of information on which to base further 'readings'. Furthermore, none of these sets of questions require specific specialist knowledge. Some of these are derived from those that are used when artefacts are identified and catalogued by archaeologists and museums.

Before handling any object, pupils and teachers alike need to be aware that some objects are more delicate than others. It should go without saying that when

you start this kind of work you (and the museum) will choose objects for their indestructibility. However, as pupils progress they can, perhaps, be trusted with less robust objects, perhaps even those that require special handling – by the wearing of cotton gloves for example.

Start with a consideration of the physical features of the object as anyone at any age or level can investigate these; also, many other questions are opened up and prompted by looking at them.

To begin with, the object should be described so that an accurate record of its *form* or *shape* is made. Making an accurate description is a very valuable exercise and should be done with the written word and with drawings. The description should be sufficiently accurate to pinpoint this one object within a collection of similar objects. To this initial analysis can be added the other information elicited by asking the questions below, thus building up an ever more complex and complete picture of the object in question.

In addition to the form or shape of the object should be added a note of its *colour*. Are the colours the natural colour of the materials used or has the object been deliberately coloured? Are any of the colours original to the object or have they been added since it was first made? If they have been added, do they replicate an original colour scheme? Are the colours significant (for example, the green glass of a poison bottle) or merely decorative? And so on.

The next set of questions to be asked of an object relate to what *condition* it is in. Is it, for example, in mint condition or has it been used and suffered the consequence of use in the form of wear and tear, accident and so on? Does it look as if, at any stage, it has been damaged in any way and have repairs been made? Has it been altered or adapted to wider or alternative use? What are the clues that will yield answers to these questions? Is it always possible to tell just by looking or should some of these questions be returned to at a later stage of the investigation?

With an initial assessment of the form and condition of the object made, it should be somewhat easier to answer the next set of questions that relate to how *complete* the object is. Is it all there or are parts missing? If parts are missing are they essential to the object or are they just fragments lost due to normal wear and tear? Again, what are the clues that will yield answers and is there any way of telling one way or the other at this stage?

It may seem odd to start with questions that probably give rise to more questions, but that is the nature of this type of work. Even if you can answer all the questions posed, they still raise problems which are then addressed by the questions that follow. It is also inadvisable to rearrange these questions so that pupils get quick and easy answers. To begin with that would be a futile quest as there are no easy answers. But even if you could do this it closes off many avenues of investigation.

So, the next set of questions, which will help towards answering so far unanswered questions, relate to what *material* the object is made of. There are three categories of material to consider. Firstly, the natural materials that can be

used as they occur naturally. These are substances like wood, stone, clay and bone. The second group of materials are those that occur naturally but which require processing before they can be used to make things. In this group you will find metals, glass, paper and some fabrics like wool, leather and cotton. Finally are man-made materials such as plastic. This picture is complicated as objects can go through many stages of production and require many different materials. So, having decided what material or materials have been used, it should then be asked why those materials were used. Were they the best available at the time (if that time is known) or were they the only ones available (if the location and circumstance is known)?

The next set of information to be gathered is, on the face of it, an easy one. That is, what are the *dimensions* of the object? However, there are all sorts of problems connected with this task. To begin with, just how do you decide which dimensions should be recorded? A cube presents little problem, but what are the significant dimensional measurements to be made in respect of an oil lamp, for example? And are such measurements of any use on their own in any case or do they need a context (such as comparison)? That is, is the object big or small and in comparison with what?

In connection with measuring the dimensions of an object, there are other forms of mensuration that can be carried out. How *heavy* is the object and is that significant? What is its *capacity* (if any) and for what? Are there any other ways of measuring the object (its speed, range, mass and so on)?

Does the object have any *marks* (scratches or other non-intentional markings) or *inscriptions* (writing or other intentional marks – decipherable or not)? The first thing to determine is whether the markings are deliberate or accidental as this will enable you to decide how to proceed with your investigation of them. If they are accidental, did they occur as a result of the normal use of the object or in some other way (for example, a dog's paw print in a clay tile)? If the markings are deliberate, do they follow a design (as in a pattern or decoration) or are they random (as in vandalism)? Or do they go one step further and provide us with more direct information? Are the marks the maker's stamp, inscription or other device (for example, a thumb print or nail mark in clay)? Are there words and are they decipherable? Are they inscribed, painted or laid on using a transfer and so on? And, finally, what information can we gain from such marks and inscriptions? Do they give clues to date and place of manufacture, the maker and the user?

In the initial stages of this investigation of an object, it is the object in isolation that is under scrutiny. The last set of questions, however, introduce other elements that begin to consider the context of that single object. We have already thought of the maker in respect of any mark they may have left on the object. Investigating the construction, function, design and value of an object also serve to add to our knowledge of the object and broaden the exploration of its immediate context.

The *construction* of an object tells as much about the person who made it as it does about the object, albeit indirectly. Of course, not all objects have been constructed. Some natural objects are suited to jobs without alteration but can still

be considered artefacts because of the use to which they have been put – a use which will have left its marks. A good example is the shoulder blade of a large animal being used as a shovel or the antler of a deer being used as a pick. If the object was made then the complexity of the operation needs to be considered. Was the object 'hand-made', that is was it constructed using tools or were machines – no matter how simple – involved? Was it made in a single piece or in several pieces which were later fixed together? If parts were fixed together, how was that achieved? Were parts, for example, soldered, glued, welded, bolted, screwed, bound, jointed and so on? Was the object made all at once or over a long period of time? If a considerable length of time was involved, why? Would the construction of the object have required more than one person? Is the finished object a machine, a tool, an ornament or something else? Finally, was it made for the person who made it or was it constructed for use by others?

Which leads neatly to questions about the *function* of the object – questions which most people consider to be the only ones worth asking when looking at an old object. That is, what was it used for? It is an important question but, as we have seen, it is not the only one by any means – even when considering function. Along with asking for what purpose the object was made it is necessary to consider how the object has actually been used and how, if at all, its use has been changed. After all, the intended function and actual use of an object may be completely different (for example, coat hangers as car aerials or chamber pots as plant pots).

The discrepancy between the intended and the actual use of an object is a function of its *design*. A well designed object is, by definition, one that is more likely to fulfil its function. It should be possible to consider whether an object was well designed, whether the design was evolutionary or nascent, whether the most suitable materials for the job were chosen (which takes us back to the question of materials used) and whether the design is one that, as well as being functional, is aesthetically pleasing – which opens up the whole question of what is meant by aesthetics.

Finally, there is the consideration of the object's *value*. As already mentioned, there are many types of value that attach to objects. Often, an object will have many types of value at one and the same time, acquiring some and losing others depending on many factors external to the object itself. These values (monetary, symbolic, sentimental, social, economic, historical, spiritual, cultural and so on) will have changed as a result of the passing of time and the reasons why this happens need to be explored. For example, how much has the value to do with the materials from which the object is constructed (such as, gold)? Does any value proceed from the purpose for which the object was constructed and consequently used? Does the value of the object attach to it because of its association with a particular person, group, or social or religious movement?

Considerations of value need to be examined at a remove. After all, does knowing the value of an object alter ones perception of it? And for everyday objects, can they assume added significance when removed from their original environments and displayed in a museum? Do museums bestow value by selecting one thing

above another to display? Conversely, has a museum chosen a particular object because of the value that already attaches to it? Is value objective or subjective?

These are some of the questions you can ask of a physical object. Practice at acquiring information from them is extremely important and the more objects that pupils can exercise with the better. No school can afford a vast collection of objects and does not need to. Everyday objects are good for starting with and easy to come by. When you wish to branch out and start investigating older objects, there are plenty of such things – small and large – to be found in museums.

You cannot always get an answer to your questions and this in itself is a valuable lesson for pupils to learn. Some questions are inappropriate or incorrectly phrased, others cannot be answered because pupils do not have enough background information for them to come to a conclusion (for example, they might not know enough about materials to recognise fired clay).

Nor is it enough simply to gather all this information and then forget about it. Although the skills learnt and exercised are a good reason to study objects, the study of objects should never be considered an end in itself. For the exercise to have real worth, pupils must learn to construct theories about objects (no matter how simple) based on the evidence they have gathered. They are then thinking about cause and effect. For example, they may describe accurately a piece of distorted and cracked glass and then go on to think about what might have caused the distortion and cracking. Was it a glazier's reject or was it from a fire-damaged window? And then a step on from that is to ask, if the glass was fire-damaged, what or who caused the fire – and why? You can also move in the other direction and consider the raw materials required to construct the object, their source, the processes involved in extracting them and the impact on environmental and social structures, the transport infrastructure implied by the movement of such materials, the economic structure that supported all this and the social position of the person or persons who constructed the object.

WORKING WITH GROUPS OF OBJECTS

A single object can only tell you so much about itself from the investigations suggested above. For a more complete picture that will enable you to decide whether it is good or bad of its type, whether it is comparatively large or small, whether it has worn well and so on, you need to place it in an appropriate context.

The problem here is deciding in which context you wish to place the particular object you have been studying. Every object stands at the heart of a series of networks that link it to other objects and situations. The direction you take depends upon your particular interest at the time. One direction of investigation does not preclude others and, indeed, starting from a single object and following as many contextual pathways as you can is in itself a revealing approach.

For example, if you have been studying a frying pan you might wish to consider it as a type and compare it with other frying pans from that same period of time to see what information can be gathered. Alternatively, you can compare it with

frying pans made before and since and so consider its place in the evolution of the design of the frying pan. It could be considered in terms of the materials used in its construction (cast iron, for example) and the place it has in relation to other cast iron objects. It could be looked at in relation to other kitchen utensils of the period.

Placing objects in chronological order is no easy task but it is still worth the effort. Certain assumptions have to be made and used as rules to elicit relative datings based on internal and external evidence. Objects can be ordered by type in a variety of sets and progressions which are not necessarily the 'correct' ones. That is part of the exercise, since once the assumptions have been put to the test it may be felt that they need to be modified.

As an example, it may be that a group of pupils, after discussion, decide to adopt a typological approach. That is, they may apply the notion that objects evolve, change occurring as a result of improvements in function, increasing sophistication in techniques of construction, discovery and use of new materials, and of changes in the environment in which the object is used. Relative dating of a series of objects can, therefore, be achieved by placing them in their apparent order of sophistication.

This may prove to be true in the case of some objects but it may well be found that improvements over time tend to simplify other objects. This partly depends on what is meant by 'sophistication', of course, but that is also part of the learning experience. It might also be found that objects have become less sophisticated over time because skills are being lost or because other pressures demand it.

The chronological ordering of collections of objects has a value but can only reveal so much. After all, the objects need to be of a type for any useful information to be extracted and comparison made. The type need not necessarily be related to the object's intended function. Material, actual use, relation to a person or group of people and so on, are all relevant categories when considering chronology.

Once you start considering the external pressures that lead to the development or degeneration of an object over a period of time, you then have to explore other pathways that relate to any given collection of objects — much in the way that you would with an individual object but with the added dimension of being able to see how various processes involved in manufacture, transport and so on, have themselves developed.

Of course, none of our observation and measurement of objects is objective. Ethnic origin, gender, previous knowledge and experience – all these and more will influence how you see things and interpret them. Objects and symbols, colours and shapes, can have deep ethnic, cultural and religious significance to some peoples and different or no special meaning to others. Gender associations do not hold across cultural and historical boundaries. In fact, no object can be categorised by gender. Take needles as an example. A lot of pupils will consider sewing to be women's work but tailors are mostly men.

A tendency to categorise can prevent close observation so it is an important lesson to learn that objects must be investigated with open minds. Previous

knowledge and experience can allow a greater range of comparison and analysis but it can also lead to prejudging an object. A jug, as we all know, is used for storing and pouring liquid. But there are some jugs that may never have been intended or used for this purpose.

All these investigations must, of course, be related to the specific work you are doing. You may find you do not have time to follow every pathway. Nonetheless, you should try to work with objects as often as possible. They are a source of information and understanding that is independent of the written word. They also put pupils in touch with the physical world – an important aspect of their education if they are to become aware of how much our present way of life is dependent upon material things.

WORKING WITH PICTORIAL MATERIAL

Pictorial material covers paintings of all types, style and age; drawings and illustrations of all types, style and age; photographs (from newspapers to mail order catalogues, family snapshots to propaganda); maps; decorations (tomb paintings, illuminated letters and so on); film; video; computer generated images; and any material in which pictures or pictographs are used.

The purpose of this chapter is to give an introduction to ways of dealing with this material in a general sense. It is not in any way meant to be an art lesson although most of what follows has relevance to that. However, if your major concern is with aesthetics and technique, then specialist or subject-specific approaches are best gleaned from those qualified to offer their expertise.

Working with pictorial material can be more difficult than working with objects or with documentary material, particularly narrative text. There are a number of reasons for this.

To begin with, whilst pupils are familiar with pictorial material (their world is saturated with it), they are not used to working with it as a source of more than rudimentary information. Where they encounter it in an educational context it is, more often than not, as an adjunct to and illustrative of narrative text. This not only places it in a subordinate position to text but also closes down many possible avenues of exploration and interpretation.

Most pupils' response to pictorial material is passive. This is not just because of the relationship of static images to text (written or narrated), but also because of the relationship to moving images. This is further complicated by the nature of much of the pictorial material to which pupils are exposed.

In essence, this creates problems in terms of subjectivity, linearity and passivity. We tend to respond to visual stimuli differently to the ways in which we respond to text. Pictorial materials also tend to evoke different responses to objects. Much of this is cultural and has to do with how pictorial materials are used. Advertising, for example, is ubiquitous. Such images (still or moving) are designed to create an emotional response whilst closing off any analytical investigation. Moving images, particularly those created for entertainment (and there is a whole discussion there is not room for here about the blurring of factual and fictional content), impose a narrative and make us passive consumers. Even interactive video games work within finite parameters and we consume the narrative created by others.

Added to this is the fact that, despite the different responses we have, if we overcome our passive relationship with pictorial material we still try to 'read' it as if it were narrative text. In other words, we look for a story, the single flow of information intended by whoever created the image. The advent of moving images has exacerbated this trend, although we have always done this. Nor can we deny it is one legitimate way of 'reading' pictorial material. But there are many others.

Static images can be 'read' in non-linear fashion. When we move away from realistic representations of the world, this becomes easier; pictorial materials then become more like objects in the way we can approach them. However, by their very nature they include content which is richer by far than objects or even narrative text. It is this richness of non-linear content that makes such material so difficult to 'read'; it is this richness that makes it so valuable as a source of information.

As with all the skills in this book, it is advisable to start with exercises and tasks that introduce the basic concepts. Before looking at photographs for their social content, for example, pupils will need to have formed the habit of looking at pictures with the intention of seeing. Looking at and seeing are two distinct things. We look at things all the time our eyes are open and our brain probably registers most if not all of what we look at. Seeing, however, is not simply physiological. There are also elements of intention, selection, analysis, understanding and so on. While these elements come into play naturally they are not often applied rigorously unless we are compelled to do so. So, when pupils are asked to study a picture they will, to begin with at least, simply look at it. To get them to see it, it is necessary for them to apply those other elements.

Visual acuity and aesthetic sense develop as the pupil grows to maturity. The ability to read depth cues and to discriminate between an image and the real thing are learnt at a very early age but this ability develops to lesser or greater degree over time. The same is true of the individual elements of the content (rather than their composition within the picture). Much of this development is linked with personal and social development. Much of this development needs to be taught. After all, a rudimentary ability to perceive expression in auditory and visual forms, present very early in a child's life, cannot be equated with an understanding of symbolic expression any more than looking at a picture of a poor person equates with a questioning or understanding of what lies behind the content of the picture.

The ability to make judgements about expression, style, composition, aesthetics and so on is only present at an early age under specially manipulated circumstances. Children do not make spontaneous judgements on these aspects of pictorial work before they reach adolescence. For 4–8 year olds, the main criteria of preference in pictorial materials is the overall subject matter and the colour. There is also a strong bias in children's preference for realism, starting at the age of 6 (when they begin to develop the psychological and motor skills necessary to produce realistic images) and peaking at the age of 11. It is only by the time people reach their late teens that they use composition and other elements as well as subject as criteria for sorting and evaluating pictorial material. And even then they are not always

equipped to make effective studies, that is, analyse and produce results to satisfy pre-set targets.

If you are working specifically with 'art' there is an extra dimension to consider – that of an aesthetic response. The ability to make judgements on aesthetics is related to the ability of a person to be able to take another person's point of view. The greater one's social and personal development (in which an understanding and sympathy with the viewpoint of others is essential), the greater one's potential for aesthetic appreciation.

There is a discernible pattern in the responses people make to pictorial materials consisting of several distinct evolutionary stages. Each stage represents the different concerns exhibited by the respondent as well as different points of view, growing knowledge and increasing self-confidence. The distinct stages of aesthetic development are loosely tied to developmental models such as Piaget's and can be summarised as follows:

- The listing of specific material objects, usually by subject and colour.
 Absolute judgements are made about what is seen based on a purely egocentric point of view.
- 2. Subject matter and the realism of its depiction become the focus of interest. A concern for the ideas of others is shown by trying to establish a general agreement of opinion about a given piece of material.
- 3. An interest in decoding the material in terms of its style, the school it represents or art period it belongs to evolves. This is a more objective stance and shows a willingness to refer to outside authority for information and ideas.
- 4. Next comes an interest in the experimental and emotional aspect of the material. This reflects a return of subjective elements to the way in which material is viewed. The main desire is to interpret the work's symbolism in a personal way.
- 5. The final stage engages the work from a variety of approaches which use all the previous stages, from analytic to emotional. Sometimes there is the desire to reconstruct and transform the artist's vision.

It is important to have gone into this at some length. An understanding of the way we develop an aesthetic sense and develop an approach to understanding visual material is rarely given the same emphasis as that applied to the written and spoken word.

Understanding the development and knowing what to do with that understanding are, however, two distinct things. Although individual forms of pictorial material need specific approaches, there are some basic approaches that can be applied to all of them. In all of this, remember that you are dealing with pictorial material. Do not ask for written responses to your exercises and other work unless you cannot possibly avoid it. Save that for later. To begin with, encourage visual and

spoken responses – stopping every few minutes to write things down, particularly emotional responses, can kill these skills at the outset.

Pitch the work you are doing to a level appropriate to the level of development of your pupils. At the same time, be conscious of the fact that you can assist that development. To begin with you can deepen their development at any given level. And secondly, you can help pupils move on to more sophisticated levels.

There are many kinds of pictorial material available to us and one of the joys is that it can easily be duplicated – especially useful if you wish to study the content of the picture rather than the way in which it was produced in the first place. Quality slides of paintings can be used time and again. Even a photocopy of a black and white photograph can provide material to work with. At the other end of the market are the increasing number of CD-ROM packages that contain works of art, old photographs and other pictorial material. Remember, though, there is no substitute for the real thing. If the originals of the material you are studying are available, then use them. As with objects, there is a psychological impact from seeing the real thing, be it an old photograph or engraving in the classroom, or an old master in an art gallery. Take your pupils to see them as much as possible. This is especially important for paintings, but it applies equally to film. If you are studying a film intended for the cinema then try to arrange to see it in a cinema. Even if you have wide-screen television a great deal of the scale and atmosphere is lost. If works of art define and reflect our culture these should be experienced in context and not in isolation.

To read a picture you need to be in the habit of asking and attempting to answer certain questions which will get you looking at the picture more closely, exploring its content in detail and seeing what is in front of you. Meaning arises when a person reflects on an experience he or she has had. By creating a situation where an experience occurs and then asking a person to describe this experience, that is to re-live it and reflect upon it, a more faithful account of the thoughts and feelings of that person will emerge.

So, whatever the material, ask pupils to look for a while and then consider the following questions. Stress that some of the questions do not have answers that are right or wrong. Use these questions as a framework for discussion – they do not have to be followed rigidly if you feel some of them would be inappropriate for the pictorial material or for the pupils you are working with. Most of all, follow up points of interest and see where they lead.

- 1. Imagine that you are going to enter the picture and explore it from the inside. Where would you start? Where would you go? Are there any places you would avoid? Are there any places you would prefer to be in more than others? What is in those parts of the picture we cannot see (that is, what is behind that building, tree, rock, what is inside that box)?
- 2. Imagine that you are a particular person or object in the picture. How would you feel? (This can even work with maps and abstract designs. After all, identifying with a crossroads on a map may lead to some understanding of their importance in society, transport and folklore). Try this with several or

- all of the persons or objects in the picture to build up an idea of how they may relate.
- 3. Imagine that this picture is a single frame from a moving image, frozen and put on view. What was happening before the image was frozen? What will happen immediately after the picture is unfrozen?
- 4. If you were to make a picture about this subject, how would you do it? Do it.
- 5. What type of picture (painting, drawing, photograph, sketch, detailed, still, moving, newspaper, magazine, art) have you been looking at? Does this make a difference to the subject matter and if so, why? Can you compare similar subjects treated through different media?
- 6. Why was the picture produced in the first place? Was the motive personal, social, emotional, aesthetic, propagandist? Is there anything about the content of the picture to suggest motive?
- 7. Does the picture contain people? If it does, are they central or incidental? If central, are they posing or caught naturalistically. If posing, are they dressed as they would normally be or are they dressed to suggest other things about themselves? Does it treat its subject accurately or does it gloss it over with a romantic light? What are the expressions on peoples faces? What are their postures? Are they aware that they are in the picture? What are they posed with (animals, family, possessions, against a scene from their lives)?
- 8. How was the picture produced? Does the method of production affect the end result? Has it been altered since it was first produced with additions, parts removed or by renovation, restoration and conservation? Do these alterations affect what you have considered about the picture so far?
- 9. Is the picture 'real' or is it 'fiction'? Can these categories apply to pictorial material? If they can, are they the only two definitions applicable (for example, what about landscapes composed of elements found in a particular location but which are not representations of an actual place)? Is there any way of telling from the material itself?
- 10. How is the picture presented? Is it left to say what it will (and is that honest given that it could be, for example, a digitally altered photograph or propaganda)? Is it accompanied by text or other pictures? Is it designed to complement text or vice versa?
- 11. What is your reaction to the picture aesthetically, critically and emotionally? Is it a picture you like? Why? Is it a picture you think adults would like? Why? Is it a 'good' picture? What does that question mean?

These sets of questions provide ways of getting close to pictorial material. They do not address ways of coming to terms with the content as that is entirely dependent upon the pictorial material you are using and the reason you are using it. In addition to them, you may need practical approaches to aid close observation. Some of these are suggested below. Many more exist and can be devised by yourself to fit your exact circumstances.

If you wish to study specific parts of a picture, be it the real thing in a gallery or pictorial material in the classroom, a piece of card with a hole cut in it can be a most effective means of doing this. The size and shape of the hole is entirely dependent upon your needs. Equally effective and more flexible are several pieces of card. These can be used to mask those parts of the picture not under study, thus aiding concentration. This is especially useful if you are studying forms of composition or the ways in which cropping photographs can produce different visual effects and psychological responses. Although you can do this with digital images on a screen, it is good practice to get pupils used to handling material objects.

To test observance and response, graphics software is an extremely useful tool. With a little practice it is fairly easy to make subtle (or not so subtle) changes to pictures you are working on with pupils. Changing the registration numbers of motor vehicles, removing or adding objects and people, expanding or reducing the picture but keeping the frame size the same so that more or less of the picture can be seen. All these can test how observant pupils are as well as testing response to such changes.

Maps, photographs and pictures of the same or similar scene produced over a period of time can be used to show how a place changes (or not) and the different ways in which something can be depicted pictorially. If you can produce enough pictorial material of a similar period of a single place (for example, your home town a hundred years ago) these can be used to reconstruct – perhaps in three dimensions – the layout of the place, providing an excellent starting point for local studies. It is important not to be afraid to translate the material that is available to you, perhaps even to the point of simple computer modelling of a building, town or place.

Maps and plans can also be made use of in imaginative ways. There are simple tasks such as asking for three different routes from A to B or a route that can be used by someone in a wheelchair. Conversion to three dimensions (from pictures as well as maps) is also a useful task that teaches how three-dimensional objects and/or landscapes are portrayed in two dimensions. This can lead to discussion and work on the usefulness of information on maps and other two-dimensional representations, whether or not there is enough, too much and so on.

More difficult tasks for more experienced pupils may involve greater concentration and a greater grasp of the skills involved. Working in pairs, one pupil (A) looks at a picture that the other pupil (B) cannot see. A must then describe the picture – its content, composition and so on – and B must make as accurate a sketch as possible from that description. Such an exercise is as useful in language development as it is in understanding pictorial material as pupils will soon see that they need to be careful and precise with their descriptions.

For pupils studying art who are expected to know and recognise something of the style and major works of artists, presenting them with small sections of pictures and asking them to identify the artist and the work, can be, for them, a useful if taxing experience. This can be done easily with a computer and projector. It is also another way of considering the importance of individual elements in any piece of pictorial material and how they contribute to the whole.

Many similar exercises can be done with moving images as well, making use of editing software. Perhaps the easiest is to show a short section of film depicting a specific event and then ask pupils to describe in as much detail as they can precisely what happened. It will surprise them how difficult it is for everyone to 'see' the same thing – a problem understood by the police, for example, when collecting statements from witnesses. The process becomes easier when you know that you are going to do the exercise beforehand, but life does not happen like that.

Reporting what has been seen can be supplemented by discussion of motivations of character (which works for fiction and non-fiction – after all, why is a particular politician saying what they are saying in such roundabout language?), camera techniques and some of those concerns that apply to photography, such as the motivation for producing the material in the first place.

Specific types of material will present you with specific types of problem that need also to be considered when using them. Portraits are a long established form of pictorial representation. The problem with most portraits is that they are produced at the behest of the sitter in order to present a public image. While the reproduction of facial features, stature and so on, may be accurate, it is possible for them to be less than truthful at the same time. One has to step warily when extracting information from the visual image, although it can be a useful exercise to compare a person's portrait with written descriptions of them produced by friends and enemies. Conversely, you can start with some written descriptions and a pile of portraits and, without revealing who they are, try to match them up. It is important always to remember that the picture was painted to make a point and the motivation of sitter and artist need to be considered.

Topographical works, although valuable visual records of the past, are also problematical. Landscape artists are often more interested in composition and technique than naturalistic reproduction. Their aim is to capture the mood of a place and if that means exaggerating some features and removing others then artistic licence allows for that. This does not invalidate their work but, as with portraits, it is important to know something of the artists and their motivations for a full understanding of their work to emerge When it comes to topographical artists there are other considerations. Many of their finished drawings were produced at a later date from sketches made on their travels. Sometimes the works were done from memory which, as we all know, is fallible when it comes to detail. There is also, even on the part of those professing to record their subject accurately, the desire to romanticise their subjects in keeping with the prevailing style (be that neo-classical, Gothic, Pre-Raphaelite and so on).

Photographs, we have been told, never lie. This is not true, of course, as all pictures 'lie' to one degree or another. Sadly, we have become used to accepting photographs at face value because our personal dealings with photography are straightforward and we are always able to fill in the background to a picture for ourselves. Photographs in the media and those used by propagandists (including advertisers) are produced by professionals whose aim is to evoke or provoke certain responses and produce certain beliefs. Even film, despite our awareness

of the process of editing, can be skilfully used to create what we believe to be the 'truth'. These problems are, of course, the ideal starting point for much discussion about the nature of advertising and manipulation, but they need to be in the front of your mind all the time and your pupils need to be made aware of them.

The final set of problems in using pictorial materials is allied to the use to which you are putting them. You will need to ask a different set of questions (or the same questions with a different slant) of a photograph if you wish to gain historical information than you would of a comic strip if you are studying various styles of comic strip artistry. Remember also that a single picture can be used for many different subjects and fields of study.

This chapter has only scratched the surface of what can be done with pictorial material. It is so prevalent in our society that you cannot help but be surrounded by it. In fact, it is so prevalent and so taken for granted, that we are vulnerable to the many ways in which it can affect us without our knowing. Having some defences against it are, therefore, very important. The best time to start building these defences is with pupils in school where they have the opportunity to explore and discuss these issues under controlled circumstances.

WORKING WITH DOCUMENTARY MATERIAL

Documentary material contains something written or inscribed that imparts factual information. Although documentary material is the most commonly used in teaching, I have quite deliberately placed it at this point in the book because all too often such material is regarded as the real thing and all the rest (sites, buildings, objects and visual material) are seen as second class or peripheral – frills to decorate written text. This is the wrong way of looking at things for ultimately all documentary material is derived from a first-hand interaction with sites, buildings, objects, visual material and with the people who have produced them. This is not to imply that documentary material is inferior to object material. All these things are of equal importance. All are central to an understanding of whatever is being studied.

The most obvious form of documentary material is a book. But writing and other inscriptions that serve the same function as writing can appear on any solid surface. Some forms of documentary material are more accessible than others and some are easily reproducible. However, do not assume that because you are dealing with the written word working can happily be confined to the classroom. In many cases, of course, it can but there are many opportunities for documentary research to be carried out in the field.

Perhaps the most easily accessible source of documentary material other than books is your local newspaper. The material is easily understood, comes provided with pictorial material and offers excellent information for the study of local history. You will find stories with follow-ups, sometimes running to many editions if the story is sufficiently important. And you will find much more as well – background features, listings, court reports, notices, advertisements and so on.

One of the pressing needs in using documentary material is to know how to gain access to precisely what you want. After all, consider how much information is contained within the pages of the books of your local library. It is of little use to you unless you know how to locate the particular books you require and then find the specific chapters or pages within those books. Librarians will help but they cannot do your work for you.

Libraries are frequently places that pupils learn how to use. But what of public records offices, public archives and the many other repositories that are prepared to give access to their material for serious study? Pupils should be introduced to these and their personnel as well. This is important because, as with other source

material, it is not just knowing how to interrogate the material that is important, it is knowing how to find it first. Learning to use catalogues and indexes is an essential forerunner to working successfully with other forms of documentary material.

Proper use means becoming acquainted with alternative terminology as catalogues and indexes may list the things you want but not in ways with which you are familiar. There are many systems of storage and retrieval and working these systems efficiently should be part of any pupil's education. Becoming familiar with alternative terminology is just one strategy amongst many. Learning to plan investigations, delineate lines of enquiry and formulate specific questions are extremely important. This is particularly true of online searches where vague search terms can lead to millions of results. Without well developed investigative skills you are likely to end up lost, pursuing the many and doubtless interesting side tracks you will find.

Although a definition of documentary material has been offered it will be obvious that there are grey areas. Dedication stones, gravestones, maps (which are also validly considered to be pictorial material), cereal packets, car manuals, are all valid forms of documentary material. But what of song lyrics, ballads, poems, novels and the like? In this you will have to use your judgement for some may give factual information and others may not (although all probably do in some way or another). What is more, whereas a piece of writing may not contain factual information within its content, factual information can still be derived from it. A manuscript version of a poem is a good example of this because it can tell us much about the way in which the poem was written.

One of the things it is important to learn, therefore, is how to discriminate between material that is worthwhile studying and that which is not. It is a skill for which there are few pointers because it depends a great deal on the enquiry being made. After all, most people would not consider popular romantic novels to be a useful source of information – unless, of course, you were studying the degree to which popular romantic novels accurately reflected the social conditions of the culture in which they were written. In the end, however, it is advisable, where possible, to seek out primary source material produced from first-hand experience.

One thing about documentary material is that it has a tendency to generate documentary material. Anything recorded by pupils (including field sketches and notes made from reading documentary material) all count as documentary material. Tell pupils this. It will make them think about the accuracy and relevance of their recording as they will be well aware of the frustrations of working with incomplete material from the past.

In essence, you work with documentary materials to gain information from their written content. However, you have to be aware of the fact that documentary materials have an existence independent of the written words they contain. For example, a book produced by seventh century monks is equally interesting as an object (in terms of study) as it is as a piece of documentary material. What is more,

the information gained from investigating it as an object has direct relevance to the information that can be gleaned from the written content.

As with any material, it was not produced for the same reasons for which you now wish to make use of it. However, this should not prevent you making enquiries to extract the information you want as long as you take this into account. Before you start, however, as with any enquiry of source material, you should try to establish the provenance of that which you are studying. In most cases someone reputable will already have done this and the location of the material is often a good indication of authenticity. The internet is a different matter. There are many reputable websites containing authentic and reliable digitized versions of documentary material. There are also many unreliable sites. Learning to discriminate between them is something that clearly needs consideration.

Most of the documentary material that you will find in the classroom is not primary source material. It is translated, edited, printed legibly and generally sanitised for the educational market. Even accurate reproductions are just that – reproductions. The value of seeing and working with the real thing extends to documentary material.

The use of archive material, catalogues, libraries and documents presents enormous problems as they are virtually useless unless the skills exist to find precisely what it is you are looking for. Preparations for using archive and other documentary material – selecting the material that will be of most use, analysing its content, collating retrieved material and so on – can be time consuming and needs to be done with great care. Any material that you select should be appropriate to pupils' skills and needs. It should also, especially when your pupils are inexperienced, be as self-referencing as you can possibly make it. That is, you should begin with materials least likely to send pupils off into blind alleys and along other routes that have no relevance to what you are studying.

Much documentary work can be tied in with information technology. The construction of appropriate databases, storage, retrieval and manipulation of information is an important part of the process. However, as much as information technology may aid the process, it is the source material and information that can be extracted from it that is important. Time away from computers is much recommended.

Indeed, much work with documentary material is at the opposite extreme from the high technology of computers. It involves a person and the material plus paper on which to make notes. And one of the most important lessons to learn is that when you work with any documentary material in this way you only ever use a pencil. If you accidentally mark source material then it can be erased (not by you, but by the keepers of the material). Drop a pen onto a document and the ink stain may be permanent – as will be your banishment.

Having made all your preparations and gathered all the necessary equipment, work can begin. By treating documentary material as an object you can pursue the lines of enquiry already outlined in Chapter 12. When it comes to the content of the document you will be making two distinct forms of enquiry that can be

done separately but which are interrelated. The first of these is concerned with the production of the material – that is, the how, why, what, where, when and so on. The second is concerned with the information it contains and how this can best be extracted to suit your needs. To investigate the production of the material as documentary material (rather than as objects) you need to ask the following questions to see what answers the material offers.

What form does the document take? Is it a letter, a statistical report, a carving, a diary, a baker's bill? The form can have a bearing on the information contained. A diary, for example, may contain the true feelings of the author with regard to other people, but is likely to be less than truthful about their self. A statistical report, on the other hand, may be long on facts without ever giving a flavour of what those facts are about. For example, knowing that a percentage of households have no electricity supply or running water tells us nothing about the people involved. Consideration of form should also include the size of the material as this can have a direct bearing on both the content and the place of the document in a wider context.

How was the document written? In one sense this set of questions belongs to an investigation of the documentary material as an object. However, all such investigations have relevance to the content of the material, this more than others. The physical act of writing will have a bearing on the content. For example, a person who must make all their own writing materials at considerable material and temporal expense is less likely to produce a sex-and-shopping novel than a person with a word processor. You need to consider, therefore, what implements and materials were used, their source and how they might have affected the style and content. Also worth considering is whether it was written in code, a private shorthand, invisible ink, big letters, small letters; was it dashed off or beautifully decorated?

Is the document real? There are, of course, different ways in which documentary material can be not the real thing. It could be fiction (not in the conventional sense of a novel but in that it is simply made up), it could be a forgery, it could be substantially genuine but doctored (with small additions, omissions or changes) or have corrections and glosses added by other hands at other dates. Even if this is the case, such documents are worthy of study. In the first instance it is instructive to investigate whether or not the falsity can be spotted. Secondly, if falsification has taken place, what were the motives for such an action? There is another level to this question in that you may have the genuine text, just as the author produced it, but is the content 'real' in the sense, for example, of being 'real' history or 'real' biography? By this stage, of course, you need to consider what is meant by 'real'.

Who wrote the material? Is the material you are working with the author's work or has it since been transcribed? There may well be a difference between the original material and that which results from transcription. Until the invention of the printing press, all books were copied by hand, often in locations many hundreds of miles from where the book was first written. Is a transcription under such circumstances an original or a copy? The transcriber can also become (wittingly

or otherwise) an editor. A Christian monk writing down pre-Christian oral tales will make changes in order to make the material comprehensible and acceptable to himself and to his intended audience. Even if the material is a straight copy of earlier material now lost to us remember that copyists can make mistakes.

When was the document written? The time in which a document is produced will have effects upon style and content as well as the intent of the author or copyist. Social pressures will prevent certain materials being produced. And not all forms of presentation have always existed or exist as they do today. Many of the conventions of style and layout that we are used to are relatively recent developments. The meanings and emphasis of words also change with time. The word 'naughty' no longer has the impact it did in the sixteenth century, for example. Other words may have become obsolete, styles of shorthand were more common than now, spelling was not standardised. Even more problematical is that if you go back to earlier than the fifteenth century AD then your native language begins to resemble a foreign language. You may need to spend some time becoming proficient in earlier forms of your native language or else be prepared to use a version of the document rendered into contemporary language.

Who was the document written for? The original readership must be considered as that will have affected the style and content. Are you part of that intended readership? If not, how should that affect your reading of the material? Are you, for example, reading personal letters that were never intended for publication? Are you reading a report that was originally produced in secret?

Why was the document written? Consider the motivations that prompted the production of the material. Was that motive personal (for example, a diary or a letter), extra-personal (for example, a gravestone done at the request of someone else) or a combination of both (for example, a social commentary – personal concern prompted by social conditions)? Did those motivations change as the material was being produced?

Where was the material written? The place of origin can have a bearing on the content. Was it, perhaps, written in First World War trenches or in a pcaceful garden, in an office or on a bus? The place will also have a bearing on the language in which it was written (as will other factors such as the author and the time). If you do not know the language in which it was originally written then you will have to rely on a translation. This can cause problems as there will always be variations that can affect understanding of the text. Is more than one translation available? There are also some words and terms that simply cannot be translated without them losing their sense completely. It can, however, be fun to try to tackle documents in a foreign language under the right conditions. Documents written in Latin contain enough words that are root to contemporary English so that a degree of sense can be made of what was written, provided of course you can first decipher the handwriting.

Once you have collected this sort of information, you can begin to extract what you require from the content of the documentary material. This is perhaps the most difficult exercise as there can be no formula. The nature of your project determines

the sort of information you require and it is largely up to you and your pupils to design methods of extracting and recording the salient details. To this end it is best to start with something practical in which the documentary material is limited by the nature of the project.

A good example of a project of this type is a full survey of a graveyard. Not only can you involve the other skills already discussed, but you can record what is written on the gravestones and use that as your documentary material. The beauty of it is that you have a strictly limited amount of material and there is little danger of pupils being sidetracked as they might if they were let loose in a public records office or with every back issue of your local newspaper. A further advantage is that although you may, in the first instance, limit yourself to the content of the gravestones, there are other forms of related documentary material available should you decide to expand your project – material that can be rationed to prevent too rapid expansion. You can examine parish registers, the obituary column of the local newspaper, census returns and so on. So, despite being finite, a graveyard is sufficiently rich in material to provide useful work.

You could, also, be providing a useful record which has been made by no one else. Older graveyards are disappearing, being 'rationalised', cleared, turned into parks and so on. These things often happen without a proper record of them being made first. And even where a good record does exist, it is still useful to record graveyards over a period of years as this provides an additional record of how they are standing up to the vicissitudes of time.

It is not necessary to do a full site survey if you are working on a graveyard – recording the inscriptions on the stones will provide sufficient material to work with. However, as a lesson in showing how the document-as-object is as important as the document-as-content, it is worthwhile trying to do a full survey. The position and orientation of stones as well as their physical properties and condition can add much information to that gleaned from the inscriptions.

If you do decide to go ahead, take into account the time of year. Winter gives you a better view of the stones but it is, of course, not so pleasant to work outside. Each memorial should be recorded both individually and in the context in which it occurs. Methods for surveying the yard have already been discussed in Chapter 10. In general terms, the orientation and location of the site will have a bearing on the state of memorials and monuments. What is important is that when you have finished you must be able to relate individual records to their context – that is, to their position on the site. The finished site plan is in itself a document and needs to be as legible as possible for future generations.

When recording each memorial, the following details should be documented:

- The type of memorial tomb, slab, headstone, footstone and so on. It can be instructive investigating and, perhaps, inventing categories.
- · The shape, dimensions and orientation of the memorial.
- The shape, dimensions and orientation of the grave if it can be seen.
- The geological identification of the memorial. If you are unable to do this,

record its colour and a detailed description of the material used.

- The face or faces on which inscriptions appear.
- All of the inscriptions in full, whatever language, and how they were made.
 If you can, make an exact copy or take a photograph to show the style and size of lettering accompanied by a transcription including translations of foreign words and the source of any quotations.
- The decorations and/or symbolic devices that appear on the memorial.
- The name and place of origin of the mason and/or undertaker.
- The condition of the monument and its inscription(s).
- Photographs of the memorial for future reference.

Once your survey is complete you will have a set of documents with which to work. The use of a computer database can make investigation of this data easier. This material will allow for many types of investigation – the distribution and popularity of names, age at death, distribution of families within the yard, social status matched to style of memorial and so on.

It may be that using a graveyard is neither convenient nor appropriate for you to start investigating documentary material. There are other approaches, such as the use of a set of street directories for one location covering a period of time. Maps, too, provide an excellent source of material. The important thing is that you get pupils to investigate documentary material for information and that they understand that it is on a par with other sources such as objects or buildings.

USING A LOAN SERVICE

A museum that houses collections may well have a loan service. That is, a proportion of the reserve collection may have been set aside for the specific purpose of being loaned out to teachers to use in schools. There are many forms of loan service ranging from pre-packaged boxes of material on specific themes or subjects to the supermarket approach where everything is laid out on shelves and you pick what you want. Some museums produce leaflets, catalogues and lists, others leave it very much up to you to find out what there is. The ways of making good use of what you borrow have already been dealt with. This short chapter is concerned with some of the more general aspects of making good use of a loan service.

There is more to a loan service than meets the eye – much more. Your dealings with it are only a small part of the picture. The material has to be selected based on criteria that satisfy both the keeper of the material and the education personnel; it then has to be catalogued for the loan collection, sorted, stored correctly and presented in a way that is useful for teachers. An administrative system has to be set up to cope with loans – and there are many professional, ethical and legal considerations involved in this. That system has to be run. The service has to be marketed. The staff member in charge has to deal with queries, suggest material for use, gather loans together for when they are required, sign them out to schools and then, when they are returned, check everything in the presence of the person who borrowed them to ensure that everything has come back in the condition that it was lent out. Even if the material is in fair condition on return, decisions have to be made about conservation of that material to ensure its continued use as loan material.

Bearing all that in mind, you will need to allow yourself sufficient time when borrowing and returning material and remember why it can be such a time consuming event. You can, of course, make good use of that time by talking with the museum personnel involved. Ask whether there are new acquisitions to the loan collection. Give them feedback on how well (or not) your pupils worked with the material you are returning.

You need to be very clear in your own mind why you wish to use loan materials. One thing you should try to avoid, unless you have no other option, is using a loan service as an alternative to visiting a museum. Working with materials in the classroom is a valid exercise and should be done whenever you can, but it can never be a substitute for leaving the classroom and making a visit. There is too much else that happens during a visit that you cannot replicate.

Preparatory and follow-up work are ideal times to introduce loans to your pupils, but it is worthwhile using them on a more regular basis as pupils need contact with our material culture. However, never introduce objects in a vacuum. 'Today we are going to learn how to look at objects,' may be all right for undergraduates on museum courses, but younger pupils will need a context. So, too, do the objects they are working with. Use them to enhance work you are already doing and introduce the skills for working with them as you progress.

In addition to that, there are other points that you should keep in mind when considering the use of loan materials. To begin with, do not assume you can obtain any object you want. Your local museum may not hold such material in its collection or its reserve. It may be that what you require is held elsewhere so be prepared to do some research and to travel to get what you want.

Furthermore, do not assume you can have what you want when you want it. Other people use the loan service as well and they may have beaten you to it. Be prepared to consider and accept alternatives to what you originally intended to borrow.

Do not borrow anything you are not familiar with. See it before committing yourself, otherwise you may end up borrowing something you have no use for. Not only does this disappoint your expectations, but it also creates unnecessary work for the museum and may well deprive other teachers of something they wanted.

If you have made an appointment to see the member of museum staff in charge of the loan service, keep that appointment or give reasonable notice if you will be unable to attend. Apart from being a common courtesy, it is worth remembering that all museum staff are very busy – they are not there just to satisfy your needs.

Do not be vague. Few things are more exasperating to a museum education officer than being asked, for example, 'We are studying the Civil War, what have you got?' Running a loans service is a complex and time consuming task. Know what you want and why you want it. If you know why you want to borrow something and can explain that to the museum personnel involved they may be able to suggest an alternative if they don't have what you want or something that would better suit your intentions.

Be sure to plan well in advance if you intend to borrow materials. You certainly cannot ask for things for the following week. The further you plan in advance, the better chance you stand of getting what you want when you want it, and of having a chat with the museum education staff who may be able to suggest additional lines of enquiry or better objects to borrow. Never choose on the spur of the moment something you see when collecting something else. Remember it and use it another time.

Keep your requests within reasonable limits. Do not ask for too much material at one time – a real temptation if the service is free and you have only just discovered it. You will not be able to use it all effectively in the time available and if you litter your classroom with too many objects the impact is lost. A single object well chosen and presented can have as much if not more impact than a hamper full of odds and ends. What is more, if it is a pick and choose service, the more you

borrow, the more paperwork you create for the museum and the less you leave for other teachers. Choose only what you really need.

Remember that stocks are limited. What they have is what they have and they cannot conjure up anything else no matter how badly you might need it. You are dealing with a finite resource – plan your work around what exists.

Remember also that you will not get the best. You certainly won't get material that is suitable for display – it will be on display. You won't get research material. You won't get valuable material. Loan collections are made up from those items that curators and keepers of collections have no use for – unless they are enlightened enough to consider education a prime function of their museum. For all that, you will not be offered rubbish. However, be realistic in your expectations and make a virtue of the condition of the material you will be borrowing. In many respects what you get is better suited for teaching than material you would not be allowed to borrow.

Always make use of the education officer or member of staff who has responsibility for the loan material. They know the material well and they will be able to suggest how best to use it – if they have time. Be helpful and give them time.

In order to fulfil the above and to gain experience in the care of materials in your custodianship, ask the museum to run a training session to introduce you to the loan service, its collection and the best ways of handling and working with what is on offer. In some cases, you may find that you have to attend such a training course before the museum will allow you to borrow any loan materials.

Although the best work is obtained from targeting material to very specific areas of work, loan materials can also be a useful general stimulus for discussion and work not directly related to the loan materials. Art classes, for example, can use objects as still life models or, along with students of design, look at the construction of objects and relate that to aesthetic considerations. An object may be offered as the stimulus for written work (creative or descriptive) or for discussion. There are many ways in which objects can be used in school and their proper use will greatly enhance the education that your pupils receive.

USING SIMULATION

This chapter looks at some of the techniques that can be used in association with museum work that come under the general heading of simulation. In this context, to simulate is to mimic, imitate or to pretend to be someone other than who you actually are in an interactive situation to gain a better understanding of a given relationship, event or way of life. This can be done in many ways with pupils either being active or passive with many degrees of involvement in between.

Of all the activities that you can do in association with museum work, these are the ones that are most open to criticism. Many people cannot or will not see the relevance and can be quite openly hostile to this form of working. They argue that it is not an appropriate way of learning, that it is not intellectually rigorous, that it wastes time better spent on other activities and so on. It is perhaps understandable in some senses for, more often than not, an outsider's attention will only be drawn to simulation work when pupils are at their noisiest and their work apparently chaotic. It is essential, therefore, that you as a teacher are fully aware of the aims and the long term nature of the use of simulation and that you are prepared to explain this to others.

The first thing you need to be clear about is that you are dealing with more than one entity. In fact, there are seven: story-tclling, drama, role play, theatre, living history, re-enactment and simulation games. Although these activities have much in common, often overlapping in terms of style, content and skills, they are sufficiently distinct to warrant considering separately. They are all valuable tools for understanding and each one has a specific role to play (a pun worth thinking about). Understanding those roles is important if you are to get the best out of these activities.

Important, to begin with, is the understanding that these are essentially activities. This is very much in common with the other ways of working in museums that we have already looked at. Pupils must be actively involved and participating if they are to get the most out of this work. Even when they are an audience to the activities of others, they must have sufficient skills and understanding to be critically engaged with what they see so that they do not simply accept what they are told and believe it without satisfying for themselves that certain basic criteria have been met.

One of the major criticisms of simulation in relation to museums is that it is a creative activity in which people make things up. This is nonsense. Nobody can

conjure things out of thin air. Even the most outlandish and fantastic piece of fiction has to be based upon the experience of the author and a communality of experience with the readers. If this was not so, it would be gobbledegook. Historians also make things up — the only difference between them and writers of fiction is that what they make up has to be verifiable with what is known about the period of which they write. They research, marshal facts, come to some sort of understanding or interpretation of those facts and then write them down in a coherent narrative form. It is only the obsession our culture has with the written word that makes this more acceptable as the finished result than a piece of theatre, for example, even if that piece of theatre is based upon the same level of rigorous research.

Story-telling, drama, role play, theatre, living history, re-enactment and simulation games are not, of necessity (as some would have us believe), pieces of fiction. A group of people can do scholarly research, marshal facts, come to an understanding of those facts and offer their interpretation as a stage play about a specific event, as a re-enactment of daily life, by adopting a specific role and staying in character to become a living textbook about a specific way of life or by producing an interactive computer game.

In doing this sort of activity, however, there does not have to be a finished product in terms of a presentation for an audience. That may well be an aim and it may be demanded of you as proof that your time is not being wasted. The importance of the work, however, lies in the participation that pupils can undergo, often coming to an understanding of something that they could gain in no other way. It is that understanding which is the major aim of this type of work. For, no matter how much you may study objects, buildings, sites and so on, academically, you will not get your greatest understanding of them until you have inhabited them and used them.

Just how this relates to museums and work in museums is an important aspect of the success of such work. After all, the skills looked at so far can be directly related to what can be seen and found at a museum. Simulation may not, at first sight, have any direct connection, no matter how important it may seem as a way of learning. However, the connection is not so much in the work done because simulation can be applied to many aspects of the curriculum. The connection is in the approach to the work you are doing. Up to now, most of the skills we have looked at are intellectually based. But work cannot be produced solely in that way. Ask anyone who works in a museum and, if they are honest, they will tell you that intuitive skills and creative imagination (drawing on an intellectually based fund of knowledge) are just as important in reaching an understanding about whatever is being studied.

One of the best and most enjoyable ways to exercise the creative imagination and intuitive skills is through simulation work. With these skills at your command you are adding another tool to aid your understanding and another dimension to the way in which you interpret things. Once acquired they can be applied in ways other than those normally associated with such activity. Painters, modellers and taxidermists, for example, need these skills to recreate events, places and objects.

So, too, do the likes of armourers and palaeontologists, especially when they are trying to reconstruct something from two-dimensional sources.

The use of simulation is important for other reasons as well. Deliberate and programmed use helps the nurture of skills in self-expression which involves as much critical reflection as it does action. In respect of work with material culture, simulations can be said to have the following aims, each of which is as important as and interdependent on the others.

Simulation provides a wide variety of direct experience (as far as is possible in a contrived and controlled situation) of those conditions of human existence connected with or derived from those parts of material culture being studied. As such, it helps to develop understanding. Pupils continuously gather information and form impressions about material culture. By engaging in simulations and thereby expressing how they feel about these impressions and discussing them with others, they will be able to clarify, understand and develop them.

Simulation is an aid to the development of imagination. Imagination, to many people, simply means the ability to conjure fantasies in one's mind. In simulations, however, imaginative work has the more specific aim of enabling pupils to restructure and re-create reality in order to transfer their self into situations and identify with persons normally outside their experience. Such use of imagination helps towards a sympathetic understanding and tolerance of situations as well as the lives and world views of other people.

Simulations give pupils the chance to work successfully in ways other than the standard classroom format and so discover that there are other routes to learning – particularly ones that are not dependent upon the written word. By placing pupils in a wide variety of learning situations, simulations can foster confidence through discovering, discussing and practising appropriate ways in which to behave and react in unfamiliar situations.

Lack of fluency can be a real problem for pupils. Lacking the ability not only to convert thoughts into words, but to string them together coherently and relate them to specific situations can be extremely frustrating. Simulations deal with this by presenting pupils with situations in which they are expected to communicate a wide selection of thoughts and ideas including those which are not native to them. This gives them the opportunity to experiment and practise in controlled and comfortable circumstances in which there is a genuine context.

Simulations help pupils to learn to listen. Articulating thoughts is only half the problem. Practice of speech is only half the solution. The ability to interpret sensitively what is heard is essential if we are to come to appreciate and understand the world. Close listening is also valuable in the development of the ability to concentrate. But above all this is the need not just to hear what is being said by other people but to actually understand *what* they are saying and the *way* in which they say it. Through the use of creative, imaginative and progressively sophisticated simulation this need becomes essential to successful work.

Simulations provide pupils with opportunities to organise their ideas and their view of the world. Pupils are given the opportunity to practise and improve their ability to organise their intellectual and intuitive faculties. Involvement in a simulation, if it is to succeed, demands a genuine understanding of the content of the work, understanding that emerges from being faced with the practical problems involved. This practical approach not only leads to a deeper understanding and appreciation of the construction of that which is simulated than does academic analysis on its own, but it also concentrates the mind of the pupil on the resolution of the problem in ways that academic study cannot even approach.

Simulations encourage the use of positive critical faculties. They are controlled situations, providing the opportunity to explore safely situations that would, in reality, be dangerous. They are also, by their nature, situations in which pupils will make mistakes or, perhaps, play out crude notions of life. All simulations, if they are to be worth the time involved must provide opportunities both during and after for pupils to make valid, sensible and constructive assessments of events – exposing them to the insights of others. This will enable them to consider alternative approaches to failed strategies and to build more sophisticated notions of life.

Simulations assist pupils in the passage to adulthood. One of the most important problems that pupils have to face is that of adapting to an adult world – often represented by material culture. All too often they are left to their own devices to pick up what notions of the responsibilities of adulthood they can. Some never do. Simulations connected with museum work will invariably involve the exploration of the adult world. By discussing, practising and exploring the sort of adult situations about which pupils may be ill-informed or in which they may feel ill at ease, they can come to some understanding of that which they will inherit.

Finally, simulations encourage creative and innovative faculties by offering first-hand experience and understanding of creative activity which is a strict and exacting discipline. The demand for personal involvement increases sensitivity towards mood, atmosphere and emotional depth which are invaluable to all persons in all aspects of life, most (if not all) of which require a degree of creative activity, be it in writing a novel, cooking a meal or coping well with a crisis.

Some of these aims may sound like extravagant claims but they are nonetheless true. It is important never to lose sight of the important and underlying reason for education – which is to provide pupils with the wherewithal to live good and useful lives. Simulation, to whatever surface aim it is directed, is work that brings pupils closest to that underlying reason. It is this importance that makes simulation work such a potent tool in exploring material culture and its motivations.

Simulation can provide an insight into what it was like to live at a given period in the past or explore specific events and give all sides of the story. This does not have to be done explicitly. Simulation should be one of many layers involved and woven in with all the others for it needs those other layers to give it depth just as it adds breadth to them.

Any use of simulation has to be well prepared to be convincing – either to those involved or to an audience. Do not assume that because children play make believe they can take this sort of thing in their stride. They cannot. Simulation work needs

much practise and experience to carry it through. Do not let this put you off, but be prepared for a lot of hard preparatory work.

Preparation *is* important, but do not load pupils down with too much. Give them sufficient material to engage effectively in the simulation but also give them sufficient space to explore and make the most of the material and the situation. Remember, the situations with the simplest rules are easiest to learn but provide the most complex of situations.

Simulation works well in school but it is better if at least part of it can be done at the museum you are involved with. There are many ways to achieve this. Part of your museum work could be research that provides the background information necessary to engage in a simulation. Conversely you may wish to simulate certain events so that pupils, when they come to visit the museum, better understand what it is they go to see. Or both of these could apply. The important thing is to ensure that it is properly integrated with everything else you are doing so that you get the most out of your visit.

There are, as was mentioned earlier, distinct forms of activity that come under the heading of simulation. We will now consider these individually to see how they can contribute to and enhance your museum work.

STORY-TELLING

Story-telling is an ancient, venerable and powerful art. Until the advent of widespread literacy it was a major means of communication. Most of our enduring myths, legends, folk-tales and epics existed for hundreds of years solely in the memories of story-tellers. For many communities, even today, a visit from a story-teller is a major event.

Nowadays, there are some who look down on story-telling as something suitable only for small children. While it is true that small children thoroughly enjoy being told stories, the skills involved in listening to and becoming involved with an oral narrative can be developed to the highest levels of sophistication. You only have to think of the popularity of the theatre in the sixteenth century when plays as sophisticated as Shakespeare's were highly appreciated by an adult audience that was largely unable to read or write. Story-telling, therefore, is not just for small children. Pupils of all ages and all levels of ability can enjoy listening and engaging with the process.

As a correlative, there are many levels of telling. A story-teller will need to use many different approaches in order to be successful. Engaging the interest of five year olds is different from engaging the interest of fourteen year olds or adults. Yet, if it is done properly, the results can be extraordinary.

It is not always possible to find a professional story-teller although there are more of them about than you might imagine. There are also a large number who do not even know that they are story-tellers. I refer, of course, to teachers, most of whom teach through story all the time. When you talk to a group about a particular event or person, when you describe an object or place, when you give instructions

or talk about issues, when you engage pupils in discussion about these things, you are story-telling in the best sense of the word.

It can be at its most powerful for pupils when it is used – by you, by a guide, by a museum education officer or by a professional story-teller – to weave a tale about an object that is in front of them or about a place that they are in. And this tale, whatever it may be, does not have to be fiction. This belief is a common error. Most stories derive from the real world and some of the most powerful to be told are about real people in real places and the things they did.

Nor does the audience of a story have to be passive. They participate, of course, by being there and listening. But the best stories involve pupils at many levels and offer them the chance to contribute, discuss and carry the story forward. The story-teller can use props, puppets and any other device to draw pupils in. Relevant, careful and subtle questioning can involve the audience while improving their knowledge and understanding of the things being related. And the fact that they are enjoying themselves at the same time will generally ensure that the experience will be remembered.

DRAMA

Drama is both method and subject. It uses certain ways of working – improvisation being foremost – that are participatory and interactive. It involves nothing but the participants, their experience and their imagination. As a subject in its own right it is concerned mostly with the personal development of those involved.

I cannot, within the scope of this book, teach you how to do drama work. That is something you must do for yourself. It is as much to do with confidence as anything else and is always worth trying. If you do not feel up to it, you can always look for alternative ways forward. The most obvious of those is to find someone who is a drama specialist and persuade them to work with you.

Drama works in an open space both physically and metaphysically. It is, therefore, well suited as a means of exploring those situations and events associated with the particular elements of material culture you are studying.

With drama, however, you are engaged not so much in instructing pupils as in creating areas of learning and experience for them to explore. And you must be prepared to share in that learning and experience. It is not enough simply to provide an initial stimulus and then sit back and wait for something to happen. Left entirely to themselves in such a situation, pupils are unlikely to extend themselves into completely new areas. Pupils need to be guided into the learning space. Once there, they need to be given assistance to explore it thoroughly and make the most of the experience.

The key word is 'explore'. Drama is not, generally, about producing a polished end result. It is about going into that open space and experiencing the tensions, conflicts, harmonies and joys of situations and events arising out of human relationships in a safe and controlled environment. The fact that you are not after a polished result does not negate the value of the work done. What pupils have done

is participate in actions, decisions, emotions and the like. And in that participation they have had the opportunity to deepen their understanding.

As such, drama is somewhat like a discussion or debate (especially so for pupils not used to such formalities) in which concepts are moved on, step by step, to more sophisticated levels. At the same time it is possible to explore alternatives to accepted understanding of situations and events or to alter known facts and consider 'what-if' scenarios. However it is used, and whatever activities take place, pupils bring away from it a more sophisticated view of the world to apply to their studies.

Drama is also very flexible. It will fit anywhere into a programme of work. It does not require special equipment so it can be done at any time and place. It can even be done on the spur of the moment if the situation demands as it needs no preparation beyond the situation that demands its application. What is more, the mind set behind the method and the skills is transferable. Someone who becomes accustomed to interactive participation and to improvisation can apply these skills and approaches to other areas of work. All in all it has much to recommend it.

ROLE PLAY

Role play is, in spirit, very much like drama, using the same skills and techniques. However, it differs in one important respect for role play has taken drama a step towards being theatre. That step is into the area of characterisation.

Whereas drama is principally concerned with situations and events, role play focuses the work of drama to give the participants an opportunity to explore and experience specific ways of life and the relationships between those ways of life. As an example, you might explore the life of parlour maids and their relationship with the employers of parlour maids. This means that you have a specific and more narrowly focused aim. It also means that the work you do is more structured, as much by the content as by the intent. Yet, despite this, there is still plenty of room for spontaneity and exploration.

A basic understanding of the roles involved is essential if role play is to work properly. There are many ways of achieving this. The important point about enacting these roles is to experience something of the dynamics involved. It is, after all, easy enough to teach about the roles of servants and masters, for example, but until these roles have been given the chance to live, it is difficult for pupils to appreciate them fully.

Of course, these roles do not have to be in conflict. Exploring the daily life of seventeenth century villagers, looking at the many tasks they had to perform and the social structure of the community in which they lived, involves little or no conflict yet still enables pupils to come to a better understanding, especially if some of the realities of that life are now remote. That is why role play is best suited for on-site activity at certain types of museum.

In a sense, you could say that role play is theatre without the script. You have made a move towards a structure through improvisation and through the very

nature of the roles being explored. This can be taken further once pupils are used to working in role. Situations can be devised and pupils can be given background information through the medium of a news-sheet containing articles pertinent to the situation. Each one can be provided with a 'Book of Manners' explaining their social status and the appropriate responses to others. They can then be given a set of 'signposts' to guide them through.

Structured improvisations like this can often provide a wealth of further information to be explored at a later date. They also provide a useful progression from situation based drama work. And, as with much of this sort of work, it allows pupils to find the level of involvement they can best cope with while providing the opportunity to step up a level whenever they feel able to commit themselves.

THEATRE

Theatre is using the skills of drama and the theatre arts to explore and then present a specific event and the persons involved. It is, perhaps, the most ambitious of the simulations to undertake. With theatre you are committing yourself to producing a polished performance. You have to be certain about what you are doing and what you hope to achieve. You also have to have a group of pupils committed to this, otherwise you will not succeed. Against that, however, you have to balance what you can gain from taking this route.

To begin with it gives you the opportunity to look in some depth at a specific event and the people who were involved. As this event has already happened it is, in a sense, already scripted and that script can be played to. You and your pupils may need to extract the salient parts of the script to craft a piece of theatre but that is all to the good in terms of understanding the event. Preparing to play specific parts can involve a great deal of research and lead to insight into the character. Nor is it just writing a script and interpreting roles. Preparation of costumes, props and sets can also provide useful insights into those aspects of the period or event under study. There is a lot to be gained from this way of working.

Theatre can also be watched. Other people's interpretations are worth considering – there are many professional companies and theatre-in-education groups who not only perform but offer workshop sessions. And don't forget video, very useful for providing background information, points for discussion and comparisons between real events and fictionalised versions of them.

LIVING HISTORY

Living history is a cross between role play and theatre. It involves actors who inhabit museums as characters relevant to that museum and who interact with visitors. These actors more often have roles rather than taking on particular characters, although it is possible to find historical personages being portrayed. They also have a prodigious wealth of background knowledge and can be interacted with in

many ways. In some cases, such as craftspeople, the knowledge they have is first-hand and can be demonstrated in a practical way.

This sort of activity is well rehearsed, works partly to a script, but is backed up with sufficient background information and understanding to be flexible enough for variation and improvisation — especially when visitors interact with those who are playing parts. It is best left to the professionals who have the time to invest in the research and who have the back-up to play with as well as the background to play in.

Although it is very popular to make use of actors in this way, living history puts people between you and the source and you have to work to their agenda and their interpretation. They may be more flexible to use than a book, for example, but they are just as rigid in being a barrier. In some cases they are worse. At least with a good book you can check the sources of the author. It is also all too easy for pupils to interrogate these folk and get all the answers they need without ever thinking about things for themselves.

If you are going to visit a museum that has some form of living history display then prepare your pupils for this. Get them to consider what sort of questions they would like answered. Try to get them to avoid obvious questions and ones that are closed (requiring 'yes' or 'no' answers) and always give them plenty of work that involves first-hand investigation.

RE-ENACTMENTS

A re-enactment is theatre without the script. One of the reasons for this is that it does not need one. This is not to say that a re-enactment need not be precise, especially if it is the re-enactment of an actual event such as a battle. However, the purpose is not to re-create in detail the personalities or motivations involved so much as it is to demonstrate *how* things were done.

To this end, as much background knowledge is required as for other forms of simulation. Professional re-enactment groups often go to quite extraordinary lengths to ensure their clothing and accoutrements are as authentic as possible. In some cases this has led to the need to rethink what we thought was known about certain things, for example, the way in which Roman body armour was made. Which ably demonstrates the importance of such an approach to understanding material culture.

It is worth considering taking pupils to see re-enactments although they will have less opportunity to interact with what is going on. Some re-enactment groups also do workshops. Better, in the end, is to work towards re-enactments of your own. This may not be quite as polished as a piece of theatre but it involves as much hard word to produce. It also means that you provide more opportunities for pupils to participate and perform, especially those who could not cope with giving a theatrical performance.

SIMULATION GAMES

Simulation games are a well established way of exploring complex issues, situations and events. They range from very simple exercises lasting half an hour or so to much more complicated games that last for days or weeks. Most simulation games can be played in the classroom but that does not prevent part or all of any particular game being played on a visit. Visits are certainly good ways of collecting background information and many museum education officers make use of short simulation games to teach about aspects of their museums and some of the concepts basic to understanding material culture.

All games represent aspects of real life with a simple model. They have much in common with some drama activities, particularly role play. In fact, they often overlap — as do all the facets of simulation discussed herein. Theatre-in-education groups presenting many-branched plays with decision making left to the pupils also have much in common. Simulation games usually present the most complex level of modelling, however, as they have, in general, a greater time scale attached to them.

In a simulation game, pupils take on roles which are based on roles in the real world. Within those roles they make decisions in response to their assessment of the situations in which they find themselves. As a result, they experience simulated consequences which relate to their decisions and performances. While the game is in progress and when it has closed they assess the results of their actions and consider the relationship between their decisions and the resultant consequences.

An example of this might be a game in which one group of pupils play colonists and another group plays natives of the land being colonised. Such a game can be based on reality, using information about motivations, equipment available, weather, attitudes of those involved and so on. To this can be added all the 'wild cards' that turn up in real life, such as poor harvests, disease and so on. It is equally possible to play such games based on entirely fictional but nonetheless plausible situations. Several groups of peoples can be placed on a fictional landscape and told to survive and develop as peoples. Situations can be given to them: rewards in the form of good harvests and useful inventions or punishments in the form of pestilence or bad weather can be handed down by the 'gods' who control the game.

It is also possible to simulate real situations without letting pupils know what that real situation was (or even that it was real). Running such simulations is very useful. Not only do such simulations never repeat themselves exactly, but also historical events can turn out quite differently. It can then be extremely instructive to see what it was, in the simulation, that altered the course of events and discussion can take place about whether historical events were inevitable or, if not, what sorts of actions have sufficient consequences to make events uncertain.

Simulation games usually consist of groups of players rather than individuals as one of the essential parts of playing is discussing moves before they are made. This is important as a lot of good simulation games are now available for computers. Although effective tools for teaching, the element of interaction between players

is lost. Playing groups can involve competition, cooperation, conflict or even collusion, but there are usually limits set to these. Whatever the limits might be, simulation games are invariably more flexible than most games. However, players do have to work to a set of rules and accepted methods of procedure. With ordinary games, the rules are the game. With simulation games, the rules act more like a mixture of social conventions and the laws of nature – a framework within which decisions take place.

Simulation games can be set up and played with the desire to come to a better understanding of the decision making process. Alternatively, the emphasis can be on the understanding of what is being modelled be that an event or a process. In reality, understanding of both will be happening and they cannot easily be separated as one affects the other.

There are, of course, things that count against using simulation work. The time factor is one, for simulations, particularly games, can be very time consuming. Operational problems can also be a setback because you may need a great deal of space and equipment, which can be difficult to come by. The cost can also be an inhibiting factor, especially if you wish to use commercially produced simulation games.

Against these negative factors you have to place the benefits which are very real. Pupils enjoy working in this way as it best reflects the way in which people learn. It does not rely on 'conventional wisdom' and allows for learning at diverse levels. It also removes the polarisation between pupil and teacher and concentrates on decision making experiences. Furthermore, it bridges the gap between classroom and reality, not only because it works with models of reality, but also because it is dynamic and interdisciplinary.

Simulations can be combined with other approaches to produce deeper understanding of situations and the roles of people in those situations — an understanding that cannot be so fully appreciated from a study solely of material things. Material culture is your starting point but with simulations you are using your knowledge and understanding to build up four-dimensional hypotheses — stretching your three-dimensional understanding of physical objects into a context that requires an understanding of what happens over time with the added factor of human motivations.

USING THE WRITTEN WORD

This may seem a strange topic to be discussing in a book primarily devoted to material culture, but we cannot avoid the fact that the written word is essential to the full understanding of whatever is being studied. And this goes far beyond the scope of the approaches to documentary material already discussed. At some stage or other, pupils will have to refer to the written word – be it originated by you, a textbook or any other documentary material you may be working with. When it comes to that, they will need the same level of skill to make the most of the opportunity as they need for working with non-written material.

Reading in this context is an active straining after meaning. It takes practice to become accomplished at this and the initial skills need to be taught. Far better to start this process in the classroom than to attempt it during a visit. What we are after here is not the ability to follow a narrative or extract facts and figures. Rather, what we are interested in here is the development of systems by which pupils can understand and construct logical, convincing, ordered arguments on any suitable topic.

Without the ability to do this, a pupil is going to have problems making sense of the arguments presented by material culture. A ruined building actually presents a logical and ordered argument about its own history if one only knows how to look for it. But looking is only half the story. One needs to be able to interpret what one sees and pass that on to others to be of any use. We are no longer an oral culture and have, therefore, to be able to convert our experience to the written form just as much as we need to be able to derive experience from the written form.

The problem, of course, is motivating pupils to read, especially when you may have spent so much time in gearing them up to work with material that has no words attached to it. But that material is one of the motives. The second motive is that whatever written material is presented to pupils it has to take them a step onward from where they are. This is best done in the form of posing a problem, the solution to which you will assess them on in some way. In terms of museum work this is relatively easy. All you need do is write down a specific assignment and then see how well it is carried out. Carrying out the assignment correctly or fully must depend on the pupils needing to read the assignment carefully and understand what is required of them.

Written material, after all, has to be read and it has to be read properly if it is to be understood and acted upon fully. If pupils do not want or need to read

something or other, they will try to avoid the necessity. They will look for short cuts to get the work finished (even if the results are nonsensical); or someone else to tell them the answers or what to do; or notes to be read later on; or reasons not to do the work at all.

Wanting to read with purpose and act upon what is distilled from that reading is generated by motive and experience. So, if you intend to make use of museum text, your pupils must have sufficient motive and the necessary experience to do so. They must also have the necessary skills. As with many other such skills, one of the reasons you may be visiting a museum is to give your pupils an opportunity to practise and enhance them. However, it is no good expecting your pupils to make sense of museum text if they cannot make sense of written material in the classroom.

Keep such tasks simple when beginning – starting, perhaps, during the preparatory phase of the visit. The aim is to instil in the pupil a working method in which various strategies for understanding are developed. You must, of course, word things carefully. Give your material an in-built motive for reading. Make it an assignment that requires understanding and action to fulfil. Encourage pupils to come to you with questions if they genuinely do not understand. But do not spoonfeed the answers. Guide them to an understanding so that they work through the logical steps that lead to the solution.

If the assignment requires pupils to read other text then they must learn note taking skills. That is, they must learn not to copy what is in front of them but read it carefully for the salient points. Having found what they want they must then write it down in their own words in note form for use later on — brief enough to be note taking but sufficiently full for them to be able to reconstruct what has been said.

Remember that any written work you produce for pupils to use in association with museum work must be designed as an efficient means to some other end. The work should never be seen as an end in itself any more than the exercise and development of language is an end in itself. You will, of course, match the written style and reading level with that of your pupils. But take the opportunity to enrich their experience by introducing new vocabulary and ideas, the meaning of which can be elicited from the rest of the text.

Do not present new information or ideas in isolation. Always relate anything new to things that pupils know well and are familiar with. It is easier for them to concentrate on new ideas and information and make sense of them if they are presented this way. This is because such associations make the new ideas and information more meaningful and more relevant, able to fit in to the model of reality that pupils are creating.

Whether you are introducing something new to pupils or simply reiterating familiar material, keep the number of units (facts, ideas and so on) to be considered by pupils at or below seven. At the same time, ensure that those units relate to one another. This increases the likelihood that pupils will assimilate the work they are doing. Information that is rich in association and presented in a meaningful context will be more accurately recognised, recalled and understood by pupils.

The need to examine museum text during the preparatory visit has already been mentioned. You need to know what that text says and you need to be prepared to use it in the way you feel is appropriate. Pupils will tend to refer to it as an authority over and above the objects it refers to, even if you have trained them well to read objects as useful sources of information.

Unless it is essential to their understanding of an object or place, refer to museum text as little as possible. Direct pupils' attention to the material and get them to use their own skills to study the objects directly. If you have a museum that is heavy on text, avoid it or ask if you can see and work with specific items isolated from the text. Too much text will distract pupils from their task as they are too used to deriving their answers from it.

If you can avoid it, have no form of written work at all during a visit. If it is a necessity, restrict it to pupils making field notes and sketches; that is, recording what they feel to be important of what they have seen. If you have to do more than that — if you cannot avoid the need for the day to be directed in part by the written word — then avoid the traditional form of worksheet. By worksheet I mean that device beloved of some teachers which consists of a sheet or sheets of paper containing a series of questions on a given topic, each question followed by a space in which the answer is to be given. There are certain situations in which worksheets are useful. Museums are not and never will be one of those situations.

A sheet of paper with a series of questions that require answers (especially if those are factual answers) is anathema – it goes against all the aims and principles of working in a museum with material culture. Objects are reduced to the equivalent of illustrations in a textbook, albeit three-dimensional pictures in a three-dimensional book. Pupils will simply search the text of the book for the right answers without paying any heed to whatever else might be there and of interest.

The worksheet becomes the be all and end all of their time on site. Worse still, if you give that same worksheet to a group of 30 pupils they will be a continuous log-jam as they work their way from question to question around the museum, copying the answers from each other. And not only a log-jam for others, but for themselves as well. Thirty pupils cannot all look at the same thing at the same time and get a great deal from it – especially if they are racing each other to finish the worksheet and spend time in the shop.

No matter how carefully you structure the worksheet, the pupils you give it to will become locked into a written exercise when they should be experiencing the material culture before them. It is far better to save such question and answer material for immediate follow-up work — on the bus home or back at school as soon after the visit as possible.

If pupils do need written reminders of tasks they have to carry out on the day, write the tasks on cards no larger than 4 in by 6 in. This necessarily limits the wording you can put on them and therefore means you have to consider very carefully what you put. Keep the task to one side and save the other side of the

card for back-up information such as vocabulary, diagrams and so on. Such tasks should be constructed so as to ensure the following:

- maximum understanding is gained of any given object, process, place or event:
- sufficient information is gathered to aid that understanding;
- maximum freedom for the pupil to explore and encounter the museum as a whole;
- new material, information and ideas are encountered to prepare the pupil for follow-up work;
- they allow for at least some exploration of tangential ideas that may arise in the course of investigation.

Worksheets, activity sheets and work books are far better used for follow-up work in the classroom, encouraging pupils to collate information they have gathered during the visit. They should contain a series of tasks and questions directed to fixing key facts and exercising certain trains of thought. Worksheets should be open ended, encouraging thought and discussion of what was observed, comparison of results, the drawing of conclusions and the formulation of opinions. Nor should they be an end in themselves. They, too, should be used to set up further investigations based upon the information they have been used to collate.

Worksheets need to be designed by the teacher specifically for their pupils and specifically for that visit if they are to be any good. Sheets provided by museums will never quite hit the mark you want unless they are designed to introduce specific skills in the use of museums. And remember, the main purpose of any work is to stimulate students to observe closely, to ask questions about what they see and to give the opportunity to gather the information necessary to answer those questions. Try to avoid anything that simply gets pupils to read a few labels.

Make sure any written work you produce is attractive, well planned, legible and illustrated. A single piece of written material will *not* do for everyone. Written material must relate to your specific project and there must be enough to avoid having 30 children all trying to work in the same place at once. Bad written material is worse than no written material for it can close the eyes of pupils to the museum itself and kill interest and joy in what should be an enjoyable educational experience.

USING ONLINE AND DIGITAL SOURCES

In 1916, the cartoonist H.M. Bateman produced a cartoon strip entitled *The Boy Who Breathed on the Glass in the British Museum* (Bateman 1971). This heinous crime not only outraged society, but also resulted in the child being sentenced to decades of hard labour. On his release, as an old man, he returns to the museum and fogs the glass with his dying breath. The cartoon made a number of insightful observations about society, one of which was the way in which museums were perceived as places of sanctity in which relics were kept safe behind glass which itself was considered untouchable.

A lot has changed since then. Many curators and museum educators have worked hard to remove both the physical and metaphorical glass between museum and visitor. Artefacts will always need protecting, of course, but museums are a great deal more approachable than they used to be and now encourage visitors to interact wherever possible whilst encouraging a more appropriate reverence for the examples of material culture in their care.

To do this, museums have embraced new ways of thinking, new approaches to exhibiting artefacts and interpreting sites, new forms of design, new ways of working and new forms of technology – including computers and the internet. You will, in all likelihood, have encountered online museum resources in your preliminary work. Some are extremely rich and there is a temptation to use them instead of making a visit. Such material is undoubtedly a boon to teachers. But it comes with its own problems and indiscriminate and inappropriate use can lead to computers becoming the new glass case.

To avoid putting barriers back in place, limit your initial use of online resources to gathering basic information. The internet is an ideal way of finding out what is in your area both in terms of museums and of other services such as transport. In addition, you can find out about opening times, costs, accessibility, the nature of the museums' collections and any risk assessment statements they have produced. Preliminary investigations for site work are much enhanced by online maps along with aerial and satellite imagery. Bookmark sites, but also keep a hard copy of basic information for inclusion in a folder (see Chapter 20).

Remember that a website can be deceptive. Accuracy of content is one thing (take note, for example, of when the site was last updated), but you also have to consider the impression made by the website. How accurately does that reflect the place you want to visit? A museum may have exactly what you want in terms of

artefacts and services but only have a basic webpage. Paucity of online content does not equate with paucity of exhibits or other resources. Conversely, a website replete with information, images, video, sound, games and interactive elements does not mean the museum will be the same. There really is only one way to find out. You have to visit.

When you do come to make use of online resources for your preliminary and follow-up work, treat the content of websites with caution. There is a tendency amongst some to assume that if it is on the internet it must be true. Like all other sources of information you, and your pupils, need to learn to ask questions of the material. Who has produced it? Why? What is offered and what has been left out? How is it presented and does this affect the content in any way? Are sources given for information? Are there links to other sites? Have authors put their name to content? All of this before you look at the actual subject matter.

The content and quality of websites and other forms of digital resource (such as CD-ROMs) vary a great deal. Whilst it is fairly safe to assume a museum website will be accurate with regard to its own collections, the authenticity and accuracy of information on other sites needs to be confirmed before allowing them to be used by pupils. Where the provenance of a site's content can be determined, the presentation of information, especially images, still needs to be assessed.

An image of an object is all well and good, and often very helpful, but online it should offer more than would a picture in a book. You need to be able enlarge the image and manipulate it so that you can see the item from all angles. You also need to know the scale and how true the colour reproduction is. As an interesting exercise it is worth looking at different reproductions of the same item taken from different sites. As with hard copy reproductions, the quality varies enormously. These differences in reproduction are a worthy topic of discussion, especially in respect of how reliable a reproduction can be in relation to the real thing (and comparisons can be made there as well if the items seen online are objects you will be seeing or have already seen in the museum). Images often come with accompanying text. In many cases this is just enough to identify the object and give some basic information. This text needs to be considered in terms of its content and the context it creates for the image.

Do keep in mind that online resources can change without warning. Sites develop, change layout and sometimes disappear altogether. This may well be the case if pages on a site are linked to a temporary exhibition. If you are going to rely on a website for a vital element of your work, check with whoever runs it that they don't intend changing it to your pupils' detriment part way through their work.

Some websites offer information packs, worksheets and other ready made resources for teachers and pupils. Whilst it is admirable that these have been produced (and the pressure of other work makes them very tempting for teachers), they should be treated with the same caution advocated for similar forms of resource elsewhere in this book. That they originate from the internet and have a professional look does not mean they are of any greater worth to you as a teacher

than any other one-size-fits-all resource. All this type of material should be checked out in the museum before you consider using it or adapting it for use.

Ready made material in digital form makes it very easy for pupils to cut and paste, creating good looking work without more than a superficial need to study or understand the content. Where material *is* lifted from websites, get pupils into the habit of making attributions to both the source and the author. There is a wider discussion here about intellectual property rights to which your work can contribute. It is also to be hoped that using computers as a means to some other end, the hands-on investigative work of the visit, will offer a more satisfying educational experience than using computers as an end in themselves.

Some tools, of course, cannot be used for some tasks. Computers, for example, cannot provide the psychological impact associated with contact with genuine examples of material culture. A computer cannot offer anything like the level of communication available in properly constructed face-to-face sessions. It will simply regurgitate information in response to a specific question. It cannot pick up on nuances a human teacher might detect; it cannot ask questions of its own to clarify and reinforce points being made. It cannot tell jokes, become serious, vary the pace, tell stories or help guide pupils into other areas of interest that they do not know exist.

Used at the appropriate time, however, online resources can enhance the experience of the visit. Preparatory work can be done in greater depth and with wider scope. Follow-up work can be consolidated and supplementary ideas explored as never before. Indeed, the danger is in losing focus because of the sheer wealth of available material. But it is the visit, the hands on work with artefacts and sites that should always remain at the core of your planning.

FOLLOWING-THROUGH

FOLLOW-UP

One of the problems with the phrase 'follow-up' is the connotation it has of rounding things up and bringing them to a conclusion. In some sense that is the case, but there is a great deal more to follow-up than that. Following a visit with a single classroom session and regarding that as sufficient should be avoided at all costs. Any visit that can be followed up in this way was not worth making in the first place. A visit should be regarded as part of a long term programme of work and should provide enough impetus to carry it forward for at least as long as the preparatory period.

You must constantly change your perspective. Do not consider the visit to be the high point of all the work that you are doing. The high point of your work, the focus of your attention, must be what you are doing at the time. Once the visit has taken place, consider it as having been preparation for the follow-up work.

In order to accomplish that change of perspective, follow-up material should not just refer back to what was done during the visit. Reinforcement of information and ideas is an important aspect, but there is much more to it than that. Once pupils have consolidated what happened, they should use the information and the understanding they have gained to move forward into new areas of learning.

To do this, you will need pupils to abandon the 'had-a-nice-day-out' approach and get them to focus on specific lines of enquiry prompted by their site work. It is important for pupils to be given the opportunity to express their feelings about the visit, but that should only be a minor part of their work. More importantly, they should be working on identifying the solutions to problems posed in preparatory work. From this they can start to assess where there are gaps in their understanding and look at devising ways of moving onward to fill those gaps.

A focused approach such as this means that everyone has to assess all the material they have collected during a visit. This is not just to see whether it answers questions already set or supports theories they have put forward. New questions will have arisen and new facts will have been discovered. Answers to new questions need to be found and new material needs to be assimilated so that it can form the basis of new or revised theories. It also gives pupils the opportunity to say how they would have designed assignments differently for the day to better answer the questions they now have.

You can only take that approach if your pupils know what they are doing. The least effective follow-up comes as the result of poor planning, preparation and

a chaotic visit. The quantity and scope of follow-up also depends on planning, preparation and organisation. If preparation was scant, if organisation was poor, if all pupils did exactly the same work on the day, then you will get less from the visit than you could otherwise have done. Furthermore, the way workloads were spread on the day can contribute to the success, or otherwise, of the follow-up work. If groups were able to experience slightly different aspects of the museum, carry out different tasks and make different investigations, for example, the starting point of your follow-up is the reporting back process and concomitant sharing of information and impressions.

So we come to the first (and perhaps only) rule of follow-up: always do it. How you organise follow-up work is up to you. It depends on what has gone before, the nature of the work you are doing and your own style of working. There are, however, certain things you should include and certain phases you should try to follow.

To begin with, always make an evaluation of the day. Do this on several levels. Your school may even require a formal evaluation, especially for your risk management plan. The following questions need to be considered:

- Did the pupils enjoy themselves and would they want to go back to that museum?
- Did you and other staff and adult helpers enjoy the visit; would they want to repeat the experience?
- Was the visit stimulating and if so, in what ways?
- Did it contribute to the course of work or curriculum you were following in the way you had intended?
- Was your planning and preparation for the visit satisfactory?
- Did the museum make you welcome and were staff helpful?
- Was the museum happy with your visit?
- Was the visit 'cost-effective'? That is, was the effort involved worth it in terms of the overall result?
- Would you return to that museum and use it again for educational purposes?

There may be other questions you need to ask that are specific to your situation.

Many of the answers will have to be arrived at in a subjective way but that does not invalidate them. Discuss the visit with helpers and with pupils and add your own thoughts on the day. But do not make your final assessment until you are well into your follow-up work as the way in which this proceeds is an important part of the evaluation process. A visit that produces little in the way of follow-up cannot be judged a complete success. Do not make the mistake, however, of assessing things solely in terms of the overt reason for the visit. There may have been social benefits which are of equal importance to any academic benefits that might have accrued.

It would be worth writing your evaluation as a short report, highlighting the academic and social benefits as well as any generic problems you encountered. Recommendations for future changes and alternative strategies should be set out as well. If you have any criticisms of the museum, phrase these in a positive way and let the museum know. Tell them about the things you liked as well. You can keep a copy of all this with other relevant material extracted about the visit in a file that will build up into a useful reference work.

In addition to evaluating the day, you must evaluate the work that was done on the day. Base this on the observed curriculum as well as on the intended curriculum. Strategies for assessing the work that pupils have done are extremely important and should have been identified during preparation. Knowing why you went in the first place is of great help in this, but you also need to target specific skills and set specific tasks for individuals and groups. Pupils should also be encouraged to discuss whether they felt they achieved all they could from the visit and, in retrospect, what they felt could have been done better or as an alternative. Try to avoid setting simplistic tests to assess whether they have reached certain levels. It is far better to find out how well they have done from the way in which they are carrying their work forward.

Once you have made your initial assessments, you need to concentrate on consolidating what has been learnt during the visit. Pupils should collate their work, observations, notes and so on, discuss these things with other pupils and determine how the information they have gathered can be used in further work. Consolidation is extremely important. The visit will have been an intense experience, especially in terms of information encountered. Although pupils have an incredible capacity for soaking up vast amounts of information, especially in environments like museums, much of it can be lost or left without relevant association if they are not given the opportunity to pull it together in a coherent fashion. There are many ways to do this and it is best to use as many strategies as you can, relating them to the nature of the investigations undertaken and the ability of the pupils involved.

Consolidating what has been done may not take very long. You are, essentially, giving pupils the opportunity to hang raw data on to a provisional framework. This is where worksheets and the like can be used to best effect. Once it has been done, it is equally important for pupils to start making use of that framework and integrating it with the preparatory work. In a sense, you are picking up the threads of that earlier work and applying this new package of information to what has gone before.

It is at this point that information gathered during the visit begins to come into its own. In the first instance you are now in a position to start answering some of the questions posed by your earlier investigations. You are also able to assess the material you gathered from the museum to see if there is information that forces you to re-think earlier notions. There will also be material that stands alone because it is not relevant to your investigations. That sort of material is precious because it forms the basis of the next stage of follow-up.

Having got this far, it will be apparent that your follow-up work is moving into a new phase, one that is no longer directly connected with the visit. Although there will still be links, what will be happening now is the crystallisation of new questions. These in turn will start to suggest new directions of investigation. And, if you have been able to change your perspective successfully, you will see that your follow-up work has now become, in its turn, preparatory work. All that remains is for you to move into this phase, following those new paths of investigation.

Of course, the curriculum followed by your school may prevent your followingup at your leisure and exploring some of the more obscure byways illuminated by the investigations your pupils will make. There may be other constraints as well. Some of the things you do may depend upon or be connected with some of the longer term strategies you may have adopted or wish to adopt. On the whole, however, you should be able to work to the outline suggested.

LONGER TERM STRATEGIES

The importance of creating a context for visits to museums has been stressed throughout this book, but that has mostly related to the planning and preparation of individual visits. There is, however, another way in which visits can be placed in their appropriate context. You will not be the only teacher in your school making use of museums. Yours will not be the only generation to do so. And you will not, between you, only ever use one museum for one purpose.

As a consequence, it is important that you, your colleagues, your school, your local group of schools, construct a broader context for the use of museums for teaching. In general terms this means developing long term strategies that improve and increase your use of museums. You cannot simply expect to impose this increased use on museums (much as they may enjoy a boost in visitor numbers and revenue) without consulting them. Nor can you hope to achieve a great deal on your own – although you may find yourself doing most of the pioneering to begin with. So, the order and the way in which you develop your long term strategies are of as much importance as developing them *per se*.

To begin with you should consider persuading your school to adopt a policy on the use of museums along with accepted procedures for planning and carrying out visits. In parallel with this you should be establishing, developing and maintaining links with museums that you already use or are likely to use in the future. Creating links with other teachers, both in your own school and in other schools, who are likely to be using the same museums should be the next step. While this is proceeding you can be building up a resource file or database containing information relevant to museums and their use. Finally, if you feel sufficiently ambitious, you could look at the possibility of creating a museum in your own school.

SCHOOL POLICY ON VISITS

Governing bodies of schools – at whatever level (or many levels if there are several levels of government) – should agree on a policy about the value and purpose of learning from museums along with procedures for carrying out visits. Procedures should include models for informing parents, liaising with other staff, discipline, contacts with pupils and so on. Any document produced should also include up-to-date copies and digests of any statutes and other binding non-statutory instructions and advices. It would be worth making the whole document available in model

form for other schools to adopt. If all the schools in a locale have the same basic policy on the educational use of museums, cooperation between schools and their individual and collective dealings with local museums become much easier.

In addition to a policy document, a school needs a designated member of staff to be given responsibility for liaising with the museum, museums or museum service local to that school or likely to be used by the school, including periodic meetings with museum staff. This person can review existing curriculum guidelines to ensure that appropriate advice is given about how pupils could learn from museum resources. They can also review existing and future in-service training provision to see how it could incorporate advice about good use of museum services. It would also be this person's responsibility to devise ways to monitor and evaluate how museums are being used and disseminate this and any other information to the rest of the school's staff.

Any or all of this will inevitably require prompting from the grass-roots. It is worth lobbying for this level of recognition of museum visits as it makes life easier when executive decisions need to be made. If there are policy statements in existence, museum work can be defended from that position of strength. Furthermore, if you can present the governing body with well thought out policy statements that formalise already successful practice, they are more likely to adopt them.

CREATING, MAINTAINING AND DEVELOPING LINKS WITH MUSEUMS

There is a difference between using museums and creating links with them. The difference in terms of the effort involved is not so great; the difference in the results, however, can be enormous. Moreover, the quality of work is dependent upon the ways in which you maintain those links once they are established.

Before you can think of creating and maintaining links with any museums, you have to have a reason for doing so – showing your existence and your interest, while necessary, is not sufficient. You need also to have an intention to improve your use of the resource. There are two ways to create links – face-to-face, either first-hand or second-hand.

First-hand face-to-face involves arranging to meet with the appropriate museum staff and talk with them about what the museum has to offer. This can be part of a general reconnaissance or part of a more specific planning exercise. You can tell them what your job involves, how the museum can help you in terms of overall service as well as with specific curriculum needs, what your pupils are like and so on. Most importantly, you have – by visiting the museum and talking with staff there – established a link. The staff of that museum now know you and know who they are talking with on the telephone.

Second-hand face-to-face contact with museums involves reaching them through others. This can be done by talking with other teachers who have used the museum or with any advisory staff of your employing authority. Of course, this is

not as satisfactory as making contact yourself, but in some instances it can save time by focusing you on the right museums.

There are other strategies for forging links which museums themselves may have in place. Many have various forms of membership schemes and friends' organisations as well as more specific committees and forums. Find out if these exist and whether they are relevant to your needs as a teacher. But, whatever links you do finally make, one of the most important things to remember is to maintain them. At first you may wonder if this is worth it as the spectacular seldom happens through such channels. However, a slow accumulation of links is much to be preferred as in this way, the links grow strong.

In essence, the maintenance of links means that you have some form of dialogue with the museums that you use or intend to use. Again, a whole range of strategies can be brought to bear. The best way, however, is to discuss each visit in detail with the appropriate museum staff. Even if you do the same thing each year, you will be working with different children who will have different approaches to the same problem. And if you are doing your job properly, each year you will assess your visit and thus provide yourself with another opportunity to talk with museum staff and discuss ways in which the next visit could be improved or altered to fulfil changing demands of the curriculum. This flow of information is useful to both sides, but it also lets the museum know that you are interested and actually care about what they are doing.

During any visit it is important to spend a few minutes chatting informally with museum staff. Do not restrict this to museum education staff – chat with reception staff, shop staff, security and so on. It does not have to have anything to do with the visit but helps to establish the fact that you are approachable. After all, they all know the museum better than you and may well have an idea that will improve your use of the resource. Furthermore, if they know that you listen then they *will* approach you.

The follow-up work your pupils do may also be of interest to the museum. Invite someone from the museum (preferably the person who dealt with you on your visit) to come and see what pupils have been doing since the visit. If that is not possible, then thank you letters, art work or even a full display is appreciated by the museum. In this way you are also involving pupils in the dialogue, deepening their involvement with the museum and increasing the likelihood of their making a visit in their own time.

You can maintain your links in this way for many years without really developing them. If such maintenance is satisfactory, there is no pressure to go further, but it would be a waste. Between them, schools and museums have elements which if brought together properly can lead to developments that can improve not only the relationship between them but also the level of education they can offer to pupils.

There are three main ways in which such developments can occur. The first of these is in-service training. If the museums you use do not offer in-service training courses for teachers then persuade them to do so. These need not be complex affairs. Simple introductions to the collections and working of the museum would

be a great way to start. More specific courses on the work of, for example, the conservation department should also be encouraged.

The second way of developing links is to persuade museum staff to visit your school. Show them how the school works and the scope of the school curriculum. Invite them to run short courses or give lectures on their work and on subjects relevant to school but which are not actually part of the curriculum – archaeology, for example. The purpose is to increase understanding of the problems each of the parties face in everyday working life. This in turn makes it easier to accommodate the other side. Increased understanding also develops trust. Trust allows for deeper and more fruitful liaison – for example, long term loan of material, treating the school as an annexe of the museum, offering advice and working together to produce exhibitions that tie closely with the school's curriculum (which in turn offers the public a chance to see what is going on in schools). It can also work for pupils – the greater and deeper the contact, the more likely they are to feel comfortable about visiting in their own time and respecting what they see.

Finally, work should be done towards developing long term arrangements with museums concerning the use your school makes of their resources. School use of museums is often on an *ad hoc* basis. This is not a good or efficient use of a resource, particularly as schools use museums quite regularly. It would be better for there to be some mechanism worked out between schools and museums whereby the educational resource was used to its maximum potential. Precisely what such a mechanism would offer depends on many factors but it should at least guarantee a level of training for teachers in proper use of the resource and guaranteed access to collections, objects and so on. A charge may need to be made for this, but it would be far better to spend money in this way than on a series of individual, uncoordinated trips. In effect, a club or user group would be set up with a committee to oversee its workings which would offer benefits to user and used alike and which would be dedicated to the continual development of the museum as an educational resource.

The whole business of creating, maintaining and developing links can be time consuming. It is important, therefore, to strike a balance otherwise you end up spending too much time in proportion to the actual use that you make of museums. Be that as it may, it is well worth pursuing such links. Without them, using museums as an educational resource will never be more than the whim of the dedicated few.

CREATING LINKS WITH OTHER TEACHERS

As a teacher you will invariably have professional links with other teachers. It would be prudent to consider how these might be developed to include links with museums and museum work. There are many different ways in which links with other teachers can be made – between those who teach children of the same age, those who teach the same subject, for example, or those who teach in the same school, those who have an interest in non-curriculum subjects (like archaeology).

Whatever the common factor that binds these groups (other than a desire to improve their use of museums) they can be extremely productive. By choosing a theme of work and organising who does what, they can produce a large quantity of material, each person producing a small part of the overall package.

A group of mathematics teachers, for example, could explore their local museums for samples of tessellation, regular solids or whatever else they have decided upon and produce a gradated package of material relating to those topics. In this way maximum benefit is derived from minimum input.

Such groups could also work in conjunction with museum education staff on more complex packages. Whereas subject specialists can cope with their own specialisms, there are other dimensions to museum work that are the specialism of museum educators. They are likely to be just as keen as teachers to see materials produced for use by school groups, especially if such packs are comprehensive. The combination of talents and experience to be found in such a working group would ensure educational material was of a high standard, interesting, usable in school and museum and relevant to the demands of the curriculum. What is more, if the working group stays together it has the opportunity to review material from time to time and bring it up to date.

BUILDING AN INFORMATION RESOURCE FILE OR DATABASE

An invaluable long term strategy is to produce and maintain a resource file of information relating to museums and museum visits. The main reasons for creating such a file are threefold. Firstly it makes the choice and logistics of museum visits easier. Secondly, the information can be tailored specifically to your school, especially if you ask colleagues to keep you supplied with information relevant to their specific subject needs. Finally, you can keep it up to date. Directories, lists of organisations and contacts and the like are often too general and soon become outdated (although they are a good place to start your research). Far better to create your own directory. However, despite the fact that it will save you a great deal of time when arranging a visit, the file should never be used as a substitute for a preliminary visit to the museum.

Given that this will probably involve leaflets and other such documents, some of which are updated on a regular basis, it would be best to collate these in a large ring binder with labelled sections. This has the advantage that it can be easily accessible to all teachers if kept in the staff room. Should you wish to index the material or keep a database of basic information (particularly relating to museum collections) this is best done as you go along rather than in retrospect.

To fulfil the purpose of the file you must have at your fingertips all the information you need about any given venue – scope of collections, programmes of work offered to schools, availability of museum staff (and names of contacts), resources available to schools (along with examples and assessments of things like workbooks, models and replicas), times of opening, costs, distance and approximate time from school, drop off and pick up points, generic risk assessments, records of

past trips (including outline work programmes and names of school staff involved) and any other information you have available and think relevant.

Bearing in mind the scope of this book, include museums, outdoor sites, art galleries, libraries, theatres, places of worship and any other venues that offer educational services for schools as well as local and national arts and cultural organisations (especially if they have education branches). Add to this any group or individual that offers a relevant outreach programme. Museums may offer these, but there may also be theatre-in-education groups, enactment societies, individual specialists and craftspersons who offer workshops for schools.

In addition to the foregoing, you should consider gathering into the same folder other information pertinent to school visits. Your employing authority, local government, national government, trade and professional associations and other education bodies will be able to supply up to date material relevant to your situation. Some will also have education advisory staff that you can contact for specific information and advice.

To begin with, collect and study any legal requirements in respect of school visits. This will cover many topics ranging from the need to ensure all adults working with children have been vetted, through the need for insurance, risk management, the responsibilities of adults in charge of children, the welfare of children in your charge, to policy on things like charging for visits.

Further to legal requirements (which are there for your protection as a teacher as much as for the protection of children in your care), there are guidance documents. These set out guidelines for and examples of best practice. Reports by inspection bodies that look at or touch on visits are also valuable as the overview and suggestions they provide will help you improve your planning.

Once you have such a collection, it is important to keep it up to date. The information most likely to change relates to opening hours, charges and temporary exhibitions. But other things change as well, including additions to permanent exhibitions and complete refurbishments. If you have a good relationship with museums and other bodies, this updated information will come your way as a matter of course.

SCHOOL COLLECTIONS AND MUSEUMS

This is perhaps the most ambitious of the long term strategies considered here and it needs a concomitant amount of thought, research and commitment. Running a museum is a time consuming and exacting business. It should not be started without first thoroughly exploring the whole project, no matter how great the temptation to build up such a resource. Nor should such an enterprise, if started, be seen as a substitute for making visits. No school will ever be able to compete with a museum. In spite of that, if the school is committed to the project and has researched it fully, there is no reason why it should not start a collection of its own.

It is important to seek advice from museum professionals. This can cover the whole range of problems to be considered such as insurance, collecting policy,

storage, conservation, environmental control, handling, cataloguing, display, security, storage and so on. If you involve a museum or museums from the start they are more likely to want to become involved than if you approach them when you start having problems. Some museums may advise against your plans for various reasons. Take their advice seriously but always ask if there are ways of modifying what you intend that would satisfy their objections. Problems are there to be solved.

Before you accept a single item you *must* have a collecting policy. This should explain the purpose of the collection, what the scope of the collection will be, the legal position regarding transfer of ownership and rights, how the collection is to be managed and, if the worst should come to the worst, how it is to be disposed of. The purpose of the collection needs, in the main, to be derived from current practice in the use made by pupils of items during visits to museums and of loans from museums. It should also look at ways in which a school collection will enhance and expand current practice. The whole curriculum should be looked at to see in what ways an in-house collection could be used to supplement work, along with the possible use of the material by pupils from other schools – especially feeder schools.

Material can come from many sources. Teachers and parents will probably be able to provide the bulk, through donating suitable items. It is unlikely that any school will ever have a budget for the active pursuit of objects. There is also the possibility, if you have a good relationship with a museum which has helped you set the system up and which is happy with your security, that it may loan material on a long term basis. The use of temporary and permanent collections should be reviewed periodically to ensure that all teachers are making effective use of them and to see whether individual items are still needed.

Permanent collections need to be catalogued and stored in a way which protects the objects and makes them accessible to all teachers and pupils. Thought needs to be given to pupil participation in the maintenance of the collection. There are many opportunities here to enlighten pupils about the care of objects, the purpose of museums and careers available in museums and associated fields such as archaeology. Strong liaison with local museums will probably mean a willing supply of professionals to come in to school to give talks and offer training sessions for pupils. Pupil participation is vital. They are trusted every day with materials that are as delicate and valuable as anything likely to find its way into a school museum, but the opportunity to work with material objects that are valued for reasons other than present utility or financial value is of the greatest importance.

There are many other longer term strategies that can be followed, many of them dependent upon the circumstances in which you find yourself. The important thing is that you develop them in all ways possible and utilise them fully. This book has only scratched the surface of the subject, introducing you to some of the basics. The rest comes with practice and experience. And whatever else may happen as you explore the educational potential of museums, you can be certain it will always be valuable and never dull.

BIBLIOGRAPHY

This bibliography contains a list of those works I used in researching this book. It is neither definitive nor indicative of the scope of the finished text as much of that was derived from personal experience and discussion with museum educators and teachers. For a more comprehensive bibliography of museum education material up to 1994, see that published by the Group for Education in Museums (GEM). See also their annual *Journal of Education in Museums*.

- Alderson, W.T. and Low, S.P. 1996. *Interpretation of Historic Sites*. 2nd Edition. Lanham: AltaMira Press.
- Alexander, E. and Alexander, M. 2008. *Museums in Motion*. 2nd Edition. Lanham: AltaMira Press.
- Ambrose, T. 1984. *Education in Museums, Museums in Education*. Edinburgh: Scottish Museums Council.
- Anderson, D. 1999. *A Common Wealth: Museums in the Learning Age*. London: The Stationery Office.
- Anico, M. and Peralta, E. (eds) 2008. *Heritage and Identity: Engagement and Demission in the Contemporary World*. Abingdon: Routledge.
- Arkinstall, M.J. 1977. Organising School Journeys. London: Ward Lock Educational.
- Atkinson, D. and Dash, P. 2006. *Social and Critical Practices in Art Education*. Stoke-on-Trent: Trentham Books.
- Bateman, H.M. 1971. *The Boy Who Breathed on the Glass in the British Museum*. London: H. Pordes.
- Bennett, F. 1985. 'Going to See' A Case Study of a Secondary School's Visits to the Jarrow Project. unpublished B.Phil Thesis.
- Black, G. 2005. *The Engaging Museum: Developing Museums for Visitor Involvement*. Abingdon: Routledge.
- Boodle, C. 1992. *A New Decade Museums and Education in the 1990s.* London: National Heritage.
- Booth, J.H., Krockover, G.H. and Wood, P.R. 1982. *Creative Museum Methods and Educational Techniques*. Springfield: Charles C. Thomas.
- Borger, R. and Seaborne, A.E.M. 1982. *The Psychology of Learning*. 2nd Edition. Harmondsworth: Penguin.

- Cann, J. and Bartholomew, J. 1987. *Cathedrals A Resource for Learning*. Chester: Chester Cathedral.
- Carr, D. 2006. A Place Not a Place: Reflection and Possibility in Museums and Libraries. Lanham: AltaMira Press.
- Carter, P.G. 1984. *Education in Independent Museums*. Bristol: Association of Independent Museums.
- Chatterjee, H. (ed.) 2008. *Touch in Museums: Policy and Practice in Object Handling*. Oxford: Berg.
- Cooksey, C. 1992. A Teacher's Guide to Using Abbeys. London: English Heritage.
- Corbishley, M. (ed.) 1983. *Archaeological Resources Handbook for Teachers*. London: Council for British Archaeology.
- Corbishley, M., Henson, D. and Stone, P. (eds) 2004. *Education and the Historic Environment*. Abingdon: Routledge.
- Cracknell, S. and Corbishley, M. (eds) 1986. *Presenting Archaeology to Young People*. London: Council for British Archaeology.
- Crane, S.A. 2000. Museum and Memory. Palo Alto: Stanford University Press.
- Curtis, S.J. and Boultwood, M.E.A. 1965. *A Short History of Educational Ideas*. 4th Edition. London: University Tutorial Press.
- Davis, G. (ed.) 1983. Museums in Education. Normal: Illinois University Museum.
- Department of Education and Science. 1989. *National Curriculum: From Policy to Practice*. London: Department of Education and Science.
- Dewey, J. 1963. Experience and Education. New York: Collier Books.
- Drama Education Working Group. 1992. Drama in Schools. London: Arts Council.
- Durbin, G., Morris, S. and Wilkinson, S. 1990. *A Teacher's Guide to Learning from Objects*. London: English Heritage.
- Dyer, J. 1983. Teaching Archaeology in Schools. Aylesbury: Shire Publications.
- Eddisford, S. 2009. *Learning in Smaller Museums*. Bristol: Association of Independent Museums.
- Ellington, H., Gordon, M., and Fowlie, J. 1998. *Using Games and Simulations in the Classroom*. London: Kogan Page.
- Emerson, C. and Goddard, I. 1989. All About the National Curriculum. Oxford: Heinemann Educational.
- Fairbrother, R. (ed.) 1983. *Environmental Studies and the Primary School*. Manchester: Didsbury School of Education.
- Fairclough, J. and Redsell, P. 1985. *Living History Reconstructing the Past with Children*. London: English Heritage.
- Falk, J.H. and Dierking, L.D. 1992. The Museum Experience. Washington DC: Whalesback.
- Falk, J.H. and Dierking, L.D. 2000. *Learning from Museums: Visitor Experiences and the Making of Meaning*. Lanham: AltaMira Press.
- Goodacre, B. and Baldwin, G. 2002. Living the Past: Reconstruction, Recreation, Re-enactment and Education at Museums and Heritage Sites. London: Middlesex University Press.

- Goodhew, E. 1988. *Museums and the Curriculum*. London: Area Museums Service for South Eastern England.
- Goodhew, E. (ed.) 1987. *Museums and the New Exams*. London: Area Museums Service for South Eastern England.
- Goodhew, E. (ed.) 1989. *Museums and Primary Science*. London: Area Museums Service for South Eastern England.
- Greeves, M. and Martin, B. (eds) 1992. *Chalk, Talk and Dinosaurs? Museums and Education in Scotland*. Edinburgh: Moray House.
- Halkon, P., Corbishley, M. and Binns, G. (eds) 1992. *The Archaeology Resource Book 1992*. London: English Heritage and The Council for British Archaeology.Harrison, M. 1967. *Changing Museums*. London: Longmans.
- Harrison, M. 1970. Learning Out of School. London: Ward Lock Educational.
- Hebditch, K. 2008. *Setting Up a New Museum*. Bristol: Association of Independent Museums.
- Hein, G.E. 1998. Learning in the Museum. Abingdon: Routledge.
- Hein, H.S. 2000. *The Museum in Transition: A Philosophical Perspective*. Washington DC: Smithsonian Institute.
- Her Majesty's Inspectorate of Schools. 1988. A Survey of the Use of Museums and Galleries in General Certificate of Secondary Education Courses. London: Department of Education and Science.
- Her Majesty's Inspectorate of Schools. 1989. A Survey of the Use Schools Make of Museums Across the Curriculum. London: Department of Education and Science.
- Her Majesty's Inspectorate of Schools. 1989. A Survey of the Use Schools Make of Museums for Learning about Ethnic and Cultural Diversity. London: Department of Education and Science.
- Her Majesty's Inspectorate of Schools. 1990. A Survey of Local Education Authorities' and Schools' Liaison with Museum Services. London: Department of Education and Science.
- Her Majesty's Inspectorate of Schools. 1990. A Survey of the Use of Archives in History Teaching. London: Department of Education and Science.
- Her Majesty's Inspectorate of Schools. 1990. A Survey of the Use of Museum Resources by Pupils Aged 5–9. London: Department of Education and Science.
- Her Majesty's Inspectorate of Schools. 1990. *A Survey of Work Based on Drama by Pupils Aged 8–16 at Museums and Historic Sites*. London: Department of Education and Science.
- Her Majesty's Inspectorate of Schools. 1991. A Survey of the Use Schools Make of Information Technology Linked to Museums. London: Department of Education and Science.
- Her Majesty's Inspectorate of Schools. 1991. *A Survey of the Use of Museums by 16–19 Year Olds*. London: Department of Education and Science.
- Her Majesty's Inspectorate of Schools. 1992. A Survey of the Use of Museum Resources in Initial Teacher Training 1991–1992, London, Department of Education and Science.

- Hewison, R. 1987. The Heritage Industry. London: Methuen.
- Hodgson, J. *Education Through the Arts at National Trust Properties*. London: National Trust.
- Holt, J. 1983. How Children Learn (Revised Edition) Harmondsworth: Pelican.
- Hooper-Greenhill, E. (ed.) 1989. *Initiatives in Museum Education*. Leicester: Leicester University Department of Museum Studies.
- Hooper-Greenhill, E. (ed.) 1992. Working in Museum and Gallery Education 10 Career Experiences. Leicester: Leicester University Department of Museum Studies.
- Hooper-Greenhill, E. (ed.) 1999. *The Educational Role of the Museum*. 2nd Edition. Abingdon: Routledge.
- Hooper-Greenhill, E., Dodd, J., Gibson, L., Phillips, M., Jones, C., Sullivan, E. 2006. What did you learn at the museum today? Second Study, Leicester, MLA & RCMG.
- Hooper-Greenhill, E. 2007. *Museums and Education: Purpose, Pedagogy, Performance*. Abingdon: Routledge.
- Janes, R. 2005. Looking Reality in the Eye. Calgary: University of Calgary Press.
- Keith, C. 1991. *A Teacher's Guide to Using Listed Buildings*. London: English Heritage.
- Larrabee, E. (ed.) 1968. *Museums and Education*. Washington DC: Smithsonian Institution Press.
- Lowenthal, D. 1985. *The Past is a Foreign Country*. Cambridge: Cambridge University Press.
- McDowall, R.W. 1980. *Recording Old Houses: A Guide*. London: Council for British Archaeology.
- Mace, C.A. 1968. *The Psychology of Study*. 3rd Edition. Harmondsworth: Penguin. Maclure, S.1988. *Education Re-formed: A Guide to the Education Reform Act 1988*. Sevenoaks: Hodder & Stoughton.
- Mobley, M., Goddard, I., Goodwin, S., Emerson, C. and Letch, R. 1986. *All About GCSE*. London: Heinemann Educational.
- Morris, S. 1989. A Teacher's Guide to Using Portraits. London: English Heritage.
- Mytum, H.C. 2000. Recording and Analysing Graveyards. London: English Heritage.
- National Arts and Media Strategy Monitoring Group. 1992. *Towards a National Arts and Media Strategy*. London: National Arts and Media Strategy Monitoring Group.
- National Curriculum Council. 1993. *The National Curriculum A Guide for Staff of Museums, Galleries, Historic Houses, and Sites*. York: National Curriculum Council.
- North Tyneside Environmental Studies Working Group. 1987. *Guidelines for the Teaching of Environmental Studies to Primary Age Children*. North Shields: North Tyneside Metropolitan Borough Council Education Department.
- Ofsted. 2008. Learning outside the classroom. How far should you go? London: Ofsted.

- Percival, A. 1979. Understanding Our Surroundings A Manual of Urban Interpretation. London: Civic Trust.
- Preziosi, D. and Farago, C. 2003. *Grasping the World: The Idea of the Museum*. Aldershot: Ashgate.
- Pumpian, I., Fisher, D. and Wachowiak, S. (eds) 2005. *Challenging the Classroom Standard Through Museum-based Education: School in the Park*. Mahwah NJ: Lawrence Erlbaum Associates Inc.
- Rebetez, P. 1970. *How to Visit a Museum*. Strasbourg: Council for Cultural Cooperation of the Council of Europe.
- Richmond, K. 1998. *Planning School Visits and Journeys*. Glasgow: Collins Educational.
- Schools Council Joint Working Party on Museums. 1972. *Pterodactyls and Old Lace*. London: Evans/Methuen Educational.
- Smith, L. 2006. The Uses of Heritage. Abingdon: Routledge.
- Talboys, G.K. 2006, *Museum Educator's Handbook*. 2nd Edition. Aldershot: Ashgate.
- Thompson, J. (ed.) 1992. *Manual of Curatorship*. 2nd Edition. London: Butterworth-Heinemann.
- Witcomb, A. 2002. *Re-Imagining the Museum: Beyond the Mausoleum*. Abingdon: Routledge.

INDEX

active learning, 24–5, 26–7, 139–40 aesthetic sense, 120 development of, 120 stages of development, 121 aims, 77 archaeological sites, 8 archaeology, 81, 91 argument, 151 Art, 94 art galleries, 8 artefacts collection of, 10–11 display of, 11	physical features, 102–3 problems working with, 102 public utilities, 105 recording, 107–8 response to study of, 108 school, 101 shape, 103 size, 103 source of, 102 survey sheets, 107 value, 106–7 built environment, 33
preservation of, 11	checklists
storage of, 11	equipment, 84–5
assessment, 162–3	journey, 84–5
ussessment, 102 3	planning, 63–4
basic skills, 80	classroom, 23
beauty, 33–4	learning outside, 23–4
behaviour (see also discipline)	collections
standards of, 82	care of, 11
booking	content of, 17
confirmation of, 60	natural history, 14
provisional, 57, 58	organisation of, 14
British Museum, 8–9	school, 170–1
buildings	scientific, 14
access to, 102	community awareness, 30
appearance of, 102	computers, 155, 157
colour, 104	concepts, 28–9
completeness, 103	conduct, code of, 82
construction, 104–5	confidence, 141
design, 105–6	conservation, 11, 82
documentary material, 107	contemplation, 77–8
function, 105	creativity, 34, 139-40, 142
function (actual), 105	critical faculties, 34, 141, 142
function (intended), 105	cross-curricular
inhabitation, 103	links, 24–5, 77
location, 103	skills, 28, 80
massing, 103	themes, 80
materials, 104	work, 40
methods of construction, 104-5	cultural diversity, 32
people, 107	cultural heritage, 29, 31, 32

curriculum	facts, 32
demand for visits, 26	field work, 99
hidden, 30, 49	skills, 80–1
intended, 52–3, 163	fluency, 141
observed, 52–3, 163	focus, 78
	follow-up
Design and Technology, 94	change of perspective, 161, 164
digital resources, 155, 156	evaluation of, 162–3
images, 156	first and only rule of, 162
use of, 157	purpose of, 161–2
worth of, 156	food, 87
direct experience, 141	1004, 07
discipline, 40, 64	games, 148-9
display, 11	Geography, 93
documentary material	graveyards, 95, 132
as object, 128–9	graveyards, 75, 152
authorship, 130–1	hidden curriculum, 30, 49
date of production, 131	History, 93
definition, 127, 128	human connection, 25–6
	numan connection, 25–6
forms of, 127, 130 handling, 129	ideas, 34
information technology, 129	organisation of, 141
lines of enquiry (content), 129–30	imagination, 32, 78, 141
lines of enquiry (production), 129–30	in-service training, 166, 167–8
memorials, 132–3	information
motive, 131	collection of, 77
online, 129	rationing of, 152
place of origin, 131	resource file, 169–70
production of, 129, 130	inspiration, 29
provenance, 129	intended curriculum, 52–3, 163
questions to ask of, 130–1	inter-disciplinary work, 40
readership, 131	interpretation, 11, 151
selection of, 129	investigation
veracity, 130	design of, 77
drama, 144–5	
drink, 87	journey
	checklist, 84–5
education, 11, 142	length, 85
models of, 38	return, 85, 86
purpose of, 35	
emergency information, 62	landscape, 33
emotions, 32, 78	language development, 27
English, 94	Languages, 94
environment	learning how to learn, 49
built, 33	liaison with museums, 165, 168
natural, 33	links
teaching, 38, 41	creation of, 166–7
environmental studies, 4, 33	cross-curricular, 24-5, 77
equipment checklist, 84-5	development of, 167-8
evaluation, 162–3	maintenance of, 167
examination groups, 26	with museums, 166–8
extra-mural stimulus, 30	with teachers, 168-9
	listening, 141

litter, 87	patronage, 14
living history, 146–7	physical coherence, 9
loan materials, 51	preliminary assessment of, 75–6
loan service	proper reverence for, 79
complexities of, 135	public access, 11, 18
definition, 135	purpose of, 10
materials, 51	reasons given for not using, 24
types, 135	responsibility, 18
use of (general), 135–6	scope of, 20
use of (specific), 136–7	skills for educational use of, 79
looking, 120	social function, 12
lunch break, 86, 87	staff, 51, 74–5, 83, 136, 168
fullell bleak, 80, 87	
ti-1lt 20 21 22	stereotypes, 9–10
material culture, 29, 31, 32	styles of, 16
Mathematics, 93	subject of study, 31
medication, 83–4	teaching environment, 38
meditation, 29	text, 152
memorials, recording of, 132–3	types of, 15
mobile galleries, 51	understanding role of, 81
motivation, 30	why define?, $7-8$
multi-faceted work, 40	
museum education officers, 37, 51, 169	name badges, 84
museum education service	natural environment, 33
pupil oriented, 51	next-of-kin, 84
teacher oriented, 50-1	note taking, 152
tiers of, 50	
museum users group, 168	objectives, 77
museums	objects
accountability, 18	abundance of, 109
administration of, 12	aim of study, 115
community, 18	as loci, 110
concern of, 17	asking questions of 111
confidence to use, 79, 80	basic strategies for working with, 111
consist of, 8–9	capacity, 113
content of collections, 17	categorisation, 116–17
continuity of, 9	choice of, 109-10
cultural memory, 15, 17–18	chronology, 116
custodianship, 12	collections of, 115–17
decision making, 18	colour, 112
definition of, 20	completeness, 112
economic function, 12	condition, 112
education, 11	construction, 113–14
evolution of, 9	context, 115–16
	design, 114
familiarisation with, 49, 73	design, 114 dimensions, 113
financing of, 15 four dimensions, 9	documentary material, 128–9
function(s) of, 10–12, 18, 19	form, 112
history of, 13–15	function, 114
image of, 9–10	gender bias, 116
not schools, 37, 38–9	groups of, 115–17
original meaning of word, 12	handling, 111–12
organic, 9	inscriptions, 113
organisational coherence, 9	limitations of, 111

marks, 113	preliminary questions, 75–6
material, 112–13	punctuality, 85
psychological impact, 39	pupils
shape, 112	briefing sessions, 82
single, 111–15	information to, 64
typology, 116	preparation (importance of), 79
value, 114–15	relevance to, 77
weight, 113	safety, 87
working with, 27, 39, 80	
observation games, 85	quiet times, 78
observed curriculum, 52–3, 163	
online resources, 56, 155	reading, 151–2
documentary material, 129	strategies for, 152
images, 156	re-enactment, 147
mutability, 156	research, 11
use of, 155–6	resource file, 169–70
worth of, 156	responsibilities, 84
oral traditions, 12	risk assessment, 67, 96
	hazard identification, 68-9
paperwork, 84	legal requirement, 68
organising, 56	likelihood and severity, 69–70
parents, 38	persons at risk, 69
information to, 60, 62	reasons for, 68
letter to, 60–1	statement, 67
permission of, 60–1, 84	risk assessment form, 71
participation, 140-1, 144	risk management, 67, 70-2
passive learning, 24–5	assessment of plan, 72
personal belongings, 82, 86	emergency procedures, 72
pictorial material	plan B, 69, 72
approaches to, 121–2	preventative measures, 70
asking questions of, 122	supervision of group, 70–1
availability of, 122	through planning, 70
comparison, 124	through preparation, 70
definition, 119	role-play, 145–6
description, 124	Tole play, 145 0
focusing, 124	safety, 67
identification, 124	school
judgement of, 120	building, 101
moving images, 125	image of, 30–1
observation, 124, 125	
photographs, 125	liaison with museums, 165, 168 links with museums, 166–8
portraits, 125	
problems working with, 119–20	museum, 101
questions to ask of, 122–3	policy on visits, 31, 165–6
	school collections, 170–1
topographical images, 125	school museums, 170–1
use of, 124, 126	collecting policy, 171
planning	pupil participation, 171
as rehearsal, 55	source of material, 171
changes to, 65	Science, 93–4
checklist, 63–4	seeing, 120
logistical questions, 58–9	shopping, 87
preliminary questions, 56–7	simulation
preparation	aims (general), 141–2

benefits, 149	discipline, 40
definition, 139	group structure, 41
drama, 144–5	health and safety, 42
games, 148–9	law, 42
integration of, 149	learning environment, 42
living history, 146–7	physical environment, 42
place of, 142	routine, 41
preparation for (importance of), 142–3	social context, 40
problems, 149	social structure, 40
re-enactment, 147	working in public, 42
relevance to museum work, 140-1	teaching environment, 38
role-play, 145–6	temporary exhibitions, 51
story-telling, 143–4	thank-yous, 87
theatre, 146	theatre, 146
types of, 140	time-table
site	re-arrangement of, 63
definition of, 91	toilets, 86
environmental aspects, 91–2	transport, 57, 60
site work	behaviour on, 85
aim, long term, 93	getting on and off, 85
aim, short term, 92–3	travel sickness, 84, 85
Art, 94	traver stemiess, o 1, os
base of operations, 95	visit folder, 84
conditions, 95–6	visits
Design and Technology, 94	access, 59
English, 94	aims and objectives, 57
equipment, 96–7	assessment of, 53
Geography, 93	chronology of, 47–8
History, 93	context of, 47, 165
key areas of, 94–5	control of, 83, 86
Languages, 94	costing, 60
Mathematics, 93	discussion of, 59
orientation, 95	facets of, 47
	folder, 84
planning and preparation, 96	
risk assessment, 96	hazards 69
Science, 93–4	integration with classroom work, 79
scope of, 93	layers of, 48–9
value of, 92	necessity of, 55
small group work, 91, 101	overt reason for, 49
socialisation, 30	preliminary, 73–4
story-telling, 143–4	progress of, 86
structure of day, 77–8	random elements of, 52–3
surveying	resource file, 169–70
accurate recording, 97	safety, 86
equipment, 96–7	school policy, 165–6
methods, 97–9	teachers' role, 83
what to record, 99	types of, 49–52
	visual acuity
task cards, 153–4	development of, 120
teacher–pupil relationship, 30	volunteers, 63
teaching	information to, 63
control of learning, 42	1.1
control of visit, 42	websites, 56, 156

work
consolidation of, 163
cross-curricular, 40
inter-disciplinary, 40
multi-faceted, 40
worksheets, 153, 154
world view, 141–2
written word, 151–4

appropriate use, 154 context, 152 means to an end, 152 note taking, 152 presentation, 154 task cards, 153–4 worksheets, 153, 154